THE EYE OF THE POET
ANDRÉ BRETON
AND THE VISUAL ARTS

THE EYE OF THE POET
ANDRÉ BRETON
AND THE VISUAL ARTS

ELZA ADAMOWICZ

REAKTION BOOKS

Published by Reaktion Books Ltd
Unit 32, Waterside
44–48 Wharf Road
London N1 7UX, UK
www.reaktionbooks.co.uk

First published 2022
Copyright © Elza Adamowicz 2022

All rights reserved

No part of this publication may be reproduced, stored in a retrieval system, or transmitted, in any form or by any means, electronic, mechanical, photocopying, recording or otherwise, without the prior permission of the publishers

Printed and bound in India by Replika Press Pvt. Ltd

A catalogue record for this book is available from the British Library

ISBN 978 1 78914 531 1

ART probably doesn't exist – it's therefore useless to sing its praises – and yet: art is made – because it's so and not otherwise – Well – what do you want to do about it? So we like neither art nor artists (down with Apollinaire).

Jacques Vaché

We are not dealing with painting here, nor even with poetry or the philosophy of painting, but with some of the inner landscapes of a man who set off long ago for the limits of the self.

André Breton, 'Caractères de l'évolution moderne' (1923)

I write as if I were engaged in silent dialogue with Breton.

Octavio Paz, 'André Breton; or, The Search for the Beginning' (1967)

Contents

one Who Are You, André Breton? *9*
two 'Whom do I haunt?': Encounters with Artists *31*
three Painting or Poetry? A Surrealist Aesthetics *61*
four Between Marx and Rimbaud: Art and Revolution *77*
five Cutting and Pasting: Breton the Artist *101*
six Surrealism and Books: Doors 'left ajar' *127*
seven Wooden Masks and Sugar Skulls: Collecting *147*
eight From Easter Island to Alaska: Art and Ethnography *169*
nine Beyond Surrealism: Outsider Art *191*
ten Travels with Art: Off the Map *215*
Conclusion: Beyond the Wall *235*

REFERENCES *239*
SELECT BIBLIOGRAPHY *264*
LIST OF ILLUSTRATIONS *269*
ACKNOWLEDGEMENTS *280*
INDEX *281*

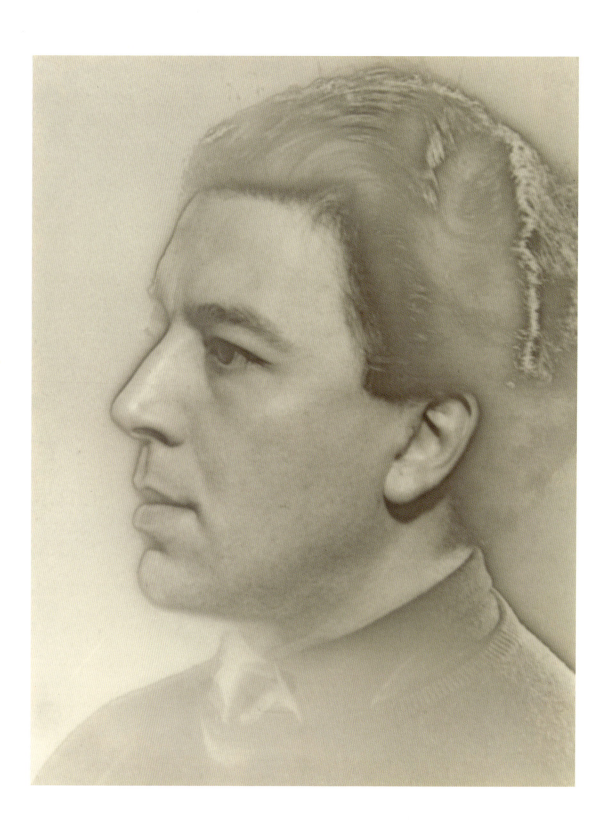

one
Who Are You, André Breton?

ANDRÉ BRETON WAS BOTH loved and hated. 'Who are you, André?' asked fellow Surrealist Paul Éluard: 'the person I cannot lose without losing my own self, my claim to life and thought' (illus. 1).[1] For the artist Marcel Duchamp, 'he embodied the most beautiful dream at a particular point in time.'[2] According to his detractors he was an authoritarian leader, doctrinaire and inflexible. Salvador Dalí, for instance, maintained that Surrealist café meetings were 'like the Court of the Inquisition', where Breton, 'orating to his court of followers like a big turkeycock', wielded absolute authority over the group, suppressing any sign of dissent.[3] Several participants, excluded from the Surrealist movement in Breton's *Second Manifesto of Surrealism* (1929), published *Un cadavre* (*A Corpse*), a pamphlet featuring a photograph of Breton with a crown of thorns and texts where he was pilloried as a 'hypocrite' and a 'false revolutionary but real ham actor', while the writer Georges Bataille denigrated him as 'the old aesthete and false revolutionary with the head of Christ . . . a representative of that unspeakable species, the animal with a great mop of hair and sputtering head: the castrated lion' (illus. 2).[4] This leonine Breton was a recurrent image, but not always sarcastic, as we see in the Haitian poet Paul Laraque's dithyrambic evocation of Breton: 'With leonine head, a mane of sun, Breton stepped forward, a god begotten by lightning. To see him was to grasp the beauty of the angel of revolt.'[5] He himself could love and hate with equal passion, according to Duchamp:

> I have never met a man with a greater capacity for love, a greater power of love for the grandeur of life, and we can understand nothing of his hatreds if we ignore the fact that

1 Man Ray, *André Breton*, c. 1930, gelatin silver print, solarized.

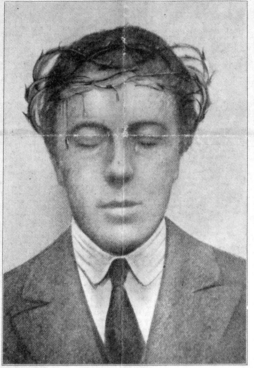

2 *Un cadavre*, 15 January 1930, tract signed by Bataille, Leiris, Desnos et al.

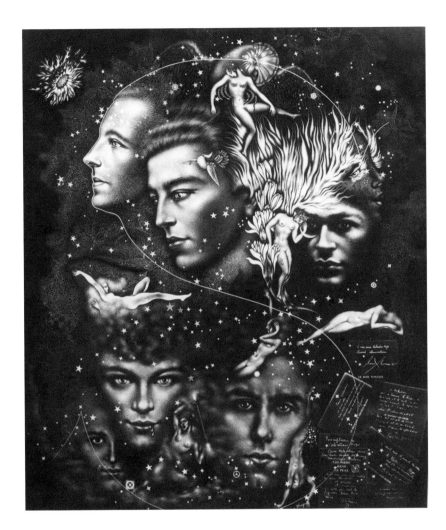

3 Man Ray, *The Surrealist Constellation of Valentine Hugo*, c. 1935, gelatin silver print.

it was a question of protecting the very quality of his love of life. Breton loved as the heart beats. He was the lover of love in a world that believes in prostitution.[6]

Admired or detested, loved or despised, the evidence reveals that Breton was indeed a paradoxical individual. His lover, the artist Valentine Hugo, described his expression as both gentle and severe, his blue eyes tender and hard. His moods would shift between enthusiasm and depression; at times he could be ponderous and dogmatic, at others lighthearted and playful. The Breton whose calm, controlled voice can be heard in a 1952 radio interview contrasts with the André

who, paralysed in the presence of Leon Trotsky when they met in Mexico in 1938, was reduced to silence for several days.

Such binaries might well account for the private individual, or at least perceptions thereof, but they fail to do justice to the public figure who will be the focus of the following pages. Published work on Breton to date has covered a wide range of topics, including philosophy, politics, poetics. He has even inspired fictional works, including Serge Filippini's recent novel *J'aimerai André Breton* (Paris, 2018) and David B.'s graphic novel *Nick Carter et André Breton. Une enquête surréaliste* (Paris, 2019). The major 1991 exhibition *André Breton. La beauté convulsive* at the Centre Pompidou in Paris, and its richly documented catalogue, generated interest in the central role of the visual arts in Surrealism and, in particular, in the neglected area of Breton's relations to art. The archive was extensively enriched in 2003 by the publication of an eight-volume catalogue to accompany the sale of Breton's private collection of artworks and manuscripts.[7] Subsequently, access to an ever-expanding website (www.andrebreton.fr) based on the digitalized sales items, with Constance Krebs as webmaster and a committee directed by Breton's daughter, Aube Breton Elléouët, together with material in Breton's published correspondence, have opened up unexplored areas of Breton's relations with the arts and artists. A number of recent exhibitions have also presented works from his collection, for example *La Maison de verre. André Breton, découvreur, initiateur* (Musée de Cahors Henri-Martin, 2014) and *André Breton et l'art magique* (Lille LaM, 2017); yet there has been little comprehensive discussion to date of Breton's relation to, and active participation in, the various fields of the visual arts.[8] This book proposes an exploration of a multifaceted Breton in the light of his passionate commitment to the visual arts: Breton as essayist, curator, collector, critic, artist, political activist; Breton's influential – and often polemical – voice in the debates that shaped the Western art world in the first half of the twentieth century. Individual chapters investigate aspects of each of Breton's multiple activities: his relations with the artists he haunted (Chapter Two); the outline of a Surrealist aesthetics (Chapter Three); relations between art and politics (Chapter Four); Breton as artist (Chapter Five); his contribution to the 'Surrealist book' (Chapter Six); Breton as collector (Chapter Seven); his passion for 'outsider art' and

ethnographic objects (Chapter Eight and Chapter Nine); and, finally, his appropriation of a range of artists, paintings and landscapes for a Surrealism that he always treated as international (Chapter Ten).

Who was André Breton?

Breton is best known as a co-founder of Surrealism, with Louis Aragon, Robert Desnos and Paul Éluard, as well as its leading theoretician (writing the *Manifesto of Surrealism* of 1924 and the *Second Manifesto of Surrealism* of 1929) and passionate if oft-contested leader. He was also an essayist and poet, exhibition curator, collector and artist. His biography, inextricably linked to the history of the Surrealist movement, has a collective dimension.[9]

The adult who celebrated childhood ('It is perhaps childhood that comes closest to one's "real life" . . . childhood when everything nevertheless conspires to bring about the effective, risk-free possession of oneself'[10]) was silent about his own. Born in 1896 in Tinchebray, Normandy, at an early age he moved with his family to Pantin, an industrial suburb of Paris. At school he developed a passion for the poetry of Paul Valéry and Guillaume Apollinaire. A medical student at the outbreak of the First World War, he was mobilized as a medical orderly in Paris at the neuropsychiatric hospital of St Dizier, then at La Pitié Salpêtrière, where he treated shell-shocked soldiers, drawing on Freudian psychoanalytical techniques of dream analysis and free association. While he shared with Freud (whom he would meet in Vienna in 1921) an interest in the unconscious, their aims differed radically: in contrast to Freud's therapeutic aim, the reintegration of the individual into society, Breton was interested in the creative possibilities of dream images and free association.[11] The French bookseller and publisher Adrienne Monnier recalls Breton at this time in the medical orderly's blue military uniform: 'He had a large nicely structured face; he wore his hair quite long and thrown back stylishly. He seemed to be disconnected from both the outside world and even himself, he was not very lively . . . He had the motionless alertness of mediums.'[12]

In 1917 he met the writer Louis Aragon, who introduced him to the work of the nineteenth-century poet of rebellion and dark

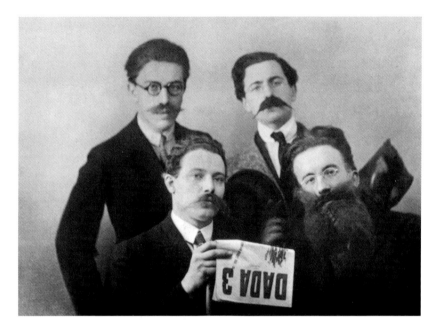

4 Dadaists (clockwise: André Breton, René Hilsum, Paul Éluard, Louis Aragon) with a copy of *Dada 3*, 1919.

romanticism the Comte de Lautréamont, author of *Les Chants de Maldoror* (1869). His friendship with Aragon, soon joined by Philippe Soupault, led in March 1919 to the launch of the ironically titled journal *Littérature* (1919–24). The first issues published Lautréamont's *Poésies* (1870), as well as extracts from an experimental automatic text written by Breton and Soupault, *Les Champs magnétiques* (The Magnetic Fields). In 1919 Breton published a collection of poems, *Mont de piété* (Pawn Shop), which marked a shift from the early influence of Mallarmé's symbolist poetics to the avant-garde aesthetics of the collage-poem. It was this commitment of the *Littérature* group of young poets to the avant-garde that led to contacts with the Dada group in Zurich. Dada, which emerged from the social upheaval of First World War Europe, was a movement of revolt and scandal founded in 1916 by Tristan Tzara, Hugo Ball and others. Among the many features that attracted the Paris poets was Dada's rejection of the rationalism which had dominated traditional Western thought for two centuries, together with the jubilant promotion of the irrational and the absurd, used to both reflect and critique the destructive forces that erupted in the First World War. The nascent Paris group enthusiastically adopted Dada and published dadaist texts, and after the war the centre of Dada activities effectively shifted from Zurich to Berlin and Paris (illus. 4).

WHO ARE YOU, ANDRÉ BRETON?

In 1920 Tzara moved to Paris where he pursued his anarchic Dada activities through a series of widely publicized 'anti-artistic' events grounded in provocation and mockery. The Surrealists took an active part in these, as a Soirée Dada in March 1920 illustrates: Breton, decked out as a sandwichman (designed by Francis Picabia), recited Picabia's 'Manifeste cannibale' to boos from the audience (illus. 5). On the same occasion he played the role of Étoile in *S'il vous plaît*, an absurdist sketch written by Soupault (illus. 6). In May 1921, the opening night of Max Ernst's first Paris exhibition, *La mise sous whisky marin*, at the bookshop Au Sans Pareil, was provocatively choreographed as a Dada event (see illus. 26). Dada activities continued in Paris until 1922, when Breton broke with Tzara, conscious of the waning impact of the Dadaists' repeated scandalous activities. In a text titled 'Lâchez tout' (Leave Everything) he wrote: 'Leave everything. Leave Dada. Leave your wife. Leave your mistress. Leave your hopes and fears . . . Set off on the roads.'[13] In a letter to her cousin Denise, Simone Kahn, who married Breton in 1921, provided a striking portrait of him at this time: 'He had the very special personality of a poet, absorbed by the rare and the impossible, just the right measure of imbalance, contained by a finely tuned intelligence . . . He was utterly sincere and direct, even when he disagreed with you.'[14]

Group activities led to Breton's first *Manifesto of Surrealism* in 1924, which marked the formal launch of the Surrealist movement and set out its philosophical and aesthetic principles. Surrealism was defined in dialectical terms as 'the future resolution of these two states, dream and reality, which are seemingly so contradictory, into a kind of absolute reality, a *surreality*.'[15] In short, far from being an escape from reality, the surreal was grounded in the real, as Michel

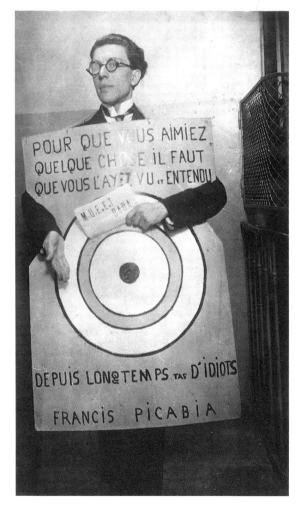

5 André Breton at the Festival Dada, Paris, with placard by Francis Picabia, 27 March 1920.

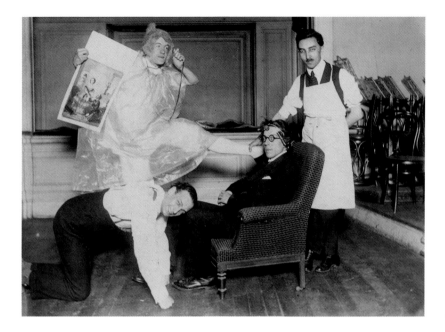

6 Dadaists (clockwise: Paul Éluard, Philippe Soupault, André Breton, Théodore Fraenkel) at a performance of Philippe Soupault's *Vous m'oublierez* (1920).

Leiris would later stress: 'In order to have Surrealism, you need to have realism, you need a reality to manipulate.'[16] Early definitions of Surrealism prioritize the concept of automatism, foregrounded in a mock-dictionary entry invented by Breton in order to underline the experimental nature of the movement:

> SURREALISM: Psychic automatism in its pure state, by which one proposes to express – verbally, by means of the written word, or in any other manner – the real functioning of thought. Dictation of thought in the absence of any control exercised by reason, exempt from any aesthetic or moral concern.[17]

Automatism was promoted as both a principle and a practice, Breton even providing instructions on how to write an automatic text, using a free association method designed to empty the mind of all rational and pragmatic considerations and liberate the voice of the unconscious and the language of desire. The method produced major texts like *Poisson soluble* (Soluble Fish) – and the *Manifesto* was originally designed as an introduction to this text. A few days before the manifesto's publication in 1924, the writer Maurice Martin du Gard sketched

a portrait of Breton: 'Today he has the bearing of an inquisitor; his looks and movements are so tragic and slow! A veritable magus! . . . with the magnetic authority of an Oscar Wilde over his followers.'[18]

The year 1924, with the launch of the journal *La Révolution surréaliste* (1924–9), was particularly active. The group opened a Bureau de recherches surréalistes, or Centrale surréaliste (Surrealist Headquarters), with the purpose of setting up a Surrealist archive where the public was invited to bring accounts of their dreams (illus. 7). At this early stage the group, with Breton as its leader, was made up of writers (such as Aragon, Desnos and Éuard) and artists (Ernst, André Masson, Man Ray and Joan Miró, among others), with only a few women, including Suzanne 'Mick' Soupault-Verneuil and Simone Kahn. Membership fluctuated over the years, impacted by ideological and personal conflicts and crises, exclusive friendships and bitter exclusions, the last in particular earning Breton the title of 'pope of Surrealism'.

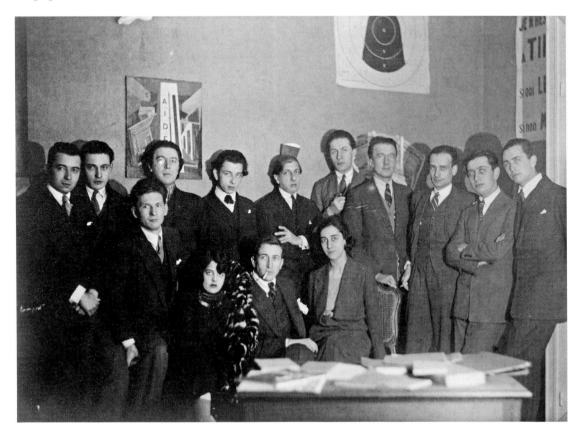

7 Man Ray, *Centrale Surréaliste*, 1924, photograph.

THE EYE OF THE POET

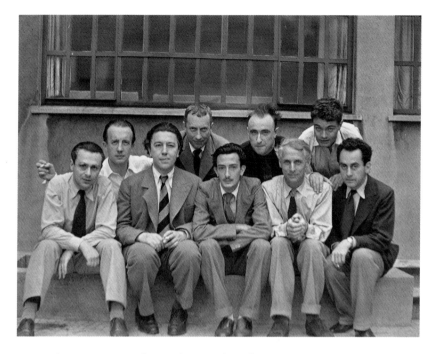

8 Anna Riwkin, *Surrealists in Paris*, 1933, gelatin silver print.

The rejection of social, moral and artistic convention was the driving force of a movement that sought to revolutionize art, literature, politics and life itself in the name of freedom, desire and revolt. The Surrealists' initial global concept of revolt, and their defence of anti-militaristic and anti-colonial issues, led gradually to a greater involvement in politics, collaboration with the left-wing movement Clarté and a rapprochement with the French Communist Party (Parti Communiste Français, or PCF). By 1927, wishing to give a concrete dimension to the concept of revolt, Breton, with Surrealists Aragon, Éluard, Benjamin Péret and Pierre Unik, joined the PCF, while continuing to give priority to Surrealist activities.

Throughout this period Breton refined the concept of the surreal as the resolution of opposites. In his *Second Manifesto of Surrealism*, first published in the last issue of *La Révolution surréaliste* in 1929, he grounded his definition in a mix of Hegelian dialectical materialism and alchemical thought. Surrealism was thus defined as the search for 'a certain point of the mind at which life and death, the real and the imagined, past and future, the communicable and the incommunicable, high and low, cease to be perceived as contradictions.'[19] The 'point of the mind' was situated, not in the present, but between

nostalgia for a lost pre-Oedipal unity (present in childhood and androgyne myths) and desire (in the messianic myth of a future totality, a collective myth charting the workings of the unconscious). The surreal was now considered essentially a project or possibility, something that clearly appealed to Dalí, Luis Buñuel, Alberto Giacometti and René Char, who joined the Surrealists that year (illus. 8). Not everyone agreed, of course, and Breton's concept of the dialectic was virulently criticized by Georges Bataille, the leader of a dissident group of Surrealists and editor of the journal *Documents* (1929–30). Bataille, a former Surrealist who was excluded from the movement in 1929 along with Desnos, Leiris and others, argued that Breton's approach was premised on an idealized notion of romantic unity. It is to this group that we owe the pamphlet quoted above, *Un cadavre*, violently attacking Breton the 'castrated lion'.

Surrealist theory and practice continued to evolve, and in 1930 *La Révolution surréaliste* was followed by *Le Surréalisme au service de la révolution* (1930–33), its sober format reflecting a shift towards a more pragmatic commitment to social revolution. This did not imply a real change of priorities, however, and the Surrealists continued to refuse to subordinate their activities to the economic revolution and thus to the discipline of the party. This led in 1932 to a break between Breton and Aragon, who put communist principles before Surrealist commitment; and in 1935 to the group's break with Communism, confirmed with the tract 'Quand les surréalistes avaient raison' ('When the Surrealists were Right'). Breton favoured henceforth an anti-totalitarian (anti-Stalinist and anti-Nazi) stance in the service of the revolution, consequently moving closer to rival Trotskyist circles.

In the 1930s Breton published two prose texts not totally enmeshed in the political, *Les Vases communicants* (1933) and *L'Amour fou* (1937); the first explores the question of the interpretation of dreams and the interrelation between the conscious and the unconscious; the second, bringing together essays from the art journal *Minotaure* (1933–9), celebrates his love for Jacqueline Lamba, whom he met in 1934 (recounted in 'La nuit du tournesol'), with reflections on 'convulsive beauty' and the notion of 'objective chance', defined as the point of intersection between inner desires and outer reality. It was in the offices of *Minotaure* that the photographer Brassaï met Breton:

'His presence, his leonine bearing, his solemn, stern and impassible face, his sober, extremely slow and measured movements gave him the authority of a leader of men, not only to subjugate and rule, but also to condemn and strike.'[20]

It was also by the mid-1930s that Surrealism gained an international dimension, with groups forming across Europe and Latin America. Breton was at the heart of this expansion, collaborating with writers and artists in organizing exhibitions and publishing collective works and editing international journals, including the four issues of the *Bulletin International du Surréalisme* (1935–6). In March 1935 he travelled to Prague, invited by the Surrealists Karel Teige, Vítězslav Nezval, Jindřich Štyrsky and Toyen; he gave two lectures on art and politics, 'Position politique de l'art aujourd'hui' and 'Situation surréaliste de l'objet, situation de l'objet surréaliste'.[21] A month later he was in the Canary Islands, on the occasion of an international Surrealist exhibition in Tenerife (illus. 10), and in 1936 he attended the International Surrealism Exhibition at London's Burlington Galleries (illus. 11). In 1938 he travelled to Mexico where he met Leon Trotsky, and together they published the *Manifesto for an Independent Revolutionary Art*, which called for 'total freedom of art'. On his return to Paris, that collaboration was given concrete shape with the launch of the Trotskyist Fédération internationale des artistes révolutionnaires indépendants (FIARI).

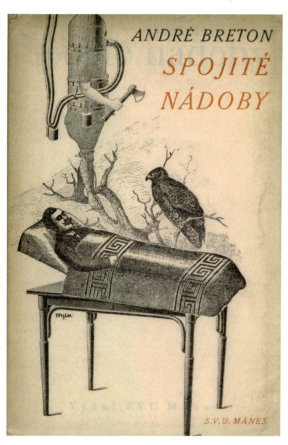

9 Maria Cerminova Toyen, cover of *Spojité Nádoby* (*Les Vases communicants*), 1935.

Breton was unwelcome in the Vichy regime introduced after the fall of France in 1940, and with his *Anthologie de l'humour noir* (Anthology of Black Humour) now banned by the Nazis, he left occupied Paris for Marseille in the unoccupied zone, along with his second wife Jacqueline Lamba and their daughter Aube. They spent the winter of 1940–41 there and, like many artists and intellectuals, were able to sail for

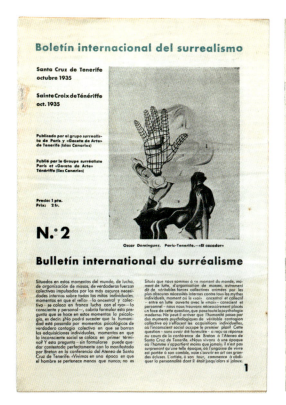
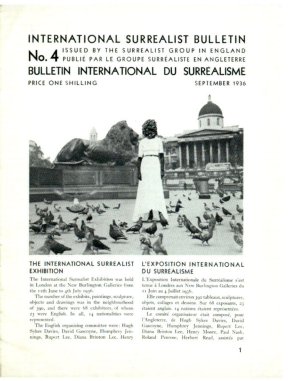

New York thanks to Varian Fry of the American Emergency Rescue Committee, set up in the United States to rescue cultural and political refugees. It was during a stopover in Martinique that Breton met the poets Aimé Césaire and René Mesnil, co-founders of the influential journal *Tropiques*.

While continuing his Surrealist activities in New York in 1941–6 with fellow Surrealist exiles Masson, Ernst and Duchamp (illus. 12), Breton earned a living as a speaker for the Voice of America. He co-edited *vvv*, the official wartime Surrealist journal, had ties with the New York artistic milieu, in particular artists Enrico Donati, Roberto Matta (illus. 13) and Arshile Gorky (illus. 14), whose works he enthusiastically promoted in his catalogue essays, as well as gallery owner Pierre Matisse (illus. 15). It was during this period that he developed a keen interest in esoteric thought and the elaboration of a new myth, as well as in the work of the nineteenth-century utopian thinker Charles Fourier, about whom he published *Ode à Charles Fourier* (1947). His prose text *Arcane 17* (1945) was written in the Gaspé Peninsula in

10 *Bulletin international du surréalisme*, 2 (1935).

11 *International Surrealism Bulletin*, 4 (1936).

12 Marcel Duchamp, cover design for André Breton, *Young Cherry Trees Secured Against Hares* (1946).

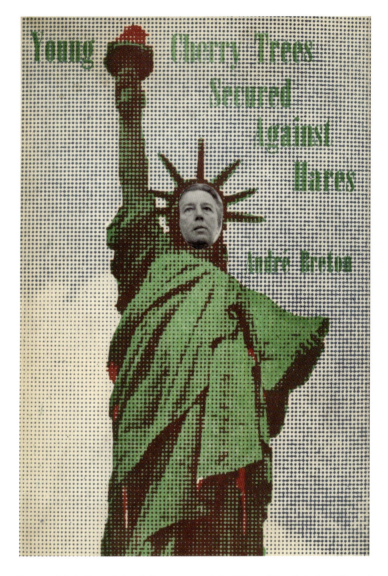

Quebec, which he visited in 1944 with Elisa, his third wife, whom he had met in 1943. In 1945 he travelled with Elisa to Arizona, where he visited Hopi and Navajo reservations and witnessed their ritual dances. In late 1945 he was invited to give a series of lectures in Haiti, where he was given an enthusiastic reception by Haitian poets and students, but social protests that eventually led to the overthrow of the government brought his stay to an abrupt end.

On Breton's return to Paris in 1946, the Surrealist group sought to resume its activities, despite the hostility of former Surrealists such

13 Roberto Matta, *Un poète de notre connaissance*, 1944–5, oil on canvas.

THE EYE OF THE POET

as Tzara. Although the exhibition *Le Surréalisme en 1947*, dominated by the theme of the esoteric, was designed to mark the renewal of the movement, some critics perceived it as a swan song. The group was nevertheless re-energized by the arrival in its ranks of a younger generation of artists and poets, including José Pierre, Jean Schuster and Gérard Legrand (illus. 16). Breton developed an interest in Celtic art and 'outsider art', co-founding the Compagnie de l'art brut with Jean Dubuffet. The commitment to political change remained strong, too, and in 1951 he joined the Citizens of the World movement founded by American pilot Garry Davis to fight against nationalism. It was during one of their congresses in Cahors that he discovered the nearby medieval village of Saint-Cirq-Lapopie, where he bought a house: 'I have stopped wishing to be elsewhere,' he wrote in 1951 (illus. 17).[22]

14 Arshile Gorky, *One Year the Milkweed*, 1944, oil on canvas.

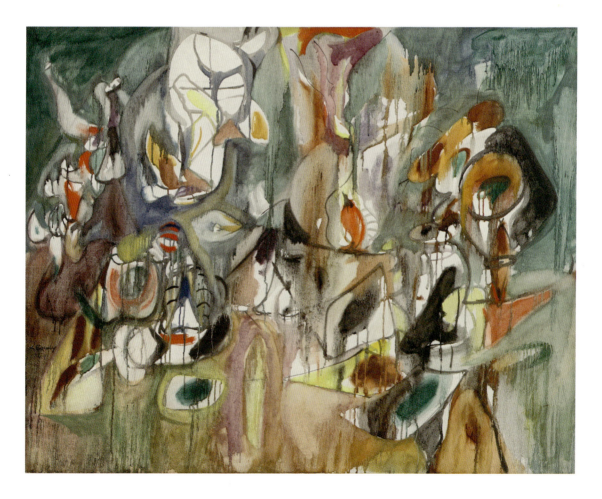

15 André Breton and Pierre Matisse, 1945.

The village became a meeting-place for his friends every summer (illus. 18). He continued to actively promote the art of younger artists, organize exhibitions – notably as artistic director of the Galerie À l'Étoile Scellée – and edit the Surrealist journals *Médium* (1953–5), *Le Surréalisme même* (1956–9) and *La Brèche* (1961–5).

On Breton's grave in Batignolles Cemetery in Paris are carved the words: 'Je cherche l'or du temps' (I seek the gold of time). After his death in 1966 the Surrealist group was formally dissolved in 1969. Surrealist groups continue to be active to this day, however, in Paris, Prague, London, Tokyo and elsewhere.

The continued self-questioning and ferment of Breton's evolving thought testify both to his refusal to reduce Surrealism to a monolithic entity or a single essentialist definition, and to his promotion

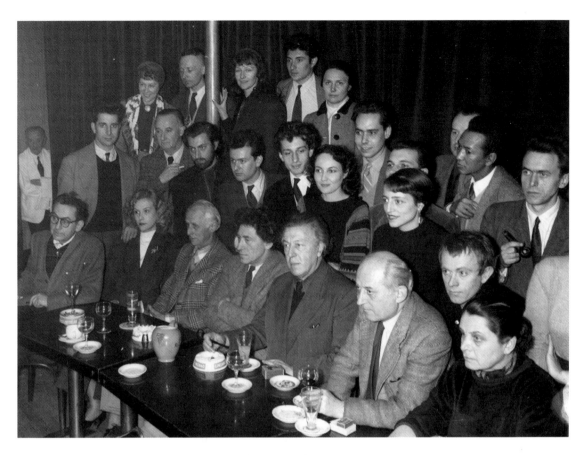

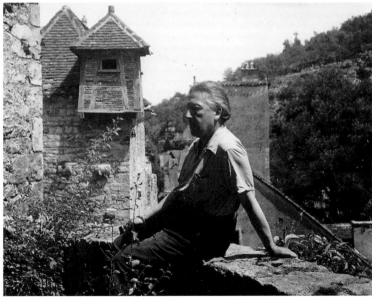

16 Surrealist group at café de la place Blanche, 1953.

17 André Breton at Saint-Cirq-Lapopie, c. 1953.

WHO ARE YOU, ANDRÉ BRETON?

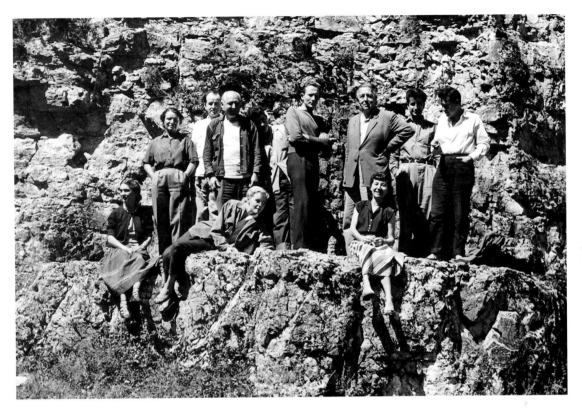

18 Surrealist group at Saint-Cirq-Lapopie, 1953.

of the movement instead as dynamic quest rather than fixed doctrine. He conceived Surrealism in radical and global terms, a unique combination of Rimbaud's injunction to 'change life' (*changer la vie*), Marx's 'transform the world' (*transformer le monde*) and the Marquis de Sade's libertarian ethos. Surrealism was thus never merely a literary movement; on the contrary the Surrealists engaged with art, politics and film, activities central to the liberation of the individual and the transformation of society. In all his activities, whether political, ethical, literary or philosophical, Breton endeavoured to reconcile ideological commitment with poetic and artistic freedom without compromising his ethical position in relation to the revolutionary transformation of society and the individual.

Surrealism and art

Breton was attracted to the visual arts from an early age. He recalls the Sunday walks with his parents at the age of sixteen when there

'was nothing more depressing', were it not for the paintings of Henri Matisse or Henri Rousseau in the windows of the Galerie Bernheim.[23] Among the artists he was first attracted to were Gustave Moreau (the Musée Gustave Moreau was close to his school), Paul Signac, Edouard Vuillard and Pierre Bonnard. He writes of the excitement of discovering new artists: 'I wish I could have kept the eye I had at seventeen or eighteen for artworks that were then totally new, facing almost unanimous hostility and intolerance! The encounter with these works, way beyond me, gave me the most exciting glimpse of the possible.'[24] In a lecture he gave in Barcelona in 1922 on the occasion of an exhibition of Francis Picabia's Dadaist works, he promoted the work of a younger generation of artists – Picabia himself, Duchamp, Ernst and Giorgio de Chirico – who were to become central to the Surrealist movement as pioneers in art, freeing painting from its traditional role as imitation.[25]

Surprisingly, however, in his 1924 *Manifesto*, apart from a brief mention of the artists Pablo Picasso, Georges Malkine, Boiffard, Picabia and Duchamp, visual artists were relegated to a footnote.[26] Yet art was actually at the heart of Surrealist activities from the outset, a position illustrated by the important place devoted to artists in *La Révolution surréaliste* and *Le Surréalisme au service de la révolution*, as well as in *Minotaure*, the glossy art magazine published by Albert Skira (the Surrealists took over its editorship in 1937). These journals reproduced paintings, drawings and photographs, as well as texts on and by Surrealist artists. And yet Breton treated art not as an end in itself – whence his disdain for pictorial techniques, his discussion of painting in terms of poetry (Baudelaire, Rimbaud), and the search for a mode of expression 'beyond painting' – but as a means of liberation. For him *'changer la vue'* (change one's vision) was an integral part of *'changer la vie'*, and he went beyond purely aesthetic considerations, annexing artists and art to Surrealism's global liberatory project.[27]

The first Surrealist exhibiton, *La Peinture surréaliste*, with a catalogue preface co-authored by

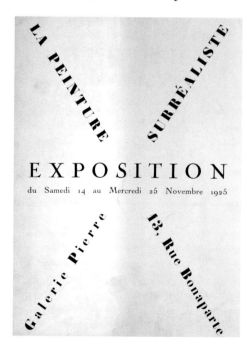

19 *La Peinture surréaliste*, exhibition catalogue, Galerie Pierre, 1925.

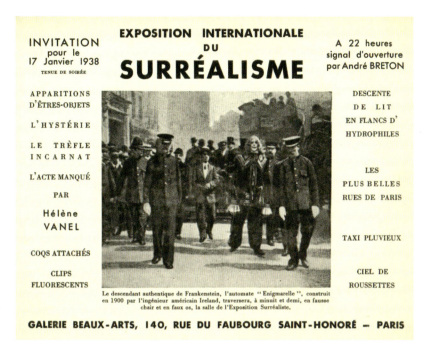

20 Invitation to opening of *Exposition internationale du surréalisme*, 17 January 1938, Galerie des Beaux-Arts, Paris.

Breton and Desnos, took place in November 1925 at the Galerie Pierre, exhibiting works by De Chirico, Man Ray, Masson, Miró, Picasso and others (illus. 19). The Galerie Surréaliste opened a few months later with the exhibition *Tableaux de Man Ray et objets des îles* (March 1926), where Man Ray's paintings were displayed alongside Oceanic sculptures and masks. The Galerie Surréaliste also held exhibitions of the works of Georges Malkine, Jean Arp, De Chirico and others; and a number of Surrealist exhibitions were organized in the Galerie du Printemps (1928), the Galerie Pierre Colle (1933), the Galerie Charles Ratton (*Exposition surréaliste d'objets*, 1936), the Galerie des Beaux-Arts (*Exposition Internationale du Surréalisme*, 1938) (illus. 20) and the Galerie La Dragonne (*Cadavres exquis*, 1948), among others. With the internationalization of Surrealism, major Surrealist exhibitions were organized worldwide from the mid-1930s – with Breton contributing as adviser or curator to several of these events – at locations including Paris (1938, 1947, 1959, 1965), Tenerife (1935), London (1936), Tokyo (1937) and Mexico City (1940). In New York the 1936 exhibition *Fantastic Art, Dada, and Surrealism*, curated by Alfred Barr at the Museum of Modern Art, had a great impact on artists based in the United States.

Breton's activities, as essayist, art collector, exhibition curator and gallery director, reveal an extraordinary breadth of interest and expertise. His passion not only covered the works of Surrealist artists (Ernst, Masson, Dalí, Miró) and, beyond these, younger artists affiliated to the movement in the post-1945 period (Marcelle Loubchansky, Konrad Klapheck, Maria), but he was curious about lesser-known painters such as the symbolist Charles Filiger or the works of 'outsider' artists like Aloïse Corbaz. The range of artworks in his own collection was similarly broad – from Oceanic masks to art naïf (naive art) works, from paintings to pebbles, tarot cards to Gallic coins. He indefatigably and enthusiastically promoted the work of artists, through not only his many prefaces and essays, but his activities as a literary and artistic adviser to the fashion designer Jacques Doucet, as artistic director with both the Galerie Gradiva (1937–8) and À L'Étoile scellée (1952–6) – spaces where he exhibited the works of both 'established' Surrealist artists (Ernst, Tanguy) and younger artists affiliated to the 'lyrical abstraction' movement.

two
'Whom do I haunt?': Encounters with Artists

'WHO AM I? . . . perhaps everything amounts to knowing whom I "haunt".'[1] Among those Breton haunted were the poets Jacques Vaché, Éluard and Péret, and the artists Duchamp, Ernst, Picasso and so on. His relations with artists fluctuated: he could be at times passionate, exclusive, supportive, at other times dismissive, aggressive or hostile. He generously, sometimes impulsively, enlisted for Surrealism artists who had little or no connection with the movement – he even tried to persuade Matisse that he was a Surrealist,[2] while the Mexican painter Frida Kahlo loudly rejected the label. At other times, just as expeditiously, he excluded others, among them Max Ernst in 1938, bringing him back later into the Surrealist fold. This chapter focuses on four artists, Picasso, Ernst, Miró and Dalí, that Breton engaged with over several decades, collaborating with them and promoting their work, appropriating them for Surrealism, at times critiquing their positions, even excluding them from the movement. They stand out among those he 'haunted' because they engaged with fundamental issues relating to Surrealist art, contributing to the elaboration of a Surrealist aesthetics: its definitions and limits (Picasso); its techniques, collage (Ernst) and automatism (Miró); and the materiality of the work of art versus its poetic dimension (Dalí). These are stories of dialogue and dispute, collaboration or conflict, passion and polemics, in which Georges Bataille appears as a jousting partner because he challenged 'orthodox' Surrealism and Breton's leadership by setting up a rival group, and his analysis of the artists discussed here differed fundamentally from Breton's.

Pablo Picasso: 'one of us'?

In a letter to Picasso in September 1935, Breton wrote: 'You know how much I admire you and how, as a young man, I dreamed of occupying a small space in your life.'[3] Admiration and enthusiasm ruled his relations with Picasso until the 1940s. Indeed, Picasso was 'among the two or three beings thanks to whom it is good to be alive'.[4] And in another letter to the artist, dated 11 April 1940, from Poitiers, where Breton had been notified to join his regiment, he wrote: 'I spent last Sunday at Royan in that light you must love, and I gazed at length at your windows, as if I hoped to be able to see through your eyes. It's true that since my last visit to your studio, my vision has become increasingly dependent on yours.'[5]

Breton discovered the artist's Cubist works in 1913 in *Les Soirées de Paris*, a literary and artistic journal founded by Apollinaire in 1912. A few years later he bought three works by Picasso dated 1913, the collage *Tête* and two still-life paintings, at the Kahnweiler and Uhde sales (1921–2), and negotiated Jacques Doucet's purchase of *Les Demoiselles d'Avignon* (1906–7). In 1922 he rose dramatically to defend his friend at the performance of Tzara's play *Le Coeur à Gaz* (The Gas Heart) when the Dadaist Pierre de Massot pronounced 'Pablo Picasso dead on the field of honour'. Leaping onto the stage, Breton struck Massot with his cane and broke his arm, before being forcibly evicted by the police along with his friends.[6] Breton was a frequent visitor to Picasso's Paris studio, and with his wife Simone Kahn he visited the artist in Antibes in the summer of 1922. In a lecture Breton gave in Barcelona later that year Picasso was listed alongside Duchamp and Picabia as examples of the 'modern spirit' in art. The following year Breton asked Picasso for a portrait for the frontispiece of his collection of poems, *Clair de terre* (Earthlight; illus. 21). While Picasso never formally joined the Surrealist movement, he had close affinities with the group, allowing his works to be reproduced in their journals and displayed in their exhibitions. It was in 1924 that he appeared alongside the Surrealist group (in the company of Freud) in the first issue of *La Révolution surréaliste*, in a photographic montage around the anarchist activist Germaine Berton (illus. 22). On 20 June 1924 the entire Surrealist group signed a declaration, 'Hommage à Pablo

21 Pablo Picasso, *André Breton*, frontispiece to *Clair de terre* (1923).

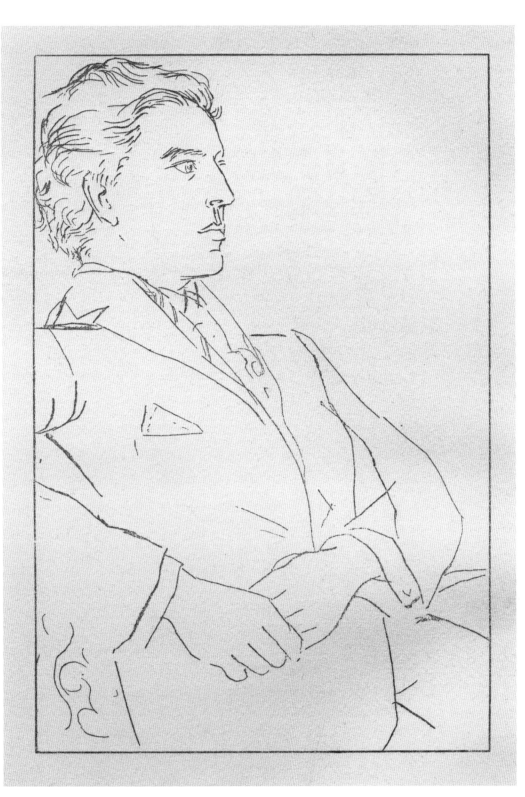

22 Germaine Berton with the Surrealist group, photomontage reproduced in *La Révolution surréaliste*, 1 (1924).

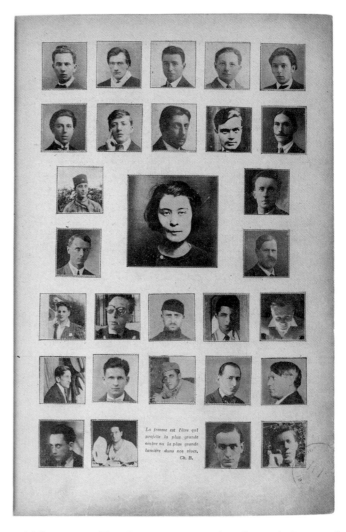

Picasso' (Tribute to Pablo Picasso), supporting the artist's contribution to the sets and costumes of Léonide Massine's ballet *Mercure*.[7] 'There has never been anything more beautiful and absolutely brilliant,' he wrote enthusiastically to Simone.[8] Admiration led to appropriation, and by 1938 the entry 'Picasso' in the *Dictionnaire abrégé du surréalisme* could claim: 'Painter whose works have participated objectively in Surrealism since 1926.'[9]

In the first instalment of 'Le Surréalisme et la peinture' (1925), Breton sees in Picasso's paintings the embodiment of the 'purely internal model' of Surrealist art, and devotes a large part of his text to a discussion of his works, with illustrations of three of his Cubist

23 Pablo Picasso, *Guitare*, 1924, sculpture, painted metal, reproduced in *La Révolution surréaliste*, 1 (1924).

and post-Cubist paintings.[10] Breton thus bypasses Picasso's post-1918 neoclassical works, preferring the more radical works of his Cubist period, while claiming that he rejects all labels, even a Surrealist one. The label may well be missing, the artist's independence thus acknowledged, yet Picasso's paintings are interpreted by Breton in the light of Surrealism. He draws the artist into the Surrealist family, alongside Ernst or Miró, as a descendant of the poets Lautréamont, Mallarmé and Rimbaud: 'True, poets spoke of a "drawing room at the bottom of a lake" ... for us it was only a virtual image,' while Picasso has materialized it in his paintings: his *Man with Clarinet* has the 'fabulous elegance' of the animals in Rimbaud's 'Enfance'.[11] Moreover,

Breton reads the paintings in terms of dreams and the imagination, addressing the poet: 'you who have taken to its furthest point the spirit, not of contradiction, but of evasion!' In the same spirit Picasso becomes the artist-adventurer exploring unknown territories, a 'future continent' compared to Alice's Wonderland, and his paintings act as a springboard for Breton's poetic development: 'From the laboratory opening on to the sky divinely strange beings will continue to escape at nightfall, dancers taking away with them fragments of marble mantelpieces and adorably laden tables.'[12] More discreet, but no less appropriative, is the positioning of reproductions of Picasso's works in the pages of *La Révolution surréaliste*, as Elizabeth Cowling has suggested. She gives the example of Picasso's Cubist construction of a guitar positioned in the centre of a prose text by Pierre Reverdy, 'Le Rêveur parmi les murailles' (The Dreamer among the Walls), where its proximity with the title gives it a dreamlike, anthropomorphic appearance (illus. 23).[13] Breton's enthusiastic appreciation is beyond doubt, but this overt annexation of a well-established artist like Picasso is probably not devoid of strategic intent, designed to equip Surrealism with solid credentials by association.

The challenge to Breton's co-option of Picasso for his brand of Surrealism was launched in a special issue of *Documents* in its own *Tribute to Picasso* (1930), in which Bataille, Carl Einstein and Leiris focused on the materiality, violence and heterogeneous character of the artist's works, openly at variance with the poetic vision promoted by Breton. The latter's response appeared in 1933 in 'Picasso dans son élément', published in the first issue of *Minotaure*, following a visit to the artist's studio.[14] Breton's response – illustrated with photographs by Brassaï of paint pots, paint stains and objects cluttering the mantelpiece of the artist's Paris and Normandy studios (illus. 24) – seems anchored in a resolutely materialist framework. He describes in detail the objects scattered around the artist's studio, and alludes to the materiality of the paintings and assemblages: a butterfly and a dried leaf pasted onto the canvas, the arbitrary use of colours, the perishable materials of the collages, the process of creating the work seen in terms of an *excretion*, 'the visible slip of the scissors or the markings on the surface of the wood'. Such an opening might suggest that Breton had crossed into Bataille's camp, and he certainly gave the impression

that he was bowing to Bataille's 'base materialism'.[15] But when Picasso showed him a small work composed of a single large lump, claiming that it represented an excrement awaiting the addition of flies to render it more authentic, Breton conjured away the (faecal) matter in a burlesque send-off: 'I was elsewhere, where everything was fine and life was pleasant, among the wild flowers and the dew; I walked freely into the woods.' For Brassaï, Breton's text was 'dazzling' but with a 'flagrant Surrealist bias'.[16] Yet the clichés and overblown style suggest self-irony: Breton appears to be mocking his opponent by initially acceding to the vision of a materialist Picasso, then ridiculing it by an overt pastiche of his own poetic style, displayed in a text that Bataille would have loved to hate.[17]

In 'Genèse et perspective artistiques du surréalisme' (Artistic Genesis and Perspectives of Surrealism) of 1941, Breton embarked on a rather more sober overview of the artistic revolution in the twentieth century, identifying two main trends in non-figurative art, the first initiated by Picasso, 'de culture occidentale', the other by Kandinsky, 'de culture orientale'. He further underlined the key role of Cubism in challenging the art of imitation through fragmentation and reconstruction of the object. Far from a form of Cubism reduced to 'finicky geometry' ('géometrie jalouse'), this is a more generous, surrealized or poetic conception of Cubism in which, 'from early on, lyrical outbursts break up its rigidity.'[18] The subject is illustrated with a papier collé titled *Tête* (1913), from Breton's own collection, its personal meaning clear from a remark to Roland Penrose, to whom he later sold it: 'I fear, should I no longer have it, that I'll feel even poorer.'[19]

The year 1944 saw the end of Breton and Picasso's long friendship when the latter joined the Communist Party. Back in 1927, when

24 Breton, 'Picasso dans son élément', *Minotaure*, 1 (1931), with photographs by Brassaï.

25 Pablo Picasso, *Stalin*, reproduced in *Lettres francaises*, 8 March 1953.

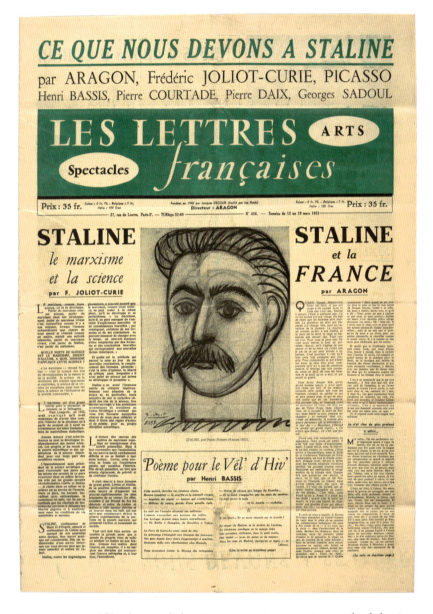

Breton himself had joined the Party, certain questions asked during his grilling by Party officials had dealt with Picasso's paintings, and notably whether they were compatible with the Revolution. Breton's response at that time had been to defend above all the artist's freedom of expression. Now, although distanced from the artist on political grounds, Breton retained his passion for Picasso's Cubist works in particular, although he was now more circumspect about their link

to Surrealism, writing in 1947 that, while remaining 'an unrepentant realist, when [Picasso] gives free rein to his lyricism, he sometimes comes close to Surrealism and even makes real incursions into it'.[20] What was now lacking, however, was the whole-hearted admiration he had felt in the past. In 1951, for instance, a text by Breton and Péret, 'La Vie imagée de Pablo Picasso', illustrated with a comic strip by the artist Paul Braig, related the life of the artist, ironizing about both his commercial success ('the slightest scrap of paper scribbled by Picasso has long had more value than a bank note') and his political commitment, now alleged to combine mystification and bad faith.[21] Irony also marks 'Le Staline de Picasso, c'est Dudule', where Breton ridicules Picasso's portrait of Stalin, published on the first page of *Lettres françaises* (illus. 25), a journal financed by the French Communist Party.[22] Finally, in an article written on the occasion of Picasso's eightieth birthday, Breton contrasted the older artist to the man who had dazzled him in his youth.[23] He reproached the artist for his 'indissoluble attachment to the external world (of the "object")', his tolerance towards Stalinism, and – referring to Picasso's famous symbol of peace – the political exploitation of 'so many deceptive and bloodless doves'. Picasso was, claimed Breton, betraying the lesson of freedom initially embodied in his work, the youthful vision that Breton remembered from the time he discovered Picasso's work.

Max Ernst: from Paris Dada to the merchants of Venice

Enthusiasm also marks Breton's first encounter with the works of the German artist Max Ernst: 'It's no exaggeration to say that we welcomed Max Ernst's first collages, with their extraordinary suggestive power, as a revelation.'[24] Ernst's first Paris exhibition, *La mise sous whisky marin*, was organized at the bookshop Au Sans Pareil in May 1921 on Breton's initiative (illus. 26). With his application for a visa having been refused by the occupying authorities in Cologne, Ernst was unable to attend the opening night, orchestrated as a Dada event. Visitors were greeted with insults, shouts and flashing lights; Soupault and Tzara played hide-and-seek in the crowd; Breton munched matches; Aragon impersonated a kangaroo. There were

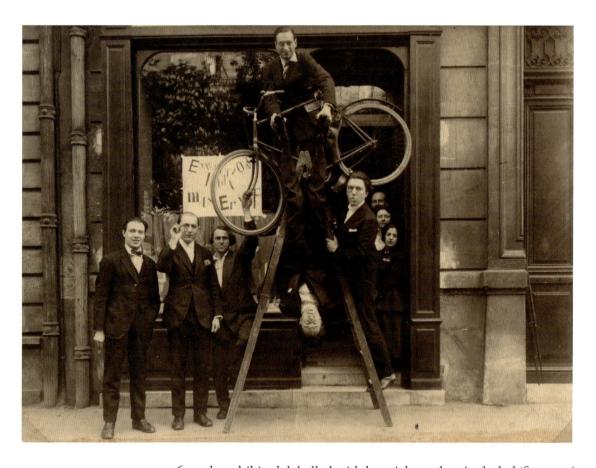

26 Dadaists (René Hilsum, Benjamin Péret, Charchoune, Philippe Soupault, Jacques Rigaut and André Breton) at the opening of Max Ernst's exhibition *La mise sous whisky marin*, Au Sans Pareil bookshop, 21 May 1921.

27 Max Ernst, *The Chinese Nightingale (die chinesische Nachtigall/le rossignol chinois)*, 1920, collage of photographic prints and ink on paper.

56 works exhibited, labelled with bus tickets; they included 'fatagaga' (collective collages), drawings, overpaintings, a sculpture, and twelve 'collages-découpages' (cut-out collages). The materials used had been cut out from various sources – encyclopaedic plates, anatomical treatises, commercial catalogues and so on – then pasted together in new combinations. *The Chinese Nightingale* (1920), for instance, combines the photograph of an aerial bomb turned 90 degrees to suggest a head, with a fan, a single eye and raised female arms, thereby recycling a war image as an image of seduction (illus. 27). The exhibition advertisement qualified Ernst's works as 'beyond painting' ('au-delà de la peinture'), and the Paris Dada group acclaimed Ernst's works with unqualified excitement. Breton's catalogue essay encapsulates the mood when he describes the collages as 'the marvellous faculty of attaining two widely separate realities without departing from the realm of our experience; of bringing them together and drawing

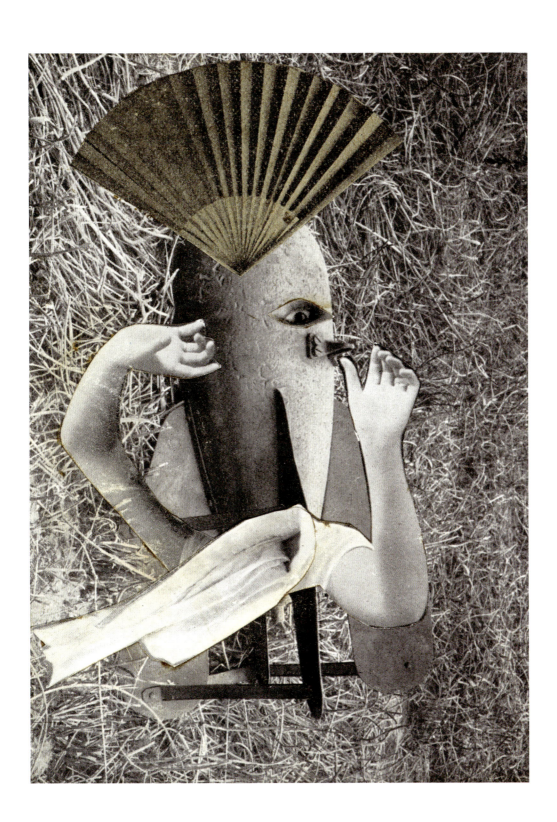

THE EYE OF THE POET

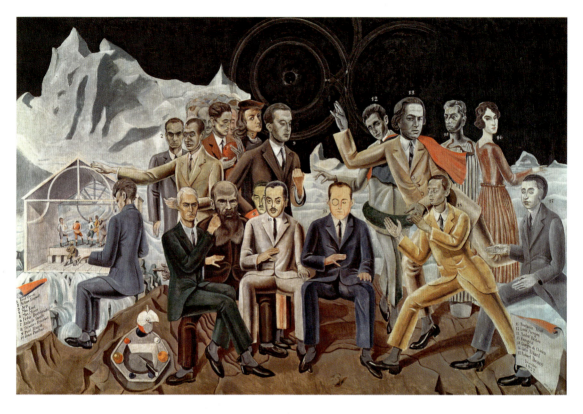

28 Max Ernst, *Au Rendez-vous des amis*, 1922, oil on canvas.

a spark from their contact.'[25] What he was outlining here was an embryonic Surrealist poetics, which would be developed in his 1924 *Manifesto of Surrealism*: 'It is . . . from the fortuitous juxtaposition of the two terms that a particular light has sprung, *the light of the image . . . the value of the image depends on the beauty of the spark obtained*.'[26]

Breton and Ernst first met in September 1921 in Tarrenz in the Tyrol, where Breton and Simone Kahn were spending their honeymoon. The following year Ernst crossed into France illegally, using Éluard's passport, and immediately plunged into the world of Paris Dada. His relations with Breton were friendly and playfully ironic, as reflected in his portraits. In a painting of 1922 of the Paris group titled *Au rendez-vous des amis* (The Rendezvous of Friends) Breton is represented leaping forwards, cape flying over his shoulder, an arm raised like an angel of Annunciation (illus. 28). A drawing of the poet, bare-chested with a bandaged arm, was used as publicity for *Clair de terre* in 1923 (illus. 29), as if the poet was struggling out of a chrysalid form. A second group portrait, the photocollage *Loplop présente*

les membres du groupe surréaliste (Loplop Introduces Members of the Surrealist Group; illus. 30), reproduced in *Le Surréalisme au service de la révolution*, depicts Breton, albeit not without a hint of macabre humour, emerging from the dark waters of the unconscious.[27]

The collaboration between the two men mainly involved Ernst illustrating Breton's texts and Breton writing about Ernst's works. Ernst's illustrations include the frontispiece of the *Second Manifesto of Surrealism* (1929), the cover of *Les Vases communicants* (1932) and illustrations for 'Le Château étoilé' for an issue of *Minotaure* (1936). As a member of the editorial committee of vvv (1942–4), the official Surrealist journal in New York, he also designed a cover for the first issue, and his drawings illustrated Breton's essay 'Situation du surréalisme entre les deux guerres' (Situation of Surrealism between the Wars) published in 1943.[28]

Breton, for his part, would pursue his reflection on Ernst's collages throughout the 1920s, a reflection that informed his concept of the Surrealist image. In the third instalment of 'Le Surréalisme et la peinture' he once again evoked Ernst's collage creations in exalted terms: 'He brought with him the unrestorable fragments of the labyrinth, like the game of patience of creation: all the pieces . . . were seeking to discover new affinities.'[29] Similarly, in his preface to Ernst's first collage-novel *La Femme 100 têtes* (1929) he tells of his fascination for the illustrations of popular stories and children's books where, through a process of *dépaysement* (disorientation) central to the structure of collage, the artist removes images from their original function and inserts them into a radically new context (illus. 31).[30] He gives the example of a statue, which 'is less interesting to consider on a square than in a ditch'. Breaking with the codes of mimesis and coherence – those codes which allegedly produced what Breton (who clearly had little real understanding of Cézanne's works) calls

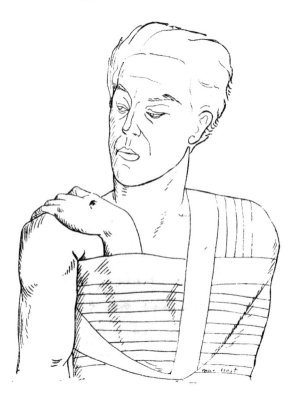

29 Max Ernst, *André Breton*, 1923, ink on cardboard.

the 'idiotic "hymn of the three apples"' – and generating the imaginative re-ordering of signs, images are freed to create new configurations. Max Ernst, he concludes emphatically, is 'the most magnificently haunted mind of today.'

The complicity between Ernst, 'Loplop Bird Superior', and Breton was interrupted for the first time in 1938 when Ernst refused to obey the latter's injunction to 'sabotage' the poetry of his close friend Éluard, who had joined the Communist Party. Ernst left the Surrealist movement, and with Georges Hugnet, Man Ray and Arp published a novella, *L'Homme qui a perdu son squelette* (The Man Who Lost His Skeleton), a satirical variation on the exquisite corpse where Breton, in the guise of an old fortune-teller, dictates incomprehensible poems to performing dogs Péret and Tanguy.³¹ The same year Ernst left Paris for Saint-Martin-d'Ardèche with the English artist Leonora Carrington; when war was declared in 1939 he was interned as an alien citizen at camps at Largentière and Les Milles near Aix-en-Provence. The time spent with the Surrealists in Marseille in 1940–41, waiting to leave France for America, seems to have given the two men an opportunity for reconciliation. He left France in 1941 thanks to the help of the American art collector Peggy Guggenheim, whom he married in 1942. Ernst and Breton collaborated once again in New York: in the exhibition *First Papers of Surrealism* (1942), co-organized by Breton and Marcel Duchamp, Ernst displayed his large painting *Le Surréalisme et la peinture*, the title of which was a homage to Breton's key essay. In a special issue of *View* dedicated to Ernst, Breton's brief discussion of the need for a new myth was followed by 'The Legendary Life of Max Ernst', which evokes the biography of the artist in terms of a mythical journey fusing a geographical itinerary, iconographic references and poetic associations.³² Their friendship was again affected, however, by Breton's depressed state following his divorce from Jacqueline Lamba. Ernst's companion, the American artist Dorothea Tanning, describes relations between the two men as 'a tangle of thrusts and

31 Max Ernst, 'Défais ton sac, mon brave', collage on laid Hollande paper from *La Femme 100 têtes* (1929).

30 Max Ernst, *Loplop présente les membres du groupe surréaliste*, 1931, gelatin silver prints, printed paper, pencil and pencil frottage on paper.

jabs and polite smiles, of Max's grinning defiance and Breton's trembling retaliation.' She recalls a loud argument at a New Year's Eve party: to Breton's 'I'll never write another word about you!' Ernst retorted: 'Je m'en fous' (I don't give a damn), whereupon, turning to the assembled friends, Breton exclaimed in disbelief: 'Il s'en fout! Il s'en fout!' (He doesn't give a damn!)[33]

In 1946 Breton returned to Paris, while Ernst stayed in Sedona, Arizona, with Tanning, before coming back to France in 1953, first to the village of Huismes in the Touraine, then from 1964 Seillans in the Var. Breton, for his part, continued to promote Ernst's works in his writings. In 1950 the Galerie La Hune organized an exhibition of the graphic work *Max Ernst. Livres, Illustrations, Gravures 1919–1949*, for which Breton wrote a short text praising the continued renewal of a work whose 'enchanted pages' led to 'an increasingly emancipated vision'.[34] The final break came in 1954, when Ernst accepted the Grand Prize for Painting at the Venice Biennale, thus arousing the disapproval of Breton, who accused him of having sold out to 'the merchants of Venice'.[35] The expulsion, however, had no effect on Breton's appreciation of Ernst's work, and in 1957 he would render him a final passionate homage in *L'Art magique*, underlining Ernst's contribution to Surrealism thanks to his experimentation in collage and frottage, which not only opened wide 'the sluice-gates of dreams', but shifted art itself to the 'territory of *magic*'.[36]

Joan Miró: 'the most "Surrealist" of us all'

'Miró's turbulent arrival on the scene in 1924 marked an important stage in the development of Surrealist art,' Breton declared in 1941.[37] To Ernst's contribution to Surrealist art through collage was now added Miró's automatism. Breton and Miró met through Masson, and for his first solo exhibition at the Galerie Pierre in 1925 the invitation was signed by the Surrealist group. True to his tendency to co-opt artists, Breton celebrated Miró's works as totally freed from pictorial conventions, thus letting him 'pass for the most "Surrealist" of us all'.[38] As for Miró, according to his biographer Jacques Dupin, he considered himself a travelling companion rather than a fully integrated member

'WHOM DO I HAUNT?': ENCOUNTERS WITH ARTISTS

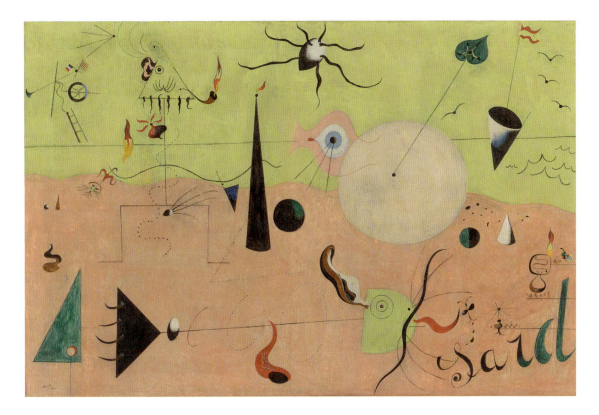

of the Surrealist group.³⁹ He was annoyed at times by Breton's dogmatism, disapproved of the frequent excommunications and rarely attended the café gatherings ('c'était triste'), preferring anarchic individualism to collective action.⁴⁰ He participated in Surrealist group exhibitions, however, including *La Peinture surréaliste* at the Galerie Pierre in 1925 and the major international Surrealist exhibitions in the 1930s and '40s.

When Miró arrived in Paris from his native Catalonia in 1921 he became close friends with the poets Desnos, Tzara and Leiris, who were experimenting in automatic writing, and he was among the first Surrealists, with Masson, to venture into the visual equivalent of automatism. Reflecting on the act of painting, he notes that the initial impulse for a drawing or painting is often aleatory, seemingly insignificant: 'I need a point of departure, whether it's a fleck of dust or a fleck of light. This form gives birth to a series of things, one thing leading to another. A piece of string, for example, can unleash a world.'⁴¹ He created a hallucinatory or dreamlike world from the

32 Joan Miró, *Le Chasseur (Paysage catalan)*, 1923–4, oil on canvas.

incongruous juxtaposition of images and the rejection of pictorial conventions, not unlike Ernst's collages. *Le Chasseur (Paysage catalan)* (The Hunter (Catalan Landscape); illus. 32) of 1924, for instance, painted in a 'magic realism' style, depicts a stick-like hunter with a triangular head, a single large ear and a floating heart, and a second hybrid form evoking both bird and aeroplane, a tree reduced to a circle and a single leaf and a dismembered eye. While working on this painting, he wrote to Leiris on 10 August 1924, describing his painting method: 'I am moving away from all pictorial conventions

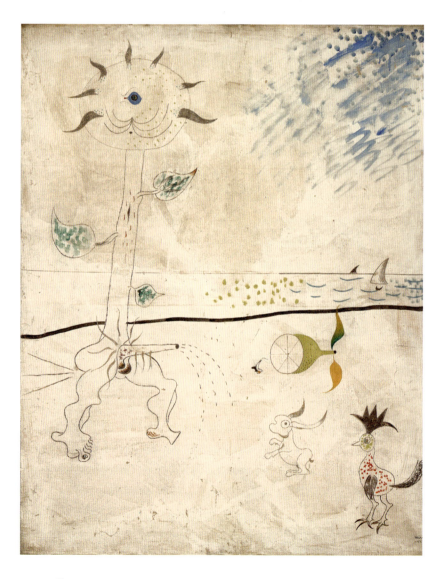

33 Joan Miró, *Le Piège*, 1924, oil on canvas.

(that poison) . . . This is hardly painting, but I don't give a damn.'[42] At this point, conventional three-dimensional forms have been flattened and schematized to simple line-drawings, while traditional unified composition has disappeared in favour of a disjunctive pictorial syntax, as in children's drawings.

It was this childlike aspect of Miró's paintings that Breton admired above all. He had seen his paintings at the Galerie La Licorne in 1921 and in Barcelona in 1922, and the two men finally met in 1924. Breton bought several of Miró's works from that period, including *Le Chasseur* and *Le Piège* (The Trap, 1924; illus. 33). In May 1926, however, Aragon and Breton penned a pamphlet to protest against the participation of Miró and Ernst as set designers for Diaghilev's Ballets Russes production of *Romeo and Juliet*: 'It is unacceptable that thought should be at the service of money,' they declared, accusing the artists of having betrayed Surrealist principles by their participation in a commercial activity for bourgeois entertainment.[43] The protest is unsurprising, no doubt, because Breton's attitude towards Miró was always ambivalent. On the one hand he admired the artist for his allegedly spontaneous improvisations, his evocation of the world of childhood in the playful innocence of his figures and his fantastic bestiaries. This was in keeping with Breton's appreciation of childhood seen as a state of innocence and purity, a magical time ruled by the imagination, a time not yet restricted by the social and rational demands of adulthood. However, while Miró's childlike innocence was appreciated, Breton also reproached him for what he deemed his retrograde childishness, claiming that Miró's development had been 'halted at an infantile stage'.[44] He was also criticized for seeing painting as an end in itself, failing to consider art in relation to Surrealism's global revolutionary project: 'Joan Miró has perhaps one desire, to give himself exclusively to painting, to painting alone,' Breton wrote in 1928.[45] As for the myth of the artist as innocent child peddled by Breton, it is singularly one-sided, openly contradicted by the aggression and violence of some of Miró's paintings and sculptures that go far beyond the Surrealist iconography of fantastic bestiaries and brightly coloured playful forms. From 1927 Miró had undertaken to 'assassinate painting', rejecting traditional pictorial codes: 'The only thing that's clear to me is that I intend to destroy, destroy everything that exists in painting. I have an

utter contempt for painting . . . I only use the customary artist's tools – brushes, canvas, paints – in order to strike more precisely.'[46] Fellow Catalan artist Salvador Dalí used a similar image in 'Nous límits de la pintura' (New Limits of Painting, 1928), echoing Miró's outright rejection of traditional techniques: 'The assassination of art, what a beautiful tribute!'[47] It is interesting to note that the image of the artist-as-criminal and of the aesthetic act as a murderous gesture was recurrent among the Surrealists. In 1929 Breton, for example, stated in his *Second Manifesto of Surrealism* that 'the simplest Surrealist act consists of dashing down into the street, pistol in hand, and firing blindly . . . into the crowd.'[48] In this destructive phase Miró created collages and assemblages from everyday materials, packing papers, feathers or string; among these is *Danseuse espagnole*, an assemblage composed of a feather, a cork and a hat pin, which he gave to Breton in 1928.[49] Other assemblages made with bits of wood, rusty chains and nails were acquired by Breton, including *Homme et femme* (Man and Woman) of 1931 (illus. 34) and *Objet du couchant* (Object of Sunset) of 1935–6. Of the latter, Miró said approvingly: 'Everyone considered this object as a joke except of course for Breton who was immediately struck by its magical aspect.'[50]

It is arguable that, given Miró's use of waste materials and his abuse of oil paint, his violent scribbles, graffiti and smears, his works have more in common with the aesthetics of the 'dissident' Surrealists – Bataille, Leiris, Einstein – and indeed Miró seems to have found their ideas more congenial than those of the 'orthodox' Surrealists around Breton. Leiris was well aware of it, drawing analogies in a review of the artist's paintings between Miró's works and the gritty urban context, the disintegrating walls of ruined buildings: 'Beautiful as snickering, or as graffiti showing the human structure in all that's particularly grotesque and horrible about it.'[51]

Miró, for his part, admitted to the writer Georges Raillard that he was always wary of Breton, who was too dogmatic and whose judgements were unclear and ambiguous.[52] He thought Breton was more interested in ideas than in painting as such, while Miró himself was fully engaged in the act of painting, which he considered a means of liberation. In his reply to a Surrealist questionnaire in 1929 on the ideological position of the Surrealists relating to the question

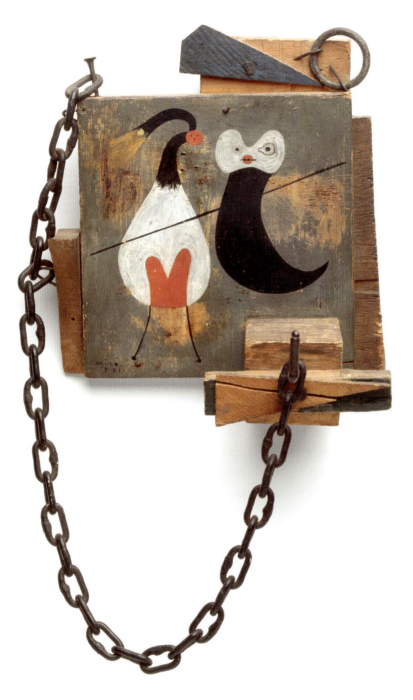

34 Joan Miró, *Homme et femme*, 1931, oil on wood, chain, metal.

of collective versus individual action, Miró replied that strong personalities cannot subject themselves to the discipline demanded by collective action, and marked his autonomy by refusing to attend the café meeting called by Breton to discuss the results of the questionnaire. Yet while Miró felt distanced from Breton, he was close to the Surrealist poets Éluard and Desnos, exploring the fusion between poetry and painting in his poem-paintings, the titles of his poems, and the many collaborations with poets like Char, Éluard, Tzara and Breton himself. Miró created lithographs for Breton's *Anthologie de l'humour noir* (1940) and the cover of *La Clé des champs* (1953); and Breton wrote poetic texts to accompany Miró's series of 23 gouaches titled *Constellations*, which is discussed in Chapter Six.

Breton and Dalí: exquisite excrement

In May 1929, the Surrealist Michel Leiris recorded a conversation with Picasso: 'Saw Picasso. Talked of the burlesque and of its equivalent with the marvellous (Reich). At the present moment, there is no way one can consider an object as ugly or repulsive. Even shit is pretty.'[53] Leiris was addressing a fundamental issue in the contemporary debate on aesthetics, concerning the materiality of the art object. An analysis of the polemics between Breton and Bataille raised by their texts on Salvador Dalí provides insight into a key moment in this debate.

When Dalí came to Paris in 1929 to collaborate with Luis Buñuel on the shooting of *Un Chien andalou*, he was introduced by Miró to art collectors, dealers and the Surrealist group (illus. 35). Maxime Alexandre recalls Dalí arriving one day at the Café Cyrano, where the Surrealists met daily, as 'a timid little young man, very self-effacing, wearing a suit and a hard collar like a shop assistant and the only one of us with a moustache'.[54] His first Paris exhibition, held in November 1929 at the Galerie Goemans, included paintings produced in 1929 such as *Les Plaisirs illuminés* (Illuminated Pleasures), *Le Grand Masturbateur* (The Great Masturbator) and *Le Jeu lugubre* (The Lugubrious Game; illus. 36). Critical response to the exhibition was mixed: while one journalist claimed that Dalí 'expresses all the poetry, both terrible and sweet, of Freudianism', another critic

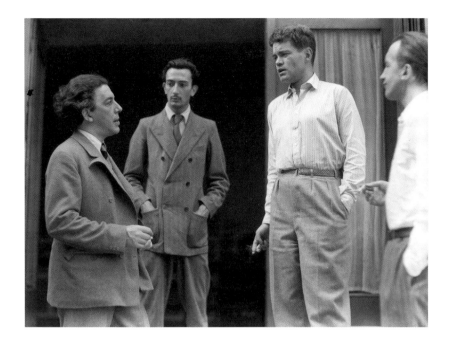

35 Anna Riwkin, *André Breton, Salvador Dalí, René Crevel and Paul Éluard*, 1931, gelatin silver print.

scathingly dismissed the paintings as 'provincial despair trying to be up-to-date . . . revolutionary gesticulations like those of a "vicious baby"'.[55] Meanwhile, two groups sought to annex Dalí for their movement, his paintings becoming the site of a polemical jousting on the (de)sublimation of art: Breton defending the 'orthodox' Surrealist position and poetic idealism, and Bataille the 'dissident' Surrealist one and 'base materialism'.[56]

Breton found the early paintings of Dalí deeply disturbing. He enthusiastically supported the young artist, later claiming that he had embodied the Surrealist spirit for 'three or four years'.[57] The December issue of *La Révolution surréaliste* reproduced two of the paintings in the exhibition and Buñuel and Dalí's script for *Un Chien andalou*. Breton bought *Les Accommodations du désir* (Accommodations of Desire) and wrote the catalogue essay for Dalí's exhibition, presenting the artist from the outset as hesitating 'between mere talent and genius'.[58] He acknowledged a certain reticence at the young artist's immediate commercial and social success among the 'mites and vermine' of Paris art lovers and aristocrats, an allusion to the art patrons the Viscount and Viscountess de Noailles, who had bought Dalí's painting *Le Jeu lugubre* (The Lugubrious Game) and warned against the danger of

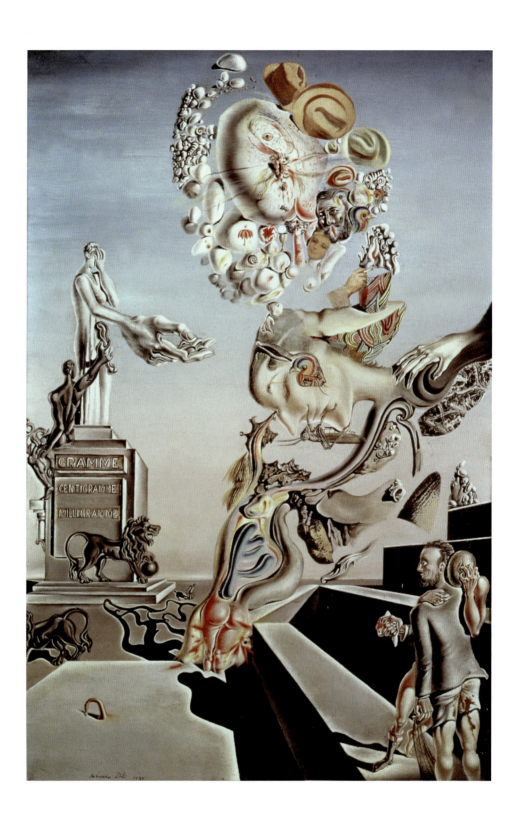

being adopted by certain 'materialists', implying Bataille's group. These 'dangers' dealt with, he goes on to celebrate the hallucinatory power and poetic qualities of Dalí's paintings, annexing him to the Surrealist doxa. His metaphors – painting as a window giving onto an inner landscape ('With Dalí, it is perhaps the first time that our mental windows have opened wide'[59]) – recall the images developed in his earlier text 'Le Surréalisme et la peinture', thereby marking Dalí's paintings with a Surrealist stamp of approval, alongside works by Tanguy, Miró or Ernst. While referring to recurrent pictorial motifs – lions' heads, ants, anteaters, scarabs, treeless landscapes – he actually focuses less on painting as icon than as effect, expressing his fear of images that appears to engulf the viewer both into the painting and into his own inner depths. Here again, with the exception of a passing allusion to the 'figure with a shitty shirt' in the lower right of the canvas, Breton turns a blind eye to the violence of the imagery – dismembered or decomposing bodies – preferring the hallucinatory to the scatalogical.

Breton's preface is not only an enthusiastic account of the discovery – or invention – of a Surrealist painter; it is a strategic annexation of Dalí for Breton's brand of Surrealism against the attempted co-option by the *Documents* group. In a short article written earlier in 1929, 'Matérialisme', Bataille had attacked the idealist tendencies among many so-called materialists, countering with his own definition of materialism as 'the direct interpretation, excluding any idealism, of brute phenomena'.[60] Breton's preface can thus be read as a riposte to Bataille: to the latter's implicit criticism of Surrealism seen as a form of idealism, Breton responds by sublimating Dalí's 'hallucinatory landscape' in excessive metaphorical language, an ironic overstatement, perhaps, in response to Bataille: 'Cimmeria, the only place we have rediscovered and we intend to keep for ourselves. Dalí, who reigns over these distant lands, must be aware of too many objectionable examples to let himself be dispossessed of his marvellous treasure land.' Cimmeria, for the ancient Greeks a misty land situated at the ends of the earth, evokes a mythical space, suggesting the effect of disorientation of Dalí's paintings on the viewer. Breton is thereby demonstrating that Dalí's 'brute phenomena' are indeed transformed in a poetic sublimation of the pictorial.

36 Salvador Dalí, *Le Jeu lugubre*, 1929, oil and collage on cardboard.

Bataille's materialism too could fittingly annex Dalí to his own camp, however, and indeed Bataille was among those who courted Dalí on his arrival in Paris in spring 1929. Clearly, there were strong affinities between Bataille and Dalí, and the latter's 1928 article 'New Limits of Painting', which had explicitly linked rotting matter and flowers, might well have informed Bataille's idea of the *informe* or formless in his own article, 'Le Langage des fleurs' (The Language of Flowers).[61] In the September issue of the journal Bataille reproduced three of Dalí's paintings – *Le Miel est plus doux que le sang* (Honey Is Sweeter than Honey), *Baigneuses* (Female Bathers), *Nu féminin* (Female Nude) – and reviewed favourably *Un Chien andalou*, 'that extraordinary film . . . penetrating so deeply into horror.'

Bataille's response to Breton's preface appeared in his article 'Le "Jeu lugubre"', where his detailed analysis of Dalí's painting constitutes not only a harsh critique of Breton's position but a case study of his own concept of 'base materialism'.[62] Having been unable to obtain permission to reproduce *The Lugubrious Game* to illustrate his text (Dalí himself had asked the Viscount de Noailles not to provide a reproduction for the article), Bataille used a schematic drawing of the painting instead (illus. 37). He aggressively refutes Breton's position (without referring to him by name, however), opposing 'black rage' and 'bestiality' on the one hand and the adversary's 'poetic impotence' on the other: 'This leads one to seriously wonder what is the position of those who see our mental windows open wide for the first time, who express an emasculated poetic complacency where there is a pressing need for recourse to ignominy.' He roundly condemns Breton's poetic approach to Dalí as both an act of cowardice and a form of escapism, adopting a deliberately anti-aesthetic position: 'Picasso's paintings are hideous . . . Dalí's are terrifyingly ugly.' He presents a violent vision of the artist's actions: 'Dalí's razors hack out of our faces grimaces of horror that risk making us drunkenly spew out that servile nobility, that idiotic idealism which left us in thrall to some ridiculous prison warders.' He focuses on images of rotting matter, mutilation, bestiality and abjection, and on actions of violent dismemberment, masturbation, ejaculation and castration. Whereas Breton mentions only in passing the excremental motif, as we saw, and hovers on the edge of interpretation in his desire to preserve the

37 Diagram of Salvador Dalí's *Le Jeu lugubre*, *Documents*, I/7 (1929).

enigmatic quality of the paintings, Bataille privileges images of sexual perversions, and makes of 'the ignoble stain' a central element of his detailed psychoanalytical interpretation of the painting, read in terms of the Oedipal scenario of punishment, castration and ignominy, and supported by explicit references to Freud's theory of dreams.

These totally divergent reading tactics reflect the differing intellectual positions of the two men. Breton the idealist, whose imaginary Cimmeria is located elsewhere, skims over the paintings, preferring to map out his own mental spaces; Bataille, whose reading of Dalí is grounded on (and in) the actual (pictorial) space of the painting, literally inscribes his narrative on the schematic drawing itself. Deliberate

mis- or partial readings are, in both cases, tools of appropriation. For Breton, the exotic paradigm, commonplace in Surrealist texts of the 1920s, suggests not so much the content of the painting as the viewer's sense of *dépaysement* when confronted with the alterity of Surrealist pictorial images. For Bataille, the intertextual filter of the Marquis de Sade (acknowledged in the title for the first draft of his article, 'Dalí screams with Sade') is used as a strategy foregrounding the violence and materiality of the artist's imagery.

The polemic continued in Breton's *Second Manifesto of Surrealism*, also published in December 1929, where Breton launched an attack on Bataille, who responded with a particularly ferocious 'cadavre', a photomontage of Breton depicted as a Christ-like figure with a crown of thorns, accompanied by Bataille's 'Le lion châtré' (The Castrated Lion; see illus. 2), where Breton is ridiculed as 'a false chap who dies of boredom in his absurd "treasure islands", that's fine for religion, for little castrated men, little poets, mystical little yapping dogs. But you can't overturn anything with a big soft club or a library-parcel of dreams.'[63]

What was Dalí's position vis-à-vis the Breton–Bataille polemic, for which he served as pretext? In 'L'Ane pourri' (The Rotten Donkey), published in the first issue of *Le Surréalisme au service de la révolution* (1930), he positions himself in relation to both polemicists, rejecting Bataille's materialism and Breton's Surrealism. On the one hand he sees the Surrealists as 'idealists who don't participate in any ideal'; on the other, he resorts to the example of a rotting donkey (a recurring image in his work), which may appear real, 'really and horribly rotting, covered in thousands of flies and ants', but which he claims is also an image created through desire:

> Nothing can convince me that this cruel putrefaction of the donkey can be anything other than the hard blinding reflexion of new precious stones. And we don't know whether behind the three simulacra, shit, blood and putrefaction, might lie hidden the desired 'treasure land'.

Dalí appears to side with Breton in his suggestion that material reality is sublimated (quoting Breton's 'treasure land'), while at the same time

gleefully focusing on base matter and parodying Bataille's language in his reference to 'ignominious scatological simulacra'. In fact, his position constitutes not just a radical questioning of the positions of both Bataille and Breton, but a key shift in the debate. By introducing the notion of the simulacrum, which is neither a real nor a symbolic image, Dalí moved the discussion from their Manichean struggle between materiality and sublimation to a plane of overt theatricalized ambiguity. This was fully developed in his idea of the 'paranoiac' image, the double or multiple image (as in the eye-parrot-hare figure in *The Lugubrious Game*) defined as a simulacrum, a means to 'systematize confusion . . . and discredit reality'.

In his autobiography Dalí returned once again to the debate, claiming that Breton, shocked by the excremental image in *The Lugubrious Game*, 'demanded that I state that the scatological detail was meant to be only a sham'.[64] Dalí replied that 'shit brought good luck and its appearance within the Surrealist corpus was a sign of the whole movement getting another chance,' and then mockingly provided an art-historical lineage for excremental allusions. His critique of Breton's Surrealism is itself worthy of Bataille's 'cadavre':

> I understood from that day forward that these were merely toilet-paper revolutionaries, loaded with petty bourgeois prejudices, in whom the archetypes of classical morals had left indelible imprints. Shit scared them. Shit and arseholes. Yet, what was more human, and more in need of transcending![65]

In the 1930s relations between Breton and Dalí turned openly hostile. At the 1934 Salon des Indépendants, where Dalí exhibited *L'Énigme de Guillaume Tell* (The Enigma of William Tell), in which Lenin was depicted with an elongated naked buttock held up by a crutch, he was boycotted by the Surrealists, who visited the exhibition with the intention of damaging the painting. (Un)fortunately it had been hung too high and was out of reach.[66] A resolution was then passed to exclude Dalí from Surrealism. Summoned to a 'revolutionary tribunal', accused of glorifying Hitler's fascism, he ridiculed the occasion by arriving with a thermometer in his mouth, wearing layers

of warm clothes, which he proceeded to take off then put back on. He went on his knees to beg Breton's pardon, defending his painting as a pure Surrealist recording of his fantasies and dreams, adding that should he dream he was having sex with Breton he would paint it in minute detail the next day, much to Breton's horror.[67]

Dalí was finally excluded from the Surrealist movement in 1939, and during the war years in New York his commercial success earned him in Surrealist circles the anagram-based nickname Avida Dollars. During that period relations with Breton turned even more acrimonious, Breton being keen to differentiate his brand of Surrealism from the shop window displays and kitsch installations of the popular version, fashionable in New York, as promoted and represented by Dalí.

Beyond the seemingly anecdotal, the battles of mud and insults, oppositions fundamental to 1920 and '30s ideological and aesthetic debates were being formulated and, of particular importance here, questions of the definition of a Surrealist painting, the authenticity of automatism or of materialism versus transposition. Ernst's collages, Dalí's paintings, Picasso's sketches or Miró's assemblages, as well as being the central subject of the various texts, are often striking points of departure, supports or battlefields, for writings that are themselves sometimes pre-texts for poetical development, polemical exchange or ideological appropriation, as in this case study of the philosophical jousting between 'excremental philosopher' (Breton on Bataille) and 'doddery idealist' (Bataille on Breton). For Breton, writing on painting is often writing alongside, against, beyond painting, with words that glance off, or turn a blind eye to, pictorial representation, in pursuit of their own deviant (and often devious) poetic, political or polemical trajectories, as will be shown in the following chapters.

three

Painting or Poetry?
A Surrealist Aesthetics

THE INVITATION TO THE Surrealist exhibition held at the Galerie Au Sacre du Printemps in 1928 features a drawing of a daisy, the heart of the flower inscribed with the question: 'Does Surrealist painting exist?', and around the petals the suggestive, though inconclusive, 'a little / a lot / passionately / not at all' (the French version of the children's game 'He loves me, he loves me not'; illus. 38). The same year, while searching for a title for his essays on art, Breton remarked to Masson: 'It's impossible to call it *Surrealist Painting* . . . There is no Surrealist painting, there are only Surrealists who paint, others who write and some who could even be boilermakers.'[1] He finally settled on *Le Surréalisme et la peinture*. The solution was in keeping with Breton's definition of Surrealism in his first *Manifesto* in terms of 'pure psychic automatism' expressing the 'real functioning of thought' without differentiating between verbal and visual expression. In his catalogue essay for Max Ernst's first Paris exhibition in 1921, he defines the image in general terms as bringing together two distinct 'realities' and producing a 'spark' from their encounter.[2] The motif of the spark recurs in the 1924 *Manifesto of Surrealism*: 'The value of the image depends upon the beauty of the spark obtained; it is, consequently, a function of the difference of potential between the two conductors.'[3] Breton's definition of the Surrealist image is a radical reworking of the poet Pierre Reverdy's definition, quoted in the *Manifesto* as

> a pure creation of the mind. It cannot be born from a comparison but from a juxtaposition of two more or less distant realities. The more the relationship between the two juxtaposed realities is distant and true, the stronger the image will

38 Invitation to *Exposition surréaliste*, Galerie Au Sacre du Printemps, 1928.

be – the greater its emotional power and poetic reality.⁴

Like Reverdy, Breton theorizes the image in terms covering both its verbal and visual manifestations, whether in relation to the materials used (realities, images, elements, objects) or the effect of their encounter (spark, light, illumination). Furthermore, when Breton actually outlined a poetics based on automatism and collage, he kept his definition non-medium specific, referring to the spontaneous flow of pen or brush on the one hand, and the juxtaposition of disjunctive visual or verbal fragments on the other. Indeed, the first automatic sentence he records – 'There is a man cut in two by the window' – is accompanied by a visual image.⁵ He even presents his poetics almost in jest, under the title 'Secrets de l'art magique surréaliste' (Secrets of the Magical Surrealist Art), in a parody of popular texts on magical spells, as if attaching little importance to the question of technique or medium.⁶ This position was confirmed in 1935 in a lecture he gave in Prague: 'At the present time there is no fundamental difference between the ambitions of a poem by Paul Éluard or Benjamin Péret and the ambitions of a canvas by Max Ernst, Miró, or Tanguy.'⁷

In Breton's writings on art the aesthetic is constantly subsumed into the poetic. His frequent use of the terms 'poetic' and 'lyrical' reflects mainstream art critical discourse of the 1920s and '30s, whether in articles by Christian Zervos and Tériade in the pages of *Cahiers d'art*, where these words were often used in a very broad sense as associated with creative thought, or in artists' statements. For example, the artist Vassily Kandinsky fused poetry and painting when he wrote: 'Each true painting is poetry. For poetry is not made solely of words, but also colours, organized and composed; consequently, painting is a pictorial poetic creation.'⁸

At the same time the term 'poetry' in its specifically literary sense was often privileged above the pictorial. The Surrealist image is given

a literary lineage (albeit with strong visual qualities), rather than an art-historical one: the Surrealists refer to Reverdy, on the one hand, but also Lautréamont, in the oft-quoted image: 'beautiful as the chance encounter, on a dissecting table, of a sewing machine and an umbrella'. When Breton outlined a classification of the Surrealist image based on its degree of arbitrariness, he chose solely literary examples, such as Lautréamont's 'The ruby of champagne' or his own image: 'On the bridge the dew with the head of a tabby cat lulls itself to sleep.'[9] For Breton, Ernst or Aragon, the precursors of Surrealist art were Lautréamont's *Chants de Maldoror* (1868), Rimbaud's *Illuminations* (1886) and Stéphane Mallarmé's *Un coup de dé jamais n'abolira le hasard* (A Throw of the Dice Will Never Abolish Chance; 1897), and painters simply followed in the wake of the poets. Indeed, on the Surrealist family tree poets are the ancestors of painters: Pablo Picasso is said to have given a material reality to Rimbaud's poetry; Max Ernst is considered to be heir to Rimbaud, Apollinaire and Jarry; while Alberto Giacometti and Yves Tanguy are affiliated to the poet Gérard de Nerval. In Breton's texts the visual was thus frequently mediated through the textual, the *jamais vu* perceived through the *déjà lu*.

Surrealist art, nevertheless

In spite of Breton's initial refusal to distinguish between verbal and visual modes of expression, visual art was a significant aspect of the movement from its early days: witness for example Ernst's 1921 Paris exhibition, the exhibitions at the group's own Galerie Surréaliste (1926–8), or the many illustrations in the journal *La Révolution surréaliste*. Breton's position on Surrealist art developed polemically in a response to fellow Surrealists Max Morise and Pierre Naville, who questioned the existence of a Surrealist style and of Surrealist painting itself in the early issues of *La Révolution surréaliste*, sparking a lively debate on the question. In 'Les Yeux enchantés' (Enchanted Eyes) Morise expresses doubts about a possible pictorial equivalent to 'pure psychic automatism' in automatic writing.[10] While a painter such as De Chirico produced Surrealist images, he argues, the expression is not automatic, since the speed of writing could not be reproduced in

pictorial mode. Picasso's early Cubist paintings and collages, allegedly based on chance and instinct, and having no preconceived subject, are considered better models, while the insane and mediums are claimed to practice a form of graphic automatism where 'forms and colours have no need for objects, organizing themselves according to a law free from premeditation'. Morise's article was illustrated with a pen-and-ink drawing by Masson, and several of his automatic drawings are reproduced in the third issue of the journal (illus. 39).

39 Automatic drawing by André Masson, 1925, *La Révolution surréaliste*, 3 (1925).

Taking up the debate in 1925 in a piece ironically titled 'Beaux-arts', Naville wrote provocatively: 'No one can ignore the fact that there is no Surrealist painting,' adding that if there were a Surrealist aesthetics, it was to be found not in the museum but in the street, in the spectacles of modernity, automobiles and newspaper photographs, films and electric lights.[11]

When Breton joined the debate later that year with the first instalment of 'Le Surréalisme et la peinture', published in the fourth issue of the journal, he acknowledged his indifference to painting as medium, which he dismissed as 'that lamentable expedient', and resolutely applied non-pictorial criteria to its analysis, proposing a definition of Surrealist painting that transcends, or simply bypasses, the pictorial to explore a 'purely internal model', that of dreams, hallucinatory or fantastic images. The illustrations in the fourth issue of the journal, consequently, encompass diverse styles and media: a mediumistic drawing, collage and collage-painting (Ernst), magic realist painting (Miró), dream-painting (Pierre Roy), drawing (De Chirico), photography (Man Ray) and post-Cubist painting (Masson, Picasso). If there is any cohesion in Surrealist art, Breton implies, it lies not in any specific aesthetic but rather in the art's ability to record 'the photography of the mind'.[12]

PAINTING OR POETRY? A SURREALIST AESTHETICS

40 Man Ray, *Explosante fixe (Prou del Pilar)*, 1934, gelatin silver print.

In the 1930s Breton moved from a general poetic to a more specifically aesthetic approach to art, formulated on the one hand in the concept of 'convulsive beauty', and on the other in a shift from an exclusively mental automatism to gestural automatism. The somewhat nebulous notion of convulsive beauty, which first appeared fleetingly at the end of *Nadja* (1928), was developed in the text 'La beauté sera convulsive', where it was defined in terms of the co-presence of contradictory elements: 'Convulsive Beauty will be veiled-erotic,

41 Óscar Dominguez, *Untitled*, 1936, decalcomania (gouache transfer) on paper, illustration in André Breton, 'D'une décalcomanie sans objet préconçu', *Minotaure*, 8 (1936).

fixed-explosive, magical-circumstantial, or it will not be.'[13] Breton gives examples in photography, the immediacy of which is better able to embody the concept than the successive nature of language. For example, he illustrates the category 'fixed-explosive' with the photograph by Man Ray of a tango dancer (illus. 40); he also imagines the image of a locomotive halted in a virgin forest, a photograph that would later be published in *Minotaure*.[14]

As for Breton's interest in gestural automatism, it was essentially the consequence of his renewed contact with Masson,[15] and of the arrival in the Surrealist group of a younger generation of artists

– among them Óscar Domínguez, Wolfgang Paalen, Esteban Francés and Gordon Onslow Ford. In his lecture 'Surrealist Situation of the Object', he broadened the reflection on automatism to focus on the artists' graphic experiments. In his essays on Domínguez and Paalen, as in 'Des tendances les plus récentes de la peinture surréaliste', he observed not only a 'marked return' to automatism among younger artists, but the appearance of '*absolute* automatism' in the pictorial field.[16] He then identified various techniques in gestural automatism: Domínguez's *decalcomania*, in which a blank sheet is pressed down over a second sheet covered in paint, then separated to reveal chance forms that are then freely interpreted (illus. 41); Paalen's *fumage*, traces of smoke produced by a candle or petrol lamp on a sheet of paper or freshly painted canvas, as in *Orages magnétiques* (Magnetic Storms) of 1938 (illus. 42); Esteban Francés's *grattage* work *Alambradas* (Wire Fences) of 1937, in which the artist 'scratches' layers of different

42 Wolfgang Paalen, *Orages magnétiques*, 1938, oil and fumage on canvas.

colours of paint with a razor blade. Breton focuses squarely on the material production of the image, the action of a razor on pigment, the flow of colours, emphasizing the formation of images rather than a fixed image, the creative process rather than the product. He refers to the emergence of images, not only from the mind of the artist but as if from the paint itself, claiming for instance that an invisible hand had helped Francés 'to free the great hallucinatory images latent in this confusion'.[17]

Significantly, Breton's promotion of new pictorial techniques indicated less a new direction in Surrealist art – after all, Masson, Miró and Ernst had been experimenting in gestural automatism from the mid-1920s – than a strategic choice on his part, at a time when he wished to promote the continuing vitality of a movement in danger of becoming ossified or simply fashionable; in danger too of being recuperated by the art establishment as an art movement dominated by literary concerns. All this at a time, moreover, when, on an ideological level, Breton looked to distance himself from the propagandist art movements of both Right and Left that were promoting realism; and, finally, at a time when Breton defended the idea of total independence and freedom of art, in the manifesto written with Trotsky. The cohort of younger Surrealist painters were perfect models for the promotion of a practice of freedom of artistic creation.

More generally, Breton's interest in automatic techniques of image production in the 1930s was in keeping with the aesthetic discourse in the pages of *Minotaure* and *Cahiers d'art*, which privileged process over product, as seen in the reproductions of drawings and preparatory sketches; in the artist's reflections on his working methods; or in the photographs of the artist's studio – in short, evidence of an interest in the creative act as much as the work created, of work-in-progress as well as the finished work.

Writing on art: eyes wide shut

'The eye exists in a primitive state' ('L'œil existe à l'état sauvage'). In the striking opening sentence of his essay 'Le Surréalisme et la peinture', Breton celebrates the eye of the artist or poet freed from the

constraints of rational control and traditional aesthetic codes.[18] He rejects Aristotelian mimesis, the representation of external reality, in favour of the depiction of an inner reality, the mimesis of dreams and hallucinations. In the nineteenth century the mechanistic model of perception was replaced by a subjective model in which perception was inflected by subjectivity (sensations, emotions, hallucinations, memory), marking a turn from classical to romantic aesthetics, in which priority was given to the visionary over vision. In his writings on art Breton praises the work of artists such as Miró and Tanguy primarily for their dreamlike qualities, and he promotes the art of the insane or of so-called naive artists, as well as works by Oceanic and Native American artists, whose perception of reality is deemed innocent, fresh, primitive, and whose works appear to be untainted by the constraints of conventional aesthetic rules, as discussed in Chapter Eight.

43 André Masson, *André Breton*, 1941, india ink on paper.

In Masson's *Portrait d'André Breton* (1941; illus. 43), the poet is portrayed with a double profile, eyes both open and closed, as an embodiment of the fusion between reality and dream that defines the surreal; while Roberto Matta's portrait of Breton, *Un Poète de notre connaissance* (A Poet We Know; see illus. 13), mixes human and animal registers. The importance given to the intermingling of outer and inner realities remains a constant in Breton's writings. For example, the title of one of his poem-objects, *Je vois j'imagine* (I See I Imagine; see illus. 69), actualizes through its paratactic structure the continuity between seeing and imagining.

Similarly, he defines the objectives of VVV, the Surrealist journal published in New York between 1942 and 1944, as follows:

> To the V that stands for viewing what is all around us,
> eyes turned outward, toward the conscious surface
> of things,
> surrealism has relentlessly opposed VV, the view within,
> eyes turned inward towards the inner world and the
> depths of the unconscious, whence
> VVV toward a synthesis, in a third term, of these
> two Views ...
> Toward a total view VVV that conveys all the reactions
> of the eternal upon the actual, of the mental upon
> the physical.[19]

Here Breton is clearly less concerned with the materiality of the work than with the notion of painting as a transparent medium, taking up, in order to subvert them, two clichés of Western art as imitation: the painted image as a photograph or a window. First, in his preface to the catalogue for Max Ernst's 1921 Paris exhibition, Breton states that 'the invention of photography has dealt a mortal blow to the old modes of expression,' promoting instead the artistic expression of an inner reality seen in terms of the 'true photography of the mind'.[20] Second, he subverts the traditional use of the metaphor of painting as a window when he states: 'it is impossible for me to envisage a painting as other than a window and why my first concern is to know what it looks out on (sur quoi elle donne).' Considered as mental windows,

paintings give on to imaginary landscapes beyond the painting itself, as in a Rorschach test: 'nothing appeals to me more than a vista stretching before me and *out of sight* [*à perte de vue*].'[21] The window thus looks in, not out, beyond the visible itself (the expression *perte de vue* also means, literally, loss of sight), expressed in the recurrent image of blindness. For example, when Breton imagines the 'binoculars for blindfolded eyes' worn by Francis Picabia, it is in order to see beyond the visible, whether a painting or a mask, a photograph or a landscape.[22] Seeing is thus related to imagining, dreaming or hallucinating, whence Breton's constant refusal to distinguish between (outer) perception and (inner) representation, considered as aspects of a single visionary faculty.

This very continuity between perceiving and imagining calls into question the alleged 'primitive' dimension of sight as expressed in the opening words of 'Le Surréalisme et la peinture', quoted above. This ideal of the immediacy of sight or 'ideology of the primitive eye', in the words of sociologist Pierre Bourdieu,[23] is at best an illusion, whether its the eye filled with the wonder of childhood recovered or the eye of the self-taught artist as a direct empathetic approach to his object. 'The innocent eye is a myth,' writes the art historian Ernst Gombrich.[24] Far from being innocent or primitive, Breton's contemplation of a found object or a painting is in fact culture-dependent, mediated through knowledge, imagination or the line of a poem. In her analysis of the interaction between eye and text, Mary Ann Caws explains that '"the innocent eye" is never again to be ours – for we cannot *de-cultivate* our vision.' She redefines the poetics of perception in terms of 'outlook' and 'inscape', combining the immediacy of vision, with its attention to surface and texture, with a gaze turned inwards to intertextual links.[25] Breton himself puts it concisely, writing that when he looked at a painting or a mask, he would link what he saw to what he remembered, recognized or imagined: 'To see or hear is nothing. To recognize (or not to recognize) is everything.'[26]

Dazzling metaphors generated by Kandinsky's lines and colours or a hasty judgement freezing Cézanne's apples and pears; a lucid analysis of Max Ernst's collages or lavish praise for Magritte's painting of the object: Breton's writings on art are exuberant and hyperbolic, often obscure or paradoxical. His eclectic and sometimes flamboyant

44 Max Ernst, *La Horde*, 1927, oil on canvas.

texts develop multiple registers where a critical approach is often combined with a programmatic declaration, a polemical statement, or lyrical effusion. Breton, in short, writes as a poet rather than an art critic: 'Do some canvases by Max Ernst, Magritte, or Brauner concern poetry any less than they do painting?' he asks.[27] He responds to the aesthetic by the poetic in texts that are often prose poems; moreover, he is less interested in the description or evaluation of a painting than in the effect produced on the viewer. At the core of his aesthetic is thus the sensory or emotional impact of the works that, as objects of fascination, awaken his desire to respond to them via a poetics of effect or affect. His first encounter with a painting by Haitian artist Hector Hyppolite is an eloquent example. He is initially struck by the work *Adoration à la Sainte Vierge* of 1944 as if experiencing 'the first overwhelming breath of spring . . . the same sensations as the most

beautiful days in the country, the tenderest tremours of the grass, seeds sprouting, buttercups, the iridescence of insects' wings, the tiny clashing cymbals of flowering creepers'.[28] Breton proceeds by analogy, first comparing his emotion when looking at the painting with the sensation of a spring day, and only afterwards becoming conscious of the subject of the painting. 'Criticism will be love or will not be,' he declares, underlining not only his sensuous but his sensual response to the artwork.[29] As Susan Sontag notes: 'In place of a hermeneutics we need an erotics of art.'[30] The aesthetic experience, whether before an artwork or a natural spectacle, is expressed poetically as 'a physical sensation in me like the feeling of a feathery wind brushing across my temples to produce a real shiver' – a sensation Breton associates with erotic pleasure.[31] This erotic dimension of his relation to the object is hinted at in his account of the experience of hanging a painting at the foot of his bed, 'in order to experience its power of seduction on me when I woke up'.[32]

When Breton does assess a work of art, it is done indirectly, measured by the intensity of the sensory or emotional resonance of the work, expressed in relation to the object's capacity to give rise to a 'poetic amplification', as Michael Riffaterre has argued in his analysis of Breton's 'lyrical ekphrasis'.[33] The act of interpreting the work of art is compared to Leonardo's wall (a recurrent metaphor in 1930s art criticism, referring to Leonardo's exhortation to his students to make out landscapes, battles or figures in the stones and stains of old walls) or to the Rorschach test (a psychological test in which the subject interprets inkblots, a test also fashionable in artistic and intellectual milieux in the interwar period), serves as a point of departure for poetic associations developed through free association or intertextual links.[34] For example, when he describes Ernst's frottage and grattage works, they become springboards for a poetic elaboration. Thus the series *La Horde* (illus. 44) suggests a hallucinatory development: 'His brush gives birth to heliotrope women, superior animals attached by roots to the soil, immense forests to which we are attracted by a wild desire, young people who can only dream of trampling their mothers underfoot.'[35] The text alludes to the hybrid figures in the painting, but departs from them to develop its own fantastic, sadistic itinerary. In another example, referring to Domínguez's technique of

allowing coloured inks to run over the surface of a canvas, he writes: 'he has set free creatures glowing with the fires of humming-birds, their texture as skilful as their nests.'[36] And to evoke the presence of metamorphosis in Masson's paintings, he refers to 'phenomena of germination and blossoming captured at the moment when the leaf and the wing, only just beginning to unfold, are adorned with the most disturbing, evanescent and magical glow.'[37] As these examples show, images appear to emerge, first from the paint itself, then from the mind of the poet through free association, the movement in the painting repeated in the dynamism of the images they evoke.

Breton's preface to Wassily Kandinsky's exhibition at the London Guggenheim Jeune Gallery in 1938 is an excellent example of Surrealist writing on art that focuses less on the art-historical context or the pictorial elements of the paintings and more on their imaginative resonance, expressed in a highly subjective poetic response:

> This oriental thread unites the robes of the pagodas to that of the whirlwinds, the path of lightning to grooves printed in the record by the voice's vibrations, the nervous system to the intermingling of ships' rigging in the bay. A form of punctuation, invented by Kandinsky, unites the star-filled sky, the musical score and eggs from every nest . . .[38]

The pictorial line – analogous to poetic thought – is compared to a 'thread' (*fil*) establishing links between and beyond the pictorial elements in a process of free association. Like Ariadne's thread, the line links elements as diverse as 'pagodas' and 'whirlwinds', 'the nervous system' and 'ships' rigging'. It alludes both to the contour of iconographic motifs and to the flow of poetic images. Kandinsky's colours also find a poetic resonance in Breton's text: 'colour exuberantly fills the pure forms he has delineated, endowing them with a seductive powder as if stolen from butterflies' wings'. The text thus recreates the open figuration of the paintings, their indeterminate forms and ambivalent pictorial syntax, as in *Dominant Curve* (1936), exhibited at the London show (illus. 45). Paintings thus appear to solicit interpretation yet resist decoding, and their mysterious qualities and poetic aura are carefully guarded by Breton. The attraction exerted by the

45 Vassily Kandinsky, *Dominant Curve*, 1936, oil on canvas.

artwork is linked to its mystery – its magical dimension, often elliptical, is a source of mystery to be indulged rather than an enigma or a riddle to be resolved.

By endowing Kandinsky's paintings with poetic qualities, Breton assimilates him into the Surrealist fold while bypassing the painter's largely geometrical Bauhaus paintings. This allows him to extend the domain of Surrealism in the 1930s beyond the closed figuration or 'photography of the mind' of Dalí or Magritte to include the open figurations of Kandinsky or Masson. Kandinsky, for his part, considered Surrealism less original than Russian Cubo-Futurism or Dada, yet there is a tongue-in-cheek acknowledgement of his debt to Breton when he writes to his former Bauhaus students in 1938: 'I will refrain from speaking ill of the Surrealists. A. Breton (the Führer of the movement) wrote a very good article on my painting in an English catalogue.'[39]

At other times the text's development is generated not by the painting itself but by a poetic reference. In his preface to Max Ernst's

collage-novel *La Femme 100 têtes*, for instance, Breton draws an analogy between the collages and Rimbaud's poetry: '*The 100 Headless Woman* will be considered the most important book of images of these times when it will increasingly appear that sitting rooms have sunk "to the bottom of a lake".'[40] Taking as his point of departure the Rimbaldian image 'un salon au fond d'un lac', which does not refer directly to the pictorial motifs of the collage-novel but to the structure of collage as the juxtaposition of disparate elements, Breton then expands his text, not from Ernst's collages, but from Rimbaud's own images: chandeliers are made from fish, gilt decorations from stars, gowns from shimmering water and so on.

While one cannot deny that Breton's writings on art can be somewhat excessive and hyperbolic, acting as a screen to the works themselves, one should note, by way of conclusion, that he was well aware that language can be inadequate in accounting for the visual image, and that any real encounter with art takes place in silence. Wifredo Lam's paintings are a telling example, when Breton acknowledges: 'Whoever has penetrated the temple of painting knows that its initiates seldom communicate with words. They show each other a fragment of the canvas – very mysteriously for the profane – pointing and exchanging a knowing look.'[41]

four
Between Marx and Rimbaud: Art and Revolution

'TRANSFORM THE WORLD, said Marx, change life, said Rimbaud. These two watchwords are one for us,' declared Breton in 1935.[1] Art played a vital role in the liberation of the individual and the transformation of society in the early twentieth century, and this chapter will explore particular moments in Breton's trajectory where art and revolution intersect.

Between Marx and Rimbaud

Rimbaud's injunction to 'change life' dominated the years of Dada scandal and provocation and the early years of Surrealism. This was a time when Louis Aragon dismissed the 1917 Russian Revolution as a 'vague ministerial crisis', contending that the spirit of revolt outweighed all political considerations.[2] Robert Short has shown how this 'politics of protest' came to dominate the Surrealists' early position, with insult and satire as its principal weapons.[3] The Surrealists adopted an anarchist stance, denouncing all forms of oppression, whether state, culture, church, family or fatherland. The art they promoted in the pages of their journals *Dada* or *Littérature* – Duchamp's ready-mades, Picabia's mechanomorphic drawings, Ernst's collages – was a form of 'anti-art', attacking traditional aesthetic norms and exploring radically new forms of expression.

From 1925, however, the Surrealists started to move from a position of anarchist individualism towards one of collective political action.[4] The turning point was the colonial war in Morocco, when they aligned themselves with the left-wing group Clarté, founded in 1919

by internationalist and pacifist Henri Barbusse as an 'international of the mind'. They wrote a joint manifesto, 'La Révolution d'abord et toujours!', where they sided with the Moroccan independence fighters.[5] Despite this initial political engagement, however, the Surrealists continued to maintain that Surrealist revolution encompassed but could not be reduced to social revolution. Their differing positions vis-à-vis the role of art is reflected in the contrasting aesthetics of the two journals: the illustrations in *La Révolution surréaliste*, favouring avant-garde Cubist and automatist works by artists such as Picasso and Masson, and the more traditional woodcuts and proletarian subjects in the Clarté group's eponymous journal by artists like André Lhote or Jean Lurçat.

While Rimbaud's injunction to 'change life' was central to the Surrealist belief in the transformatory role of art, the group moved closer to Marx's collective ideal in their rapprochement with the French Communist Party (PCF) from the mid-1920s. While Breton finally joined the PCF in 1927, along with other members of the Surrealist group such as Aragon, Éluard, Péret and Pierre Unik, their position nonetheless remained ambivalent: in the pamphlet 'Légitime défense' Breton defended the autonomy of the Surrealist movement while confirming his 'enthusiastic' alignment with communist principles.[6] These positions were not easy to reconcile, however, since the communists gave priority to the social revolution, considering art as a post-revolutionary concern and avant-garde art as a form of bourgeois decadence, while the Surrealists maintained that artistic freedom and experimentation were an integral part of revolutionary action itself. This was the position reiterated by Breton in the *Second Manifesto of Surrealism*: 'The problem of social action is only one of the forms of a more general problem which Surrealism set out to deal with, and that is the problem of human expression in all its forms.'[7] This was unlikely to allay communist suspicions that Surrealism was counter-revolutionary, hence the communists subjected Breton to a series of interrogation sessions, where they criticized him for his support of artists such as Picasso: How is Picasso a revolutionary artist? Which way up should we look at his paintings? What does his work represent?[8] André Masson recalls that Breton took a copy of *La Révolution surréaliste* to a meeting of the cell as evidence of his revolutionary

46 André Masson, *L'Armure*, 1925, oil on canvas.

credentials. Unfortunately, on seeing a reproduction of Masson's *L'Armure* (The Armour, 1925; illus. 46) – depicting a female figure with flame-head, violin-torso and pomegranate-sex – the cell leader is said to have exclaimed: 'Monsieur Breton claims that all his friends who contribute to this journal are revolutionaries! But look at this! . . . is it revolutionary? It's sadistic and sick.'[9] Breton had envisaged contributing to the cause through his Surrealist activities; instead, he was assigned to the gas workers' cell of the 10th arrondissement in Paris and given the laborious task of writing a statistical report on the gas industry in Italy. Further criticism came from Bataille, who accused the Surrealists of idealism – 'trop d'emmerdeurs idéalistes' (too many idealistic assholes) – and of being addicted to words – 'phraseurs révoutionnaires' (revolutionary windbags) – rather than concrete action.

Communist distrust of the Surrealists' political commitment continued, in spite of the fact that *La Révolution surréaliste* was replaced in the early 1930s by *Le Surréalisme au service de la révolution*, marking a shift towards a more concrete political engagement, and confirming the Surrealists' anti-militarist, anti-clerical and anti-colonial positions. It published fewer Surrealist texts and poems, and more political articles, where Sade and Dalí rub shoulders with Hegel, Marx or Lenin. In 1931, as a riposte to the *Exposition coloniale*, whose aim was to celebrate France's 'civilizing mission' and the economic importance of France's colonies, they published a tract, 'Ne visitez pas l'Exposition Coloniale', and the communist Anti-Imperialist League, with Aragon, Éluard and Tanguy, organized a counter-exhibition called *La Vérité sur les colonies* (The Truth about the Colonies). In 1932 Breton and fellow Surrealists joined the PCF-linked Association des Écrivains et Artistes Révolutionnaires (Association of Revolutionary Writers and Artists), whose aim was to mobilize artists and writers in the fight against fascism and promote the role of art in a revolutionary culture. While Breton continued to reject the subordination of art to politics, claiming that poetry and art were weapons of liberation and transformation, Aragon gave priority to the Party and left Surrealism. When the Communist Party demanded the Surrealists exclude Dalí from their movement for his painting *The Great Masturbator* (1929) and his text 'Rêverie',[10] deemed pornographic, the Surrealists defended

him in the name of freedom of expression. When he was eventually excluded in 1939 it was for his commercial activities, his scatalogical portrait of Lenin (*Six Apparitions of Lenin on a Piano*, 1931) and his declared mystical attraction to Hitler.

The doctrine of socialist realism, adopted as the official Soviet art form in the early 1930s, demanded that art should serve the revolutionary cause directly through its content (proletarian subjects) and form (realism). Having refused to subordinate an independent revolutionary art to propaganda, Breton broke with the PCF in 1935, but remained committed to Marxism. In 'Political Position of Today's Art', a lecture given in Prague, he attacked Stalinism and socialist realism and continued to defend the freedom of the revolutionary artist.[11] The same year he was excluded from addressing the International Congress of Writers for the Defense of Culture after punching the Russian delegate Ilya Ehrenburg, who had recently berated the Surrealists for being 'too busy studying pederasty and dreams', perhaps partly because homophobia was a sensitive issue for Breton.[12] In the latter's absence Éluard read his declaration to a largely hostile audience: 'From where we stand, we maintain that the activity of interpreting the world must continue to be linked with the activity of changing the world. We maintain that it is the poet's, the artist's role to study the human problem in depth in all its forms.'[13] The following year Breton denounced the Moscow show trials.

An independent revolutionary art

After his break with the French Communist Party Breton sought new political directions. In 1935–6, reconciled with Bataille, he took part in *Contre-Attaque*, a group of anti-fascist intellectuals who opposed the reformist politics of the Popular Front and advocated the radical transformation of society. He also moved closer to Trotskyism, which rejected the idea of proletarian art and defended the freedom of artistic creation. By the mid-1930s, the Russian Revolution was replaced in Breton's eyes by the Mexican Revolution as a new revolutionary myth, encapsulating his hopes for social transformation. 'There is at least one country in the world where the wind of liberation has not

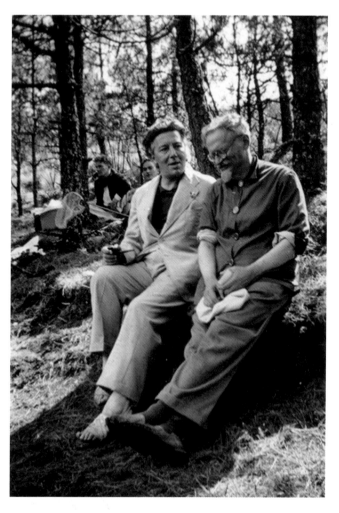

47 Breton and Trotsky in Mexico, 1938.

abated,' he wrote in 'Souvenir du Mexique' (Memory of Mexico).[14] Henceforth he looked to an idealized Mexico to counter European political decline and re-energize the Surrealist spirit, telling the Mexican artist Diego Rivera: 'In Mexico everything related to artistic creation is not adulterated as it is over here.'[15]

During his four-month stay in Mexico in 1938 Breton met Leon Trotsky, who had been granted asylum after his expulsion from the Russian Communist Party in 1929 (illus. 47).[16] The two men met on several occasions and had lively discussions on subjects ranging from art, revolution and objective chance to collective myths and . . . dogs. According to Jacqueline Lamba their relation was a mix of mutual affection, shared unlimited curiosity, and differences.[17] While

both defended the freedom of artistic creation, for instance, their literary tastes differed widely: Trotsky, who was a great admirer of the novels of nineteenth-century naturalist Émile Zola and whose artistic appreciation stopped at the Impressionists, could not understand Breton's passion for Sade and Lautréamont, precursors of Surrealism. There were also more fundamental divergences: on the subject of the Freudian unconscious Trotsky reproached Breton for keeping 'a little window open onto the beyond', a criticism strongly denied by Breton, who rejected all forms of transcendence.[18] More generally, Trotsky the materialist, whose interest lay primarily in political and economic issues and who considered art as a secondary issue, was unconvinced by Breton the romantic revolutionary for whom art was central to the debate on revolutionary change. And yet, in spite of their differences, they co-authored the manifesto *For an Independent Revolutionary Art*, signed by Breton and Rivera (at Trotsky's request, for political reasons).[19]

In this manifesto they sought to outline a common position on the relations between art and politics. They attacked the repression of artists in totalitarian states, defending those who had been reduced to subservient roles under Hitler, or instruments of communist ideology

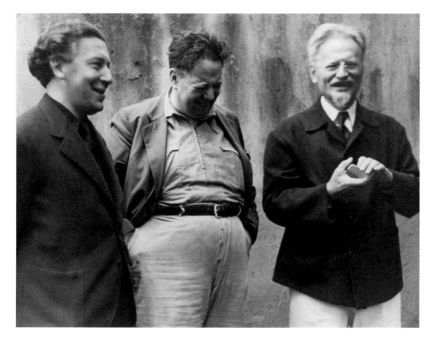

48 Breton, Rivera and Trotsky in Mexico, 1938.

49 André Masson, *Le Thé avec Franco*, *Clé*, 2 (1938).

under Stalin. They advocated art as an expression of freedom liberated from all constraints, and as an integral part of the broader aim of social transformation: 'Pure art cannot not be revolutionary or not aspire to a complete and radical reconstruction of society.' The central idea, the interdependence of art and revolution, is reaffirmed in their final words: 'Our aims: the independence of art – for the revolution; the revolution – for the complete liberation of art.'

The manifesto was written as the founding text of the Fédération Internationale de l'Art Révolutionnaire Indépendant (FIARI), a leftwing organization of artists and writers set up by Trotsky with Rivera and Breton. Seeking to steer a revolutionary path free of Fascist and Stalinist totalitarianisms it rejected nationalism and militarism, promoted support for the Spanish Republicans, and defended artistic

freedom. The manifesto was published in the FIARI's bulletin *Clé*. On the cover of the second issue, André Masson's drawing *Le Thé chez Franco* represents three grotesque figures (illus. 49). The prime minister Neville Chamberlain, depicted by an umbrella, sits on a City toilet (symbolizing the political and financial support of the English government for Franco) and serves tea to Franco, whose uniform scarcely contains his rotting body, and a Nazi soldier, whose body is all spikes and excrement; the legs of the two military men are chained together, indicating their complicity. By selecting a Surrealist drawing for the cover, the editors of *Clé* were declaring their openness to innovative, avant-garde art. We should, no doubt, note that such tolerance was quite rare on the far left, since Trotskyist parties tended as a rule to be little more receptive to modernism than the Stalinists.

From politics to myth

Breton's view of Mexico was couched essentially in primitivist terms, as a country where men lived in harmony with nature, free of capitalist influence, an idealistic position clearly contradicted by Mexico's real politico-economic situation, as discussed in Chapter Ten. Although Breton expressed his wholehearted engagement not only with Mexico's Precontact past but with its revolutionary present, there are few references in his texts and interviews to social and political issues in Mexico, such as the recent attempted coup d'état against President Cardenas, and he does not mention the fact that his scheduled lecture series had to be cut short because of social unrest. Unsurprisingly, after his opening lecture at the Universidad Nacional de México, newspaper articles denounced Surrealism as an 'ivory tower', because, as Louise Tythacott notes, 'for all their radical intent, many Surrealists remained locked within the framework of early 20th century Eurocentric primitivist references.'[20]

The two strands come together in 'Souvenir du Mexique' (Memory of Mexico), written on his return to Paris in 1938, where Breton discusses Mexico's War of Independence (1810) and Revolution (1910), and links the country's pre-conquest past to its revolutionary present. He weaves together history and myth, arguing for instance that the

THE EYE OF THE POET

50 Diego Rivera, *The History of Mexico*, 1935, mural.

Aztec deities Coatlicue and Xochipilli are still alive in modern Mexico as cult objects for the indigenous population, 'Mexico having barely awakened from its mythological past'. He is referring here to the indigenous Mexicanidad movement, which combined myth and modernism.

A similar interweaving of past and present, myth and politics, is present in Breton's discussion of Diego Rivera, one of the three major Mexican muralist painters of the 1920s and '30s ('los tres grandes'), alongside José Clemente Orozco and David Alfaro Siqueiros.[21] It was Rivera who introduced Breton to Trotsky; in fact Breton appears to have been closer to Rivera than to Trotsky himself during his stay in Mexico.[22] 'Diego, my dear friend,' he wrote in 'Memory of Mexico', 'I understand your thought so well.' Although according to Rivera

Breton actually appears to have misunderstood or perhaps chosen to ignore the political and social realities of the country, he defended Breton against the hostility of Mexican communist intellectuals and their attempts to obstruct his movements during his stay in Mexico. Breton, he wrote, responded sensitively to the spirit of Mexico and 'has understood the beauty, pain, repressed strength and black humour that lie smouldering in this land'.[23]

Rivera's monumental murals celebrate Mexico's national history, its Precontact past, portraying the activities of its peasants and workers while outlining the vision of a new society. He idealized Aztec society as a paradise destroyed by colonialism, glossing over the militarism and institutional violence of the Aztecs themselves. One of

his murals in Mexico City's National Palace (illus. 50), for example, opposes revolution and conquest in the figures of Zapata (depicted in the upper part of the image standing among revolutionaries from various epochs, holding a banner inscribed with the words 'Tierra y Libertad' (Land and Freedom)) and Cortés (in the lower part, among the Spanish conquerors killing, plundering, exploiting and converting the indigenous population). Given centre stage in the image, an eagle with a snake in its beak illustrates the myth of the founding of the Aztec capital. Breton's admiration for Rivera was not based on aesthetic criteria, however; after all, Rivera's political murals were closer to socialist realism than to Surrealism's 'inner model'. For Breton, Rivera was the embodiment of the revolutionary spirit: 'He personifies, in the eyes of an entire continent, the struggle being waged so brilliantly against all the forces of enslavement, and in my eyes too he embodies everything that is most valuable in this world.'[24] Above all, Breton expresses his admiration for a work belonging to a regionalist Mexican tradition of popular art, rooted in the Mexican soil: 'you are linked, through thousand-year roots, to the spiritual resources of your land, for you and for me the dearest land in the world.' In an exalted tone he declares that 'the buildings of Mexico . . . will bear testimony to his loyalty to the cause of human emancipation which, through his painting, is expressed in the most concrete and exciting language.' He proclaims Rivera the artist of

> an *epic work*, unparalleled in Europe, tracing the century-long uninterrupted struggle for Mexico's independence and through it, the constant aspiration of man for greater consciousness and freedom, which, beyond the period of the Spanish conquest, reconnects with the most precious relics of bygone Indian civilizations.

For Breton, Rivera's murals transcend contemporary socio-political concerns; indeed they go beyond any simple political reading. He weaves the murals into a grand narrative in which myth and history are commingled, from an imagined Aztec past to the realities of contemporary Mexico. He argues that Rivera's murals transcend Mexico itself, thanks to the artist's 'gigantic atlas forever open on the walls of

the buildings of Mexico City, Cuernavaca and Chapingo', because they link Mexico and the universe, rising 'to an ever greater consciousness of the progress of the universe'. Breton thus reaches beyond the actual frontiers and politics of the country, in a shift from politics to universal myth, from historical revolution to an a-historical utopian space, making of myth and mysticism, as Keith Jordon notes rightly, 'an alternative, not an adjunct, to Marxism'.[25]

The shift in Breton's attention from Rivera's murals to his landscapes is another example of the slippage from politics to myth, no doubt because, while the murals are undeniably political art, the landscapes proved to be more easily retrievable for Surrealism. Indeed, the murals themselves were interpreted in terms of the Mexican landscape, thus openly bypassing their political dimension: 'the murals, independently of the grand historical role they assume, create a unique harmony with life, the colours of the sky, of the earth and the trees of his land.'[26] Consequently, Breton illustrated 'Memory of Mexico' not with Rivera's murals but with these politically less problematic landscapes. They are appropriated for Surrealism, situated as they are 'at the most critical point where sight is equated with vision, and there is no longer any gap between the imaginary and the real'. Rivera's works

51 Manuel Álvarez Bravo, *Obrero en huelga asesinado*, 1934, gelatin silver print.

THE EYE OF THE POET

are thus retrieved from politics-become-propaganda and reinserted into 'orthodox' Surrealism.

The tactic of displacement from a political to a mythical – and Surrealist – reading of a Mexican artist is encountered again in Breton's interpretation of Manuel Alvarez Bravo's photograph of a worker assassinated during the trade union struggles, *Obrero en huelga asesinado* (Striking Worker Assassinated; illus. 51). When reproduced in *Minotaure* to illustrate 'Memory of Mexico', the title, *Après l'émeute (Tehuantepec)* (After the Rebellion (Tehuantepec)), is less politically charged than the original; moreover, it is preceded by the shot of a

52 Rufino Tamayo, *Mystère de la nuit*, 1957, oil on canvas.

grave with a flowering cactus and followed by the photograph of a man asleep, *El Soñador* (The Dreamer), thus displacing its original political significance as a record of anti-capitalist struggle, and recontextualizing it within the (Aztec) idea of the reconciliation of life and death and the (Surrealist) tactic of the juxtaposition of opposites.[27] The same photograph, with the title *Ouvrier tué dans une bagarre* (Worker Killed in a Fight), was displayed at the *Mexique* exhibition in 1939, interpreted not in political terms, but in relation to Baudelaire's 'style éternel', thus raising it far above mere political connotations and into the temporality of myth.[28]

A similar movement towards a universal dimension is evident in Breton's 1950 catalogue essay on the Mexican artist Rufino Tamayo (illus. 52). While he acknowledges the artist's specifically Mexican motifs (volcano, sacrifices of human hearts, vultures, codex, mother and child . . .), he evokes an 'eternal Mexico', a space less geopolitical than mental, informed by Mexican mythology and Zapotec philosophy and based on the principle of universal analogy, where 'everything finds its echo from the top to the bottom of creation', and where man's nervous system is linked to the constellations.[29] By looking at the paintings of Tamayo and Rivera through a Surrealist lens, Breton co-opted these artists for his movement, in an attitude not altogether devoid of cultural imperialism.

Art and ideology, post-1945

While in self-imposed exile in New York, in a lecture to a student audience at Yale in 1942, Breton re-affirmed his unwavering attachment to freedom: 'In 1924 I wrote at the beginning of the first *Manifesto of Surrealism*: "The very word of liberty has not ceased to be a source of elation". This elation has remained. Liberty . . . the word has not been corrupted. It is the only word that would burn the tongue of Goebbels.'[30] In spite of this reference to contemporary events, the wartime and immediate post-war periods were largely marked by a shift towards the utopian socialism of the philosopher Charles Fourier, and a concept of myth, alchemy and the esoteric tradition that largely transcended historical and political realities.

At the Paris opening of the exhibition *Le Surréalisme en 1947*, a number of critics asked if Surrealism had died in 1945 and whether Surrealist art had become commodified. They deemed the event Surrealism's swan song rather than a fresh initiative, criticizing the Surrealists for their supposedly retrograde attachment to 'chromo-anecdotal painting' and ridiculing the exhibition as 'a kind of Luna-Park' or an 'old defused grenade'. Charles Estienne, art critic for *Combat* and *L'Observateur*, who promoted contemporary abstract art in the immediate post-war period, labelled Surrealist artists realists, denouncing their aesthetics of juxtaposition of images as out of fashion and asserting that 'Dalinian beauty is no longer convulsive or scandalous.'[31] Some critics maintained that Surrealism's radical pre-war revolutionary position had been abandoned in favour of myth and magic. And in a public lecture that year, 'Le Surréalisme et l'après-guerre' (Surrealism and the Post-war Period), former Surrealist Tristan Tzara criticized Breton for fleeing France in 1941, for his non-participation in Resistance activities in occupied France and more generally for his failure to reconcile action and dream.[32] Breton and friends attended the lecture and, unsurprisingly, noisily interrupted Tzara. Their protests, recalling past Dada events, were met with applause and cries of 'Vive Breton!' from a large part of the audience.

The debate stemmed from the fact that, on his return to Paris in 1946, Breton was politically marginalized.[33] Aragon, defending Stalinist Communism, denounced his anti-communist and anti-revolutionary stance. Among other prominent and increasingly influential Paris intellectuals, the philosopher Jean-Paul Sartre dismissed Surrealism as irrelevant in post-war France: 'the total abolition that Surrealism dreams of . . . is an absolute situated outside history, a poetic fiction.'[34] The Surrealists responded to these attacks in a collective tract, *Rupture inaugurale* (Inaugural Rupture, 1947), in which they denounced the communist idea of revolution as little more than economic, and advocated instead total revolution, which would bring about both mental and social liberation.

The Surrealist movement was nevertheless revitalized in the post-war period, thanks notably to the participation of a group of younger artists and writers such as José Pierre and Jean Schuster. In his 1952 *Entretiens* (Conversations) Breton confronted the challenge

of ensuring the continuity between pre-1939 activities and a renewed impetus by opening Surrealism to both artistic experimentation and new political commitments. This gave rise to fruitful collaboration with revolutionary syndicalist and anarchist groups and continued support for opposition movements, via collective declarations and protests, for example against the war in Indochina ('Liberté est un mot vietnamien', 1947), the Soviet intervention in the invasion of Hungary ('Hongrie soleil levant', 1956) and the Algerian War ('Pétition des 121', 1960).

Pre-war Surrealist art, based on the principle of the 'internal model' or 'photography of the mind', could not avoid the risk of reification in the post-war artistic milieu, given its uncertain position somewhere between socialist realism à la André Fougeron on the one hand, and the return to figurative art à la Matisse on the other. Moreover, automatic painting risked being overtaken by a new generation of avant-garde artists who resorted to the technique for purely pictorial ends. The key question was, therefore, how was post-war Surrealism to situate itself? In the artistic field, Paris was dominated by fierce debates opposing academic and socialist realism, 'realism' and 'abstractivism', and 'geometric' versus 'lyrical' abstraction. Moreover, in the context of the Cold War, art was often instrumentalized for ideological purposes, socialist realism as the propaganda arm of Soviet Communism, and abstract expressionist painters vigorously promoted in Europe by the United States as models of democratic freedom and (American) liberalism. Rival exhibitions included *Véhémences confrontées* at the Galerie Nina Dausset (1951), which lined up in a quasi-militaristic confrontation works from both sides of the Atlantic – Willem de Kooning and Jackson Pollock versus Georges Mathieu or Hans Hartung among others – and *Regards sur la peinture américaine* at the Galerie de France (1952).

Realisms: academic and socialist

In his preface to an exhibition of Jacques Hérold's paintings in 1947 Breton launched a vigorous attack on the defenders of all forms of realism, from eighteenth-century France to the twentieth-century

53 Jean-Baptiste Greuze, *La Cruche cassée*, 1771, oil on canvas.

Soviet Union, concluding: 'We have had enough of portraits of dictators and generals, enough of clichéd realism à la Greuze.'[35] His position was provocative in the France of the immediate post-war years, when academic realism became the model for a return to traditional aesthetic codes at a time of instability and reconstruction. This much-hyped 'return to order' was lambasted by Breton in 'Comète surréaliste' (Surrealist Comet, 1947), where he deplored the retrograde tendency of French painting, decrying the banality of their subjects, epitomized by the 'complex of the pitcher', alluding to Jean-Baptiste Greuze's *La Cruche cassée* (The Broken Vessel) of 1771, denounced in

a pastiche of Marxist language as 'enemy number one', the sign of 'a profound abdication of human desire' (illus. 53).³⁶ 'No more pitchermen,' he exhorted, calling for a renewal of the visual arts in order to 'express human desire in its unceasing fluctuation', instead of the allegedly retrograde values of French art represented by Braque, Bonnard, Lhote or Matisse.

Enemy number one was also socialist realism, the official aesthetic doctrine of the Soviet regime adopted from the early 1930s and agressively promoted in Western Europe during the Cold War through exhibitions and journal articles. In 'Pourquoi nous cache-t-on la peinture russe contemporaine?' (Why Is Contemporary Russian Painting Kept Hidden from Us?),³⁷ Breton launched an attack on Soviet art as state propaganda, claiming that socialist realism used retrograde techniques and reduced the subject to 'the dullest, or the flashiest, if not the most sordid kind of *anecdote*', exemplified by a list of titles such as *Preparations for Stalin's Birthday* or *The Stakhanovites Are Keeping Watch*. He concluded that, given Soviet control over the artist, contemporary Russian art was incapable of producing anything beyond popular prints and department store calendars (illus. 54). In contrast, Breton advocated the freedom of art as 'a spiritual adventure', giving the examples of Blake, Delacroix, Van Gogh and so on, 'and it extends magnificently all the way to us'. The same year, 1952, saw the publication of 'Du "réalisme socialiste" comme moyen d'extermination morale' (On 'Socialist Realism' as a Means of Moral Extermination), Breton's response to a series of articles by Aragon, 'Reflections on Soviet Art', published in early 1952 in *Lettres françaises* (the organ of the French Communist Party).³⁸ For Breton, socialist realism as promoted by Aragon was 'but one more imposture to lay at the door of a regime that alienates human freedom'.

54 Ilya Mashkov, *Girl with Sunflowers (Zoya Andreeva)*, 1930, oil on canvas.

'Lyrical' abstraction

Among the other artistic movements that flourished at the time, as an expression of the gestural and mental freedom of the artist acting on the level of dreams and desire, 'lyrical abstraction' was considered as a renewed form of automatism and promoted as a language of freedom. In his preface to the exhibition *L'Imaginaire* at the Galerie du Luxembourg in 1947 Jean-José Marchand distinguished two forms of 'abstractivisme', geometric abstraction and 'lyrical' abstraction, the latter originating in Baroque art and represented by contemporary artists such as Hartung, Wols and Jean-Paul Riopelle. Breton gave his support to the latter group, claiming their art had expressive or poetic qualities, in a characteristic slippage from the pictorial to the poetic register; qualities, he argued, that were totally lacking in geometric abstraction, the product of 'a profound abdication of human desire'.

In 1951 the art critic Charles Estienne, who a few years earlier had criticized Surrealism for being stylistically retrograde, promoted a rapprochement between Surrealism and artists working in 'lyrical' or gestural abstraction. The following year he collaborated with Breton as artistic director of the Galerie A l'Étoile Scellée (At the Sealed Star, referring to the theme of alchemy also present in the 1947 exhibition), an exhibition space open to both the first generation of Surrealists (Ernst, Tanguy and others) and younger artists close to the movement working in a range of styles (Jean-Pierre Duprey, Adrien Dax and so on).[39] The promotional text for the opening of the gallery hailed the enterprise as a challenge, exhibiting artists who were steering a course between abstraction and figuration, these two pitfalls of the post-war art scene.[40] In collaboration with Estienne and Péret, Breton curated a number of exhibitions and wrote catalogue essays, promoting younger artists such as Jean Duvillier, Jean Degottex (illus. 55), Marcelle Loubchansky (illus. 56) and Endre Rozsda (illus. 57), underlining how the works of these artists, based on gestural freedom and an open figuration – or 'prefiguration' (Estienne) – extended the practice of automatism. It is clear now that it was above all this younger generation of artists who, while affiliated to Surrealism, prospected new directions in their artistic practice, expressing themselves with an enthusiasm unhindered by the difficult task that Breton had set

himself of revitalizing Surrealism while simultaneously claiming continuity with pre-war activities. In 1954 Estienne and José Pierre carried out a survey, 'Situation de la peinture en 1954', asking artists about the new directions in painting: the results confirmed an orientation that goes beyond a polarized figuration/abstraction and favours automatism as an alternative to the 'sterilizing repetition of geometric abstraction', and to realisms of both Left and Right.[41]

Faced with an unimaginative socialist realism and the retrograde painting of post-war France, Breton promoted new forms of art able to renew the expression of desire.[42] A key question remained, nevertheless: was Surrealism in danger of losing its identity in its drive for self-renewal when embracing such a wide range of artists working in diverse styles? This drive was made all the more urgent in 1954, at a time when 'the merchants of Venice' (the Venice Biennale) had just

55 Jean Degottex, *Désincarné*, 1955, oil on canvas.

56 Marcelle Loubchansky, *Bethsabée*, 1956, oil on canvas.

attributed its prestigious Grand Prize to Max Ernst, thus marking the commodification of Surrealism on the art market (the 'grotesque, stinking beast called money' that Breton had mocked back in the 1920s).

The period was rich in such disputes and alliances, and in conclusion we should note that in spite of the close collaboration between Estienne and Breton evident at this juncture, their aesthetic concepts actually differed and thus help to illustrate the continuity in Breton's thinking. While Estienne defended the plasticity of the work of art, 'the transmutation of natural space into plastic space', Breton, on the contrary, unyielding in his rejection of painting as message, as practised by Soviet artists, continued to express his indifference to painting as matter, valorizing the mythical or poetic quality of the works or painting as sign (even where the sign is indecipherable). And while Estienne envisaged the renewal of the concept of automatism as an opening onto an original pictorial practice, it is doubtful whether automatism as practised by younger artists was of the same nature as the 1930s Surrealist automatism of Breton, less a technique and an end in itself than a means of liberation of the mind, a revelation of the processes of the unconscious.

57 Endre Rozsda, *Amour sacré, amour profane*, 1944, oil on canvas.

five
Cutting and Pasting: Breton the Artist

BRETON'S OWN ARTISTIC activity is an essential component of his engagement with the visual arts. He experimented in a wide range of media and genres – including collages, photomontages, poem-objects, frottages, decalcomania, drawings – and produced collective collages and drawings with fellow Surrealists. Since many of these works were ephemeral pieces, fashioned out of fragile or everyday materials and, arguably, demanding more imagination than technical skill, they have been treated as little more than examples of artistic experimentation in a minor key. This chapter will seek to counter this neglect by exploring Breton's collages, poem-objects and his contributions to collective artistic activities, such as the game of exquisite corpse and the Marseille Tarot game, in order to show that they were in fact central to the Surrealist project, both because they dismantle traditional artistic categories and established aesthetic hierarchies, and because they correspond directly to Lautréamont's influential injunction that 'Poetry should be made by everyone. Not by one.'

Collages

Zapping with fellow Dadaist Jacques Vaché from one cinema to another in wartime Nantes, creating incongruous montages from the random fragments viewed; producing an active collage-space on gallery or studio walls by juxtaposing Oceanic masks alongside Surrealist paintings or photographs; composing collage-letters for his Dada friends from textual or pictorial fragments: it is through such varied practices that we discover how collage, montage or assemblage

58 Breton, *Untitled*, n.d., ink and wax on paper.

59 Breton, collage poem, c. 1924.

materialized for Breton not just as image or object but as event and performance. The Surrealists produced provocative installations at exhibitions and confrontational modes of display, staging the clash of disparate elements, making of them both subversive gesture and artistic statement, hence creating the much sought-after *étincelle* or creative spark. While Breton's collage poems (illus. 59) and poem-objects have received some critical attention, his pictorial collages have remained largely unexplored.[1] This could be explained partly by the very discretion of collage, considered an ephemeral genre; moreover, the

cut-and-paste technique recycles flimsy everyday materials. 'Collage is poor,' writes Aragon in a mock-disparaging tone. 'For a long time its value was denied. It appears to be easily reproducible. Everyone believes they can produce one.'[2] The deceptive simplicity of collages like those of Breton is compounded by the fact that they were long held far from the public eye, in private collections or the archives of museums and libraries, and have only recently resurfaced on the occasion of a sale, a publication or an exhibition.[3]

Collages were frequently a means of private communication, between Breton and his wife Elisa (*Hébé, Nice te rit*, 1953), his daughter Aube (*Lotus de Païni*, 1962, dedicated '*pour Aube, tendrement*'; illus. 60) or friends. They can prove difficult to decipher, because they are sometimes highly idiolectal, expressing the private codes of personal exchanges or comments on contemporaneous (and now forgotten) matters. Yet while the context may often have been personal, their status of polemical gesture or poetic expression makes such collages far more than a minor artistic activity. They reveal another, perhaps more spontaneous Breton, playful, ironic or nostalgic. The pleasure we derive from discovering them is grounded first in the realization that we are catching Breton off guard, as it were, indulging in a seemingly casual activity of cutting and pasting fragile fragments or handwritten messages. This is André (he signs many of them by his first name) rather than Breton, private individual rather than public personage, who might be seen at last to lose his bearings ('perdre le nord'). However, beyond such voyeuristic pleasures hovering at the edge of our academic labours, these collages merit more attention, not in order to reposition Breton as a major collagiste alongside the likes of Dada *photomonteurs* – Raoul Hausmann, Kurt Schwitters, Hannah Höch – or within the Surrealism of a Max Ernst or Jindřich Štyrsky, but in order to better appreciate the full range of his activities in the field of the visual arts.

Breton created more than forty pictorial collages. He favoured materials that were defunct, devalued, banal: fragments of newspapers and advertisements, letters and envelopes, old tickets, stamps, visiting cards or other memorabilia, images or words removed from their original cultural context, bits and pieces whose meanings had been eroded through time. These ephemera, fragments bereft of a

60 Breton, *Lotus de Païni*, 1962, collage paper, aluminium, leaves, ink on paper.

fixed meaning and marooned in the present from an almost forgotten past, are revitalized by the artist's cutting and pasting of material and the reader-viewer's imaginary associations. Like Ernst, Breton found some of his collage material in popular nineteenth-century scientific journals such as *La Nature*, whose illustrations, already old-fashioned by the 1920s, had acquired the aura of temporal and semantic distance. His choice focused primarily on illustrations of experiments

in '*physique amusante*' (popular science), no doubt because they already had a strange, surreal quality. This is well illustrated by *Le comte de Foix allant assassiner son fils* (The Count of Foix About to Assassinate his Son) of 1929 (illus. 61), which depicts a masked male figure with a long weapon, about to strike a pole resting on two wine glasses perched on chairs.[4] The original image, drawn from *La Nature* (illus. 62), illustrates an experiment to which Breton has added a mask on the main protagonist and an outsize aquarium with plants, tadpoles and tritons.[5] Breton has been far less meticulous in his cutting and pasting than Ernst, since the left leg of the man observing the experiment is still visible to the left of the image. The collage is enigmatic, like a moment in a dream, inhabited by something unidentifiable and suspended as if before an imminent fatal action. The dreamlike is even more marked in *Charles VI jouant aux cartes pendant sa folie* (Charles VI Playing Cards During his Madness) of 1929 (illus. 63),[6] where the original image (also sourced in *La Nature*), illustrates the optical illusion of reflexions on convex and concave surfaces.[7] Superimposed over the top half of one of the two men playing cards is a giant coffee-pot on whose surface appear three distorted and inverted reflections of a male figure. In cases like this, the collagist's attraction to the original images has both a temporal and a spatial dimension. It derives partly from the formally outmoded technique of wood engravings (obsolete by the end of the nineteenth century when it was replaced by photomechanical processes), and partly from their spatial isolation on the pages of the original publications, producing a palimpsest of meaning, the traces of earlier strata from a

61 Breton, *Le comte de Foix*, 1929, collage of printed papers, reproduced in *Intervention surréaliste*, *Documents 34* (1934).

62 'Experiment on inertia', illustration from Gaston Tissandier, *Les Récréations scientifiques, ou, L'enseignement par les jeux*, 4th edn (1884).

63 Breton, *Charles VI jouant aux cartes pendant sa folie*, 1929, collage of printed papers, reproduced in *Intervention surréaliste*, *Documents 34* (1934).

past both historical (in the eroded cultural signs) and individual (in the almost forgotten images of childhood).

Collages like these vary in the greater or lesser visibility of the assemblage of their elements. In the case of *Charles VI Playing Cards* and *The Count of Foix* there is a quasi-absence of visible seams in the imported fragments, which have been fully integrated; hence perceived disjunctions derive from the representational incongruities (mask) and shifts of scale (giant coffee-pot or aquarium), which in turn enhance the hallucination suggested in the title. On the other hand, in a number of the collages dating from the 1950s attention is drawn to the material process by the visible tears, disparate media and surface textures, as in *La Chouette noire* (The Black Owl) of 1955, a collage composed of frayed printed and coloured papers and a fragmented text (illus. 64). The palimpsest suggested by the superimposed papers, the enigmatic verbal combinations and the visible fragility of the materials used, combine to produce a diffuse poetic effect, a code tinged with nostalgia, the trace of a forgotten incident or a lingering private emotion.

CUTTING AND PASTING: BRETON THE ARTIST

In some collages the ludic element is dominant, as though they constituted a simple playful manipulation of signs. In a case like the photocollage portrait of Éluard entitled *La Nourrice des étoiles* (Nurse to the Stars) of circa 1938 (illus. 65), the image is a visual pun on 'the milky way', humorously encoded in the rows of milk bottles above Éluard's head and in a jacket cut out from an astronomical chart, giving the figure the air of a magician or astrologer. The title was provided by Philippe Soupault, who invented such phrases to designate his friends. Unfortunately, we have no collage for Breton himself to accompany his nickname, 'une tempête dans un verre d'eau' (a storm in a teacup).

64 Breton, *La Chouette noire*, 1955, poem-object.

65 Breton, *La Nourrice des étoiles*, 1938, photocollage.

Beyond word-games or playful cutting and pasting, the collages often include a poetic or metaphorical dimension. In *Chapeaux de gaze, garnis de blonde* (Gauze Hats Trimmed with Light Lace, 1934), for instance, hats have been cut out of a milliners' catalogue and pasted onto an engraving of a romantic landscape of cliffs and waterfalls (illus. 66). As if suspended above the landscape, the hats evoke butterflies, jellyfish or exotic plants. For the attentive viewer the hats have both a literal presence, retaining their original identity as hats, and a transformative metaphorical presence; they hover, in a play on the indefinite, between hats, animals and plants.

The 1930s saw an explosive development of satirical collage and photomontage, especially in works by Ernst or Štyrsky. Breton himself produced two satirical collages, reproduced in *Le Surréalisme au service*

66 Breton, *Chapeaux de gaze garnis de blonde*, 1934, collage on printed paper.

de la révolution in 1933, where figures of authority or institutions are exposed to ridicule. One of these, *L'Oeuf de l'église (le serpent)* (The Egg of the Church (The Serpent)) of 1932 (illus. 67), combines images drawn from a catalogue of clerical vestments – mitre, cardinal's hat, bishop's staff, stole – with a cut-out female head and a reclining female figure in evening dress, in an acerbic critique of the ecclesiastical establishment. By isolating the (carefully numbered) props of the Catholic Church and perversely combining them with female figures, juxtaposing ecclesiastical display and discourse of desire, Breton is pointing satirically to the ritual masking of a taboo.[8]

Such material, poetic or satirical strategies dismantle comfortable aesthetic, social and historical discourses, destabilizing and extending analogical processes (such as hats to jellyfish in *Gauze Hats*), narrative

THE EYE OF THE POET

67 Breton, *L'Oeuf de l'église (le serpent)*, 1932, collage on paper, reproduced in *Le Surréalisme au service de la révolution*, 6 (1933).

68 Breton, *Le Torrent automobile*, 1934, handwritten text on paper, penknife bound with twine mounted on card.

69 Breton, *Untitled (Je vois j'imagine)*, 1935, poem-object.

suspense (*The Count of Foix*), or the principle of identity (*Nurse to the Stars*). They occupy a paradoxical space, between matter and metaphor, presence and sign, fragmentation and totality, and can be linked to the effect of the poem-object, discussed in the next section.

Poem-objects

Breton described the poem-object as 'a composition which tends to combine the resources of poetry and visual art and to speculate on their power of reciprocal exaltation'.[9] Of the twenty or so he produced himself, some are visibly just cobbled-together pieces, juxtaposing a manuscript text with various everyday objects: a postcard (*Jack l'éventreur*); a cigarette packet (*L'Océan glacial*); a penknife (*Torrent automobile*; illus. 68); a text with tactile objects, feather, stone, fur, silk or lace; or a box containing an assemblage of objects, such as *Je vois j'imagine* (illus. 69). Like his collages, they were often ephemeral objects, several later lost and leaving only a photographic record. Yet, like the collages, his poem-objects are often dated and signed, no doubt because they were created as gifts for female friends or lovers: *Le Torrent automobile* (1934), for instance, was dedicated to Valentine Hugo, and *Page-objet* to Marcelle Ferry (illus. 70), while *Carte resplendisssante de ma vie* (Resplendent Card of My Life, 1937; illus. 71) and *Ces terrains vagues* (1941) were dedicated to Jacqueline Lamba.

In the early 1930s, in response to the Surrealists' drive to anchor poetry in external reality, there was a shift from a focus on the 'internal model' to an intense theorization and practice of the material object and materialist poetics. As Breton was to claim in 'Crise de l'objet' (Crisis of the Object) in 1936, 'the creation of "Surrealist objects" answers the need to establish, according to Éluard's decisive

Le torrent automobile de sucre candi
Prend en écharpe un long frisson végétal
Étrillant des débris de style corinthien

André Breton
26-12-34

À l'intersection des lignes de force invisibles
Trouver
Le point de chant vers quoi les arbres se font la courte
échelle
L'épure du silence
Qui veut que la vigueur des navires livre au vent son
trousseau de chiens bleus

André Breton 12-1-35

70 Breton, *Page-objet*, 1934, assemblage.

71 Breton, *Untitled (Carte resplendissante de ma vie)*, 1937, assemblage.

expression, an authentic "physics of poetry".[10] The third issue of *Le Surréalisme au service de la révolution* (1931) published texts on the object by Dalí ('Objets surréalistes'), Tanguy ('Poids et couleurs') and Breton ('Objet fantôme'), with photographs of Surrealist objects by Giacometti, Miró, Breton and Gala Éluard. In their visits to the flea market the Surrealists came across objects whose sudden revelation was seen in terms of objective chance, defined as the manifestation in reality of an inner desire. Breton gives as an example a wooden spoon with a tiny shoe fixed to the underside of its long handle, materializing an object seen in a dream, accompanied by the phrase 'cendrier-cendrillon' (Cinderella-ashtray). Surrealist interest in the object culminated in 1936 with the *Exposition surréaliste d'objets* at the Galerie Charles Ratton,[11] where a wide range of objects was displayed (natural objects, disturbed objects, found objects and so forth),

including Hopi Kachina dolls, Peruvian pottery, Inuit masks, as well as Duchamp's 'readymades' (such as *Bottlerack*). Many of the Surrealist pieces exhibited were everyday objects either transformed (Meret Oppenheim's *Fur-lined Breakfast*), incongruously juxtaposed with another object (Dalí's *Lobster Telephone*) or combined with a text to form a poem-object (Jacqueline and André Breton's *Le Petit Mimétique*).

Breton's particular interest in, and creation of, poem-objects derived from both his fascination for the confrontation – or, for some critics, fusion – between the visual and the verbal, and the questions encountered in the juxtaposition of words and objects. 'An object never has the same role as its name or its image,' Magritte states in 'Les Mots et les images' (Words and Images), underlining the non-illustrative character of juxtapositions in the text-object.[12] It is the intermedial character of the poem-object that is foregrounded in Breton's own description of 'the experiment that consists of incorporating objects, ordinary or not, within a poem, or more exactly of composing a poem in which visual elements take their place between the words without ever duplicating them.'[13] The experimental nature and the hybrid structure of such non-illustrative configurations or simple collocations of words and objects is central here. While Magritte's point of departure was the material object, and Breton's was poetry, both artist and poet explored 'what could result from juxtaposing concrete words with great resonance . . . with forms that negated them or, at the very least, did not rationally match them.'[14] This shows quite clearly that the structure of the poem-object developed directly from the founding principle of the Surrealist image, namely the encounter of disjunctive elements. Looking beyond the producer, Breton emphasized the effect on the reader-viewer of the poem-object's intricate and disturbing interplay: 'the reader-spectator may receive quite a novel sensation, one that is exceptionally disturbing and complex, as a result of the play on words with these elements, nameable or not.'[15]

The viewer is in fact often confronted with the hermetic quality of poem-objects, derived partly from their circumstantial character, evidence of the intimacy of a personal relationship, its secret language and at times erotic implications, as in the collages discussed earlier in this chapter. More generally, poem-objects can be the materialization of desires or dreams. Breton described one of his poem-objects,

Rêve-objet, as the 'figuration in three dimensions' of one of his dreams, for which he then provided a detailed description and interpretation, thus presenting it as an enigma to be decoded.[16] Actually, the poem-object often appears as more of a mystery than an enigma, something to be imagined rather than decoded, a paradoxical figure adrift between object and sign. To summarize this paradox in the words of Octavio Paz: 'Torn from their context, objects are deviated from their use and meaning. They are no longer really object and not quite yet signs.'[17] A good example of this paradox is the bound penknife in Breton's *Le Torrent automobile* (1934), a poem-object that combines a penknife with a pink handle, attached with string to cardboard (see illus. 68). Above it a short handwritten text reads: 'The automobile torrent made of candied sugar / Hits sideways a long plantlike shiver / slaughtering corinthian style debris.' It is signed 'André Breton' and dated '26.12.1934', and was a gift to Valentine Hugo, as indicated by a card attached to the back of the work. For José Pierre word here becomes object, and object, word:

> Breton is trying to tip the object – a humble penknife – into the poetic field, to integrate it as the equivalent of a fragment of writing, a few verses, into the subjective domain of the poem, while, reciprocally, the written poem tends to take on the objective quality of the penknife.[18]

Complementarity is evoked in the horizontal shapes of text and penknife; the echoes between the colour of the penknife and the 'candied sugar'; the connotation of violence in 'automobile torrent' and the penknife as weapon (although closed); and in the erotic suggestions of the phallic shape and colour of the penknife and the 'long plantlike shiver'. Yet these are only partial associations, and the penknife, resolutely closed, is confronted as object, while resisting as sign.

Needless to say, the hermetic quality of such poem-objects has created a challenge for critics unable to resist the lure of interpretation: as emblems or 'beaux monstres', breaking with the natural order (Paz); as example of verbal-visual fusion (Pierre); as fetish object (Powrie); or cryptogram (Mourier-Casile).[19] The poem-object's hermeticism might well explain why Breton himself was not averse to

detailed interpretations, often linked to a highly personal mythology or a rebus. For example, for his poem-object (now lost) *Portrait de l'acteur A. B. dans son role mémorable en l'an de grâce 1713* (Portrait of the Actor A. B. in His Memorable Role in the Year of Our Lord 1713, 1941), exhibited at the opening exhibition of Peggy Guggenheim's Art of This Century Gallery in New York in 1942, an illustration of the object was accompanied in the catalogue by a detailed exegesis under the programmatic title 'The Poem-object'.[20] In this text Breton freely associates the personal (the similarity of his initials to the date 1713) and the historical, listing in detail the significant historical events associated with the date, thus playfully linking the individual – as performer, not person – and the collective.[21]

'Alors, on joue?': collective artistic activities

'Entertaining games for all ages / poetic games etc.' ('Jeux très amusants pour tous âges / jeux poétiques etc.'), wrote Breton in his collage-poem 'Le Corset Mystère' (1919), in what resembles a mock-advertisement for Surrealism.[22] Games and play were an integral part of the Surrealist group's activities. Over the decades they invented a wide range of games, which they played in their meetings in cafés and studios or recorded in their journals.[23] Many of them were based on chance encounters between words and images. Among these was the 'definitions game', based on the question-and-answer principle, where player A formulates a question asking for the definition of a word, while player B answers without knowing the question asked. This produced absurd or poetic dialogues such as 'What is daytime? – A woman bathing naked at nightfall'. The 'hypothesis game', based on similar rules, produced fantastic narratives: 'If everything flew off on a windy day / There would be even more somnambulists walking on the edge of roofs.' While simple sounding, these were more than mere society games, not least because, from a Freudian perspective, as Jean Schuster observes, 'the game activity in Surrealism, however episodic it is, should nevertheless be seen as fundamental . . . it gives the pleasure principle form and power, what is needed to face the reality principle dialectically.'[24] More generally, we can see that games involved the interplay of chance and rationality, a form of resistance to

the social and cultural order, via the destabilization of linguistic and iconographic codes. In his position as master of ceremonies Breton maintained that the pooling of participants' contributions becomes a melting pot of chance and imagination, 'one of the most extraordinary spaces of encounters'. We can thus understand how the imaginative freedom unleashed by games had an important collective dimension, expressing the group's shared desires, thereby strengthening the ties between them. In short, the Surrealists' engagement with ludic activities – both linguistic and graphic – fully embraced the two directions of the French term *jeu*: both as *play*, a spontaneous aleatory activity, involving the liberation from rational or functional constraints, as in automatism; and as *game*, a regulated but non-serious activity, bounded by codes and frames, as in the 'exquisite corpse' explored in the next section.

Exquisite corpse

The game of exquisite corpse (*cadavre exquis*), invented in 1926, was without doubt one of Surrealism's most creative and best-known collective activities. Its definition was straightforward: 'Game of folded paper consisting of several players composing a sentence or drawing, without their being able to see the preceding contribution(s).'[25] The game – named after the first sentence produced collectively, 'Le cadavre exquis boira le vin nouveau' ('The exquisite corpse will drink the new wine') – was based on a rule and its transgression. In its verbal form the players followed a conventional syntactic structure (subject – verb – object), while in its graphic form, whether drawn (illus. 72) or collaged (illus. 73), they followed the normative anatomical structure (head – torso – legs, and so on). The random assemblage of words and images generated within these structural rules defies the codes of coherence of the sentence and the unitary body of classical aesthetics, giving rise instead to an aesthetic based on chance, fragmentation and the clash of disparate elements. Looked at as a variant of the children's game of consequences or 'heads, bodies and legs', or the artisanal ancestor of the cyborg, it allowed its participants to stretch the written sentence to its extreme or to re-imagine the (limits of the) human body. In its verbal form the subject-verb-object

progression produced sentences at the edge of meaning: 'Le caméléon rouge et vert ouvre la cuisse physique' ('The red and green cameleon opens the physical thigh'); 'La grève des étoiles corrige la maison sans sucre' ('The stars' strike corrects the sugarless house'). In its graphic form they exploded the conventional aesthetic of the unified body, producing instead a composite figure made up of an assemblage of disjunctive parts, limit-forms of bodily representations, yet preserving a minimal framework to ensure the legibility of the image. Drawn or collaged, they generated disjunctive entities composed of objects standing in for body parts. In playing with the 'corpse' of normative syntax and anatomical structure, the Surrealists were thus celebrating the death of the classical and the rational. And yet death is also denied and transcended in the 'exquisite' reorganizing of body parts. In his preface to the exhibition *Le Cadavre exquis, son exaltation* at the Galerie Nina Dausset in 1948, Breton claimed that the images produced tend to 'raise anthropomorphism to its highest pitch', thanks to the associative freedom of the game, exploited as 'an infallible means of suspending the mind's critical powers and fully freeing its metaphorical possibilities'.[26]

One question haunts all these ludic activities based on chance: do they have an aesthetic dimension? In the chance encounters between words or fragments of images, where the analogical principle is conflated with the arbitrary, are the disjunctive assemblages meaningful? Are the sentences poetic or simply absurd? It is true that some of the sentences ('The winged vapour deducts the locked bird') and bodies created have an immediate poetic or fantastic appeal. Moreover, it is clear that the Surrealists are parodying Renaissance construction principles of the body, based on the assemblage of limbs lined up for selection in artists' manuals. More generally, they free the mind from the constraints of rationality by liberating its analogical capacities. But above all, the game was linked to the pleasure principle, as Breton asserted: 'Pleasure was the order of the day, and nothing else.'

If there is a valid argument in what precedes, then it is perhaps unsurprising that the game of exquisite corpse and other collective activities should be revived during the winter of 1940–41 when the Surrealist group, like so many fleeing German occupation in war-torn France, was in Marseille waiting for visas to flee to America.

72 *Cadavre exquis* (Salvador Dalí, Valentine Hugo, Gala Éluard and André Breton), *c.* 1934, pen, ink and pencil on paper.

The Marseille Tarot game

When German forces occupied northern France, many anti-Nazi Europeans who could afford to do so sought refuge in the open port of Marseille in the free zone, in the hope of finding a passage to the Americas. Ships were infrequent, however, and administrative procedures lengthy. Among the Surrealists in Marseille were

Duchamp; German-born Ernst and Hans Bellmer, released from Les Milles, an internment camp for enemy nationals near Aix-en-Provence; and Benjamin Péret, escaped from Rennes prison, and his companion Remedios Varo. Between October 1940 and March 1941 Breton and his family, along with Russian revolutionary and writer Victor Serge and his son Vlady, were lodged in Villa Air-Bel (renamed Château Espère-visa), in a suburb of Marseille (illus. 74), by the American Emergency Rescue Committee run by Varian Fry with Daniel Bénédite, whose mission was to organize the passage of intellectuals and artists from France to the United States (illus. 75).[27]

Jacqueline Lamba has an unusually euphoric memory of these suspended months at the Villa Air-Bel that was probably not shared by many of those desperate to flee: 'Thanks to the American Rescue Committee we played, dreamed, created with a feeling of calm and happiness, as in a childhood home.' During these months of forced seclusion Breton, for his part, would spend time in the conservatory writing *Fata Morgana*, and hunt for praying mantis in the grounds of the villa. In the evenings and on Sundays he organized activities for the lodgers of the villa and visiting friends like the artists Domínguez, Victor Brauner and Lam: they held auctions and exhibitions of artists' works, including an exhibition of Max Ernst's paintings, hung from the branches of the plane trees on the terrace in front of the villa; games, debates and collective drawings and collages occupied their evenings after dinner (illus. 76). They would also meet in the lively atmosphere of the café Au Brûleur de Loups on the port, the haunt of many refugees, including exiles from Republican Spain. Where Lamba writes of dreams and childhood, Breton's writings reveal a more anxious mood, while in his overview of this period fellow Surrealist Jean-Louis Bédouin acknowledges that resorting to games was 'an effective measure against the temptation to sink into despair. It was not a matter of trying to deny the gravity of the situation. It was a matter of preserving, at any cost, sufficient freedom of mind with respect to it.'[28]

Among the Surrealists' activities at the Villa Air-Bel was the game of exquisite corpse discussed above, and the game of portraits, which consisted of creating the portrait of a particular individual with invented objects. It was this method that was transposed in the

73 *Cadavre exquis* (Jacqueline Lamba, André Breton and Yves Tanguy), 1938, collage on paper.

74 Victor Serge, Benjamin Péret, Remedios Varo and Breton at Villa Air-Bel Marseille, 1940–41.

75 Jacqueline Lamba, André Masson, Breton and Varian Fry, Marseille, 1941.

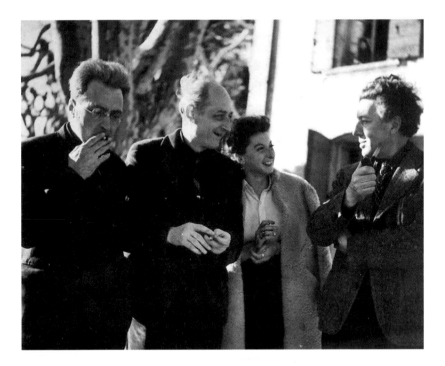

CUTTING AND PASTING: BRETON THE ARTIST

'Jeu de Marseille', a set of tarot cards.[29] Inspired by the Marseille Tarot, a well-known deck of cards dating from the seventeenth century, Breton researched the origins and history of playing cards.[30] Of course, the Surrealists rejected the (military) symbolism of historical playing cards, even though it was a symbolism that had been largely lost over time. While the structure of the deck was preserved (32 cards, red and black suits) they sought to renew its symbolism (illus. 77). Traditional suits and emblems were replaced by Love (represented by a flame), Dream (a black star), Revolution (a bloody wheel) and Knowledge (a keyhole). Finding the playing cards of the French Revolution more palatable, they abolished the court hierarchy: the king was deposed, replaced by a Genius, and the queen by a Siren; the knave, freed from his subordinate status, was replaced by the Magus; and the joker gave way to Jarry's famous drawing of Père Ubu. The cards

76 Collective drawings (Breton, Lamba and Lam), 1940, ink and coloured pencils.

77 Jacqueline Lamba, *Baudelaire, Jeu de Marseille*, 1940, gouache, india ink and collage on paper.

78 Breton, *Paracelsus, Jeu de Marseille*, 1940, black and coloured ink on paper mounted on cardboard.

were also enriched by association with literary or historical figures favoured by the Surrealists: fictional characters (Lamiel, Alice, la Religieuse), poets (Novalis, Baudelaire, Lautréamont), revolutionary figures (Pancho Villa, Sade), the medium Hélène Smith, the Swiss alchemist and philosopher Paracelsus, the philosopher Hegel, among others. When the project launched, lots were drawn to distribute the design of the cards, each participant creating two cards: Masson (*La Religieuse portugaise*, Novalis); Lam (Alice, Lautréamont); Brauner (Hélène Smith, Hegel); Domínguez (Freud, black star); Hérold (*Lamiel*, Sade); Jacqueline Lamba (*Roue de la révolution*, Baudelaire). Breton, for his part, designed the emblem of the lock, drawn from an esoteric symbol (he was researching the French occultist Eliphas Levi at the time), and the Swiss alchemist and philosopher Paracelsus,

represented by an octopus (illus. 78), based on an illustration from a popular journal.[31]

The creation of collages, poem-objects and playing cards by Breton and fellow Surrealists thus contributed to the challenging of traditional aesthetic principles in multiple ways: through the exploration of chance and coincidence; the non-distinction between individual and collective artistic creation; the transformation of the banal everyday image or object into the surreal; the passage from dream to object. Hierarchies were jettisoned, in particular the distinction between 'noble' (permanent) and 'base' (ephemeral) materials. And in collage, process (the visibility of the cutting-and-pasting technique) was valued over product, collective production (exchange) replaced consumption (possession).

six

Surrealism and Books: Doors 'left ajar'

WHAT IS A SURREALIST BOOK? The Surrealist book is an open concept, ranging from a dreamed object to an installation. Breton dreamed of a 'curious' book whose spine was a wooden gnome with a long white beard, and whose pages were made of thick black wool.[1] Surrealist painters and poets collaborated on the artist's book, such as the luxury edition of *L'Air de l'eau* (The Air of Water, 1934), which combines Breton's poems with four engravings by Giacometti. In *Le Surréalisme en 1947*, curated by Breton and Duchamp, the stairs were made up of the spines of the Surrealists' favourite books, from Fourier and Sade to Nietzsche and Freud.

This chapter will focus on the book as a collaboration between poet and artist. Until the end of the nineteenth century the image in its role as illustration was subservient to the text. By giving equal importance to the verbal and visual components of the book the Surrealists abandoned illustration's traditional mimetic function. One can usefully apply to this new configuration Breton's definition of the poem-object, quoted in the last chapter, as the 'reciprocal exaltation' between the verbal and the visual.[2] Strategies, of course, varied greatly: in the examples of books chosen for the present chapter, the photographic image in *Nadja* initially appears to be illustrative while actually interrupting and challenging the reading process; in the manuscript of *Arcane 17* text spills into image and image into text; finally, Breton's 'parallel prose' poems use Miró's gouaches in *Constellations* as springboards for their own autonomous developments. What they have in common, however, in each instance of intermedial encounter, is the 'reciprocal exaltation' or exchange – whether harmonious, contradictory or conflictual – between text and image.

Nadja: 'a disturbing book'

Originally published in 1928, *Nadja* is a hybrid text, simultaneously diary, memoir, essay, fiction and medical report, a complex weaving together of the factual and the fabricated, the banal and the marvellous, the verbal and the visual. It was illustrated with 44 photographs selected and assembled by Breton himself; a revised edition was published in 1963 with an introduction and four additional photos.[3]

'Who am I?' The opening words of the text raise the question of identity, that of Breton first, of Nadja later, an identity formed through encounters with others, a shifting self conceived as an existential quest. The question is soon displaced, from the visible to the spectral, becoming 'whom I "haunt"'.[4] The first section describes the people, places and events that Breton frequents or 'haunts', linked to everyday Surrealist life in Paris, where fragments of autobiography are experienced in terms of the 'everyday marvellous'; the coincidences between events or objects ('certain juxtapositions, certain combinations of circumstances'[5]); chance encounters (with Éluard, later with Nadja) or dreamed encounters; a fascination with certain elective sites (the flea market, Paris squares) and objects (a half-cylinder, a bronze glove, a statue). In stark contrast to the powerful attraction of certain objects and places, the photographs appear to reveal little: empty squares, mute objects, banal signs.

The central section recounts Breton's encounter with a young woman, Léona Delcourt, who called herself Nadja.[6] He first met her on 4 October 1926 on a busy Paris boulevard, attracted by her eyes. It was a chance meeting – chance understood as a force capable of upsetting our habitual perceptions, tearing the veil of habit and repression, transforming the drab Paris streets and revealing the hidden order of the city. They met daily over the next nine days. Their relationship was anchored in Paris streets, real and imaginary, and their walks through the city were apparently aimless yet latently purposeful – the English Surrealist George Melly calls them 'haphazard yet deliberate strolls through Paris'[7] – open to the signs, historical palimpsest and unconscious of the city. Nadja was attracted to, indeed it seems magnetized by, certain areas of Paris, elective sites such as the Place Dauphine, sites invested with suggestive, irrational significance. Their meetings,

made up of both intense moments and empty ones, are recorded by Breton in diary form.

'Who is the real Nadja?' asks Breton: the woman whose hallucinatory qualities and apparent freedom from social constraints make her such a free spirit, an 'always inspired and inspiring creature', or 'the most wretched of women', who leads a less-than-Surrealist life of financial hardship, with an illegitimate child and hints of past drug-addiction?[8] His fascination mixed with boredom, Breton considers her both as a natural Surrealist and a frivolous individual. After 12 October his interest appears to have waned, and he saw her less often. Her erratic behaviour was to lead to her internment in March 1927. Breton visited her once; and in the closing section he launches a violent attack on psychiatric institutions, claiming they actually make people insane. The text ends with a new encounter, with X (Suzanne Muzard). Nadja is all but forgotten.

The photographs in *Nadja* depict people and places mentioned in the text, African sculptures, flea market objects, and Nadja's drawings. The relations between the text and the photographs are diverse, however, sometimes simply illustrative, elsewhere enigmatic. Photographs provide a tentative anchor in the real Paris (advertisements, shop signs, newspaper clippings, theatre programmes), an objectivity in keeping with the neutral tone adopted in the account.[9] In his preface to the 1963 edition Breton noted that their function, based on anti-literary principles, was to replace descriptions, in line with his rejection of literary realism in the 1924 *Manifesto*: 'And descriptions! There is nothing to which their vacuity can be compared.'[10] In fact, it is the documentary role of the photographs themselves that is both asserted and questioned, because beyond their descriptive function they have a disorienting effect, acknowledged in a letter to Lise Meyer where Breton wrote that the addition of photographs would make the text 'a much more disturbing book'.[11] The reader is struck initially by the fact that several photographs come well before or after the passages they refer to (indicated by a page number and a quotation), thus interrupting the reading process. Moreover, as Renée Riese Hubert remarks, they 'do not "fit" into the text as enticement or explanation.'[12] Ian Walker argues that the photographs do not so much illustrate as destabilize, in a 'constant state of provocation and uncertainty that

continues to make *Nadja* a major example of how photographs and text can work together, not to provide certainty, but to undermine it'.¹³ For Jean Arrouye, too, the text undermines the apparent objectivity of the photographs: 'As the objective traces of an arrested reality they appear to almost contradict the account of those coincidences that take you beyond appearances.'¹⁴

It is noteworthy that the photographs themselves are not Surrealist, insofar as the majority do not present any distortion, fragmentation or other manipulation of the image. It is thus their relation to the text that has to be qualified as surreal, the destabilizing effect resulting from the disparities between text and photographs. To take one example of the apparent absence of match between representation and text: the rather austere photograph of the courtyard of the Manoir d'Ango (replaced by a photograph of the dovecot in the 1963 edition), where Breton wrote *Nadja* in 1927, which contrasts openly with the evocation of the place reimagined by Breton as a fantastic vision: 'Last of all, now, the tower of the Manoir d'Ango explodes and a snowfall of feathers from its doves dissolves on contact with the earth of the great courtyard once paved with scraps of tiles and now covered with real blood!'¹⁵ The open disparity between text and image is also striking in the 1928 text, where Breton refers to 'the impossibility of obtaining permission to photograph an adorable wax-work figure in the Musée Grévin . . . it is a woman fastening her garter in the shadows, and is the only statue I know of with eyes; the eyes of provocation.'¹⁶ The photograph (by Pablo Volta) is included in the later edition, revealing only the lower half of the figure and, strangely, not the eyes.

Relations between photographs, text and experience are similarly incongruent in the street scenes. After writing his text Breton revisited the places linked to the events

79 Jacques-André Boiffard, Hotel des Grands Hommes, 1928.

recounted, in search of photographs taken from the spot at which he had been standing. Having asked the photographer Jacques-André Boiffard to shoot the street scenes, Breton deemed the shots 'beautiful' but was forced to acknowledge his disappointment: 'I realized that most of the places more or less resisted my venture, so that, as I see it, the illustrated part of Nadja is quite inadequate.'[17] The photographs strike the viewer as empty of presence and event, like a painting by Giorgio de Chirico, a resemblance implicitly made by

80 Giorgio de Chirico, *The Enigma of a Day*, 1914, oil on canvas.

Breton himself, since an extract of *Nadja* published in *La Révolution surréaliste* (1928) is illustrated with De Chirico's painting *Delights of the Poet* (1913).[18] Photographs and painting are haunted by an atmosphere of loss or expectation, as if the streets and squares had been the stage for an event forever lost, or had anticipated an event to remain forever unknown. Raymond Spiteri notes a similar 'atmosphere of anticipation' in the resemblance between the photograph of the Hôtel des Grands Hommes (illus. 79), where Breton lived, and De Chirico's *The Enigma of a Day* (1914), a painting owned by Breton (illus. 80), in the gestures of the statues, the figures in the background and the stationary vehicles.[19]

Photographs of this type can best be understood if we link them to Breton's preoccupation with 'facts which may belong to the order of pure observation, but which on each occasion present all the appearances of a signal, without our being able to say precisely which signal, and of what.'[20] Arrouye follows this line when he argues that the very banality of the shots of empty streets activates the imagination, thus intensifying their enigmatic qualities. They stage the *unheimlich*, the deeply disturbing experience of encountering the strange in the familiar, the mystery within the commonplace. Moreover, the photographs of street scenes, almost devoid of human presence, openly contradict the actual experience of the street for the Surrealists for whom it was, on the contrary, a space of chance encounters and surreal experiences. In *Nadja* the street is offered as a space of flânerie, the place where the everyday can tip into the imaginary. For Nadja herself the street was 'the only region of valid experience for her . . . accessible to interrogation from any human being launched upon some great chimera'.[21] The experience is replicated in the objects found at the Clignancourt flea market, where Breton went in search of 'objects that can be found nowhere else . . . old-fashioned, broken, useless, almost incomprehensible, even perverse',[22] objects that do not yield their secret, like a strange half-cylinder that turned out to have been a population graph. It is true that here Breton was less interested in uncovering their possible meanings than in recording their effect on Nadja.

Nadja's own drawings too reveal a disparity between text and image. The drawings are framed – perhaps even constrained – by

SURREALISM AND BOOKS: DOORS 'LEFT AJAR'

Breton's commentaries, while the interpretations offered are filtered through his perception of Nadja as a natural Surrealist, 'a free genius ... one of those spirits of the air'.[23] He appropriates her drawings and words, making the hybrid figures and enigmatic juxtapositions fit his personal gallery of Surrealist images. The medical student who might have been expected to recognize in her drawings and texts signs of mental disturbance, a cry for help from a deeply suffering individual, is replaced by the Surrealist who sees only the marvellous: magical drawings and poetic utterances.

The photographic portraits reveal a further disruption between text and image. From the opening lines of the book Breton considers identity as mobile and fluctuating, yet Man Ray's portraits of Éluard and Peret, like the portraits of Breton himself and of the psychiatrist Professor Claude (taken by the professional photographer Henri Manuel), are formal portraits, fixed, revealing nothing.[24] They stand in stark contrast to two photographs by Man Ray of Desnos in a hypnotic state, with eyes closed then open: the still photographs are reproduced as if they were frames from a film strip, endowing

81 Nadja's eyes, photograph, in *Nadja* (1963).

82 Léona Delcourt, *c.* 1926.

THE EYE OF THE POET

83 Léona Delcourt (Nadja), *Who Is She?*, 1926, drawing.

84 Léona Delcourt (Nadja), *La fleur des amants*, 1926, drawing.

them with the illusion of movement.[25] The disparity is underlined by Breton himself in a letter to the actor Blanche Derval, where he comments on photographs of a scene from the play *Les Détraquées* (The Deranged, 1921), contrasting his intense subjective experience with the objectivity of the photographs:

> These photographs of *Les Détraquées* are far from giving me the extraordinary impression which certain episodes in the play left on me, and above all certain expressions which I saw you adopt during its performance. Such as they are, though, they are still infinitely moving, and I thank you for having given me the means of confronting my faithful and passionate memory of several evenings at the Two Masks with this all too fixed and objective a print.[26]

It is arguable that the text-image disparity is at its most manifest in the photographic portrait of Breton himself. Here, the fixity of the formal identity photograph contradicts – in a rare instance of self-irony? – his ongoing quest, voiced from the opening words, for a notion of identity as something fluid, emerging from encounters with people and places. Nadja clearly agreed, considering him in fluctuating terms as eagle, sun or god.

SURREALISM AND BOOKS: DOORS 'LEFT AJAR'

Significantly, there is no formal portrait of Nadja in the book, and Max Ernst is said to have refused to paint her portrait. The 1963 edition includes an anonymous montage of Nadja's 'fern-coloured eyes', superimposed in four horizontal bands suggesting a fan or fern shape, a fragmented, incomplete mysterious presence (illus. 81), based on a photograph of Léona Delcourt (illus. 82). They recall Man Ray's 1922 portrait of the Marquise Casati (eyes doubled) or

85 Léona Delcourt, prints of Nadja's drawings, 1926.

the photograph of Gala's eyes on the cover of Dalí's *La Femme visible* (The Visible Woman) of 1930 and, in this way, can be seen as associating Nadja with other Surrealist women. Rosalind Krauss sees in the technique of photographic 'doubling' a strategy used to denaturalize the Surrealist image: 'The double is the simulacrum, the second, the representative of the original', thus underscoring the fictional status of the photographic subject.[27] And indeed, multiple materializations of Nadja haunt the text, particularly through her words and drawings. 'Who is she?' are the words accompanying the drawing of a wistful female figure encircled by a question mark (illus. 83). In her hallucinations she identifies with mythical or historical figures: the legendary Mélusine, the medium Hélène Smith, a person in Marie Antoinette's circle. Her drawings too offer shifting identities, as a flower (illus. 84), a siren, a butterfly with the body of a Mazda bulb (illus. 85). She refers to herself as 'the heart of a heartless flower'; elsewhere she experiences the self as insubstantial: 'I am the thought on the bath in the room without mirrors.'[28] Breton in turn sees her through metaphor, comparing her to Mélusine or the Sphinx. More than a real person, in short, Nadja appears as the shifting, elusive object of Breton's desire.[29]

Arcane 17: a material book

Arcane 17 was written between August and October 1944, during an excursion by Breton and Elisa to the Gaspé peninsula in the St Lawrence estuary in Quebec. The title refers to the tarot card of the Star, 'emblem of hope and resurrection', referring both to the liberation of Paris in August 1944 and to the presence of Claro, whom Breton had met in December 1943.[30] The text, both poetic and philosophical, is wide-ranging: an account of the couple's travels and descriptions of the maritime landscape of the peninsula are juxtaposed with reflections on historical figures such as Charles Fourier and Flora Tristan; the notion of myth as a form of resistance to the war in Europe and the threat of totalitarianism;[31] the mythological figure of Mélusine, the 'child-woman' seen by Polizzotti as 'part Lolita, part Salome, part Nadja . . . the distillation of the female principle';[32]

SURREALISM AND BOOKS: DOORS 'LEFT AJAR'

the idea (through romantic writers Novalis and Nerval) of the female as a medium of salvation; and reflections on the esoteric, a theme explored in Péret's *La Parole est à Péret* (Péret has the Floor, 1943), in articles in *View* and *vvv*, culminating in the exhibition *Le Surréalisme en 1947*.[33]

Shortly after their travels Breton offered Claro the original handwritten manuscript of *Arcane 17* in a 48-page lined exercise book. It is a unique example in Breton's oeuvre of the material book, both manuscript and object. On the first page, in a calligram handwritten on paper printed with gold stars, folded to suggest the wings of a bird, he dedicates 'this exercise book of our playing truant' ('ce cahier de

86 Breton, *Arcane 17*, original manuscript page, 1944.

87 Breton, *Arcane 17*, original manuscript page, 1944.

grande école buissonnière') to Elisa, whom he compares to Dante Gabriel Rossetti's *Beata Beatrix*, to a star and a bird's wing.[34]

The working manuscript is on the right-hand page in Breton's small compact writing in black ink, with its numerous scorings-out and additions, spilling over in places onto the left-hand page. The documents collaged on the left-hand page include train tickets, travel brochures, maps, a maple leaf, tarot cards, newspaper articles (extracts from the Quebec press such as 'Retour à la sauvagerie', an editorial against the dangers of nationalism and the need to teach 'world history'), found objects (a plastic ruler, a piece of bark) and photographs taken by Claro (gannets, Percé beach, totems). These documents

in turn sometimes invade the text on the right. The effect is one of interpenetration of text and collaged elements, which thus enter into multiple relations with each other. A number of documents function simply as a record of the couple's journey recounted in the text: a collage of different-coloured bus tickets with names of villages in Gaspésie; a list of evocative place-names on Route no. 6 – Rivière aux Renards, Rivière à la Martre, Ruisseau Castor; Elisa's photographs; a tourist office map (illus. 86). Many of the collaged elements, on the other hand, can be linked to esoteric and cabbalistic imagery – such as tarot cards and the Star from the Marseille Tarot – as a

88 Lucienne Thalheimer, binding, *Arcane 17*, 1956.

complement to, rather than an illustration of, the esoteric theme developed in the text.³⁵

In an extensive study of the text, Pascaline Mourier-Casile interprets the collaged elements as 'material generators' of the text, parallel to its 'textual generators' (Nerval, Novalis, Hugo, Jarry and others), considered as 'pre-texts' or 'counter-texts' to the manuscript.³⁶ She gives as an example the sequence on Mélusine, which she interprets as generated by the collage of a maple leaf pasted over the scorecard of a card game, with a hole revealing a heart; below is the Petit Larousse dictionary entry for Mélusine (illus. 87). However, since it is impossible to determine whether the text preceded or followed the collage it might be more fruitful to consider them in dialogue with each other, in an interactive relation between the traces of lived experience and text.

Such exchanges between text and image, while enhancing the impression of work-in-progress, also underline the materiality of the manuscript, something that becomes clearer when in 1956 Breton asked Lucienne Thalheimer to produce a binding for the exercise book: on a rawhide cover she placed a portrait of Elisa by Man Ray under glass, framed by a heart-shaped leaf (illus. 88).³⁷ Bindings like this, whether for single copies or limited editions, highlight the quality of the Surrealist book as a material, aesthetic object, as we see for example in René Char's copy of Breton's *Nadja*, in black morocco binding, onlays of three photographs of Breton by Man Ray (1934) and a large glove made from red box calf.

Miró and Breton, *Constellations*

Our final example of Breton's pleasure in the Surrealist book involves one of the many collaborations between an artist and a poet. In its simplest form such a collaboration involves an artist friend providing a frontispiece, a drawing or a set of engravings for a book of poems or an essay, as in the case of Breton's *Mont de piété* (Pawn Shop, 1919), where two drawings by André Derain function as a simple testimony to a friendship. When the drawings or engravings are by a Surrealist, on the other hand, they are often the sign of a shared aesthetic. Among these are Wifredo Lam's line drawings for Breton's *Fata Morgana*

89 Joan Miró, *Personnages dans la nuit guidés par les traces phosphorescentes des escargots*, 12 February 1940, ink, watercolour and chalk on paper, in *Constellations*.

(see illus. 119) produced in Marseille in the winter of 1940–41; *La Clé des champs* (Free Rein, 1953) with a cover by Miró; or the 1940 edition of *L'Anthologie de l'humour noir* (Anthology of Black Humour) with a frontispiece by Picasso.[38]

Among the finest examples of the artist's book is *Constellations*, combining Breton's prose texts and Miró's gouaches. In contrast to Breton's texts on Miró of 1928 and 1941, which mingle enthusiasm with reservations, in the texts Breton wrote in 1958 to accompany Miró's *Constellations* he voiced his wholehearted admiration for the artist. Miró painted a series of 22 gouaches between January 1940 and September 1941: the first one, titled *Le Lever du soleil* (Sunrise), was painted at Varengeville-sur-mer in Normandy; the last one, *Le Passage*

THE EYE OF THE POET

90 Joan Miró, *Le Chant du rossignol à minuit et la pluie matinale*, 4 September 1940, gouache and oil wash on paper, in *Constellations*.

de l'oiseau divin (Passage of the Divine Bird) in September 1941 in Palma de Mayorca and Mont-roig. It is immediately clear that he has abandoned the violence of his 1930s 'savage period' for a more harmonious style; in a 1948 interview he admitted that his paintings had been a way of dealing with the destruction of the Second World WarI: 'I felt a deep desire to escape. I deliberately closed myself within myself. The night, music and the stars began to play a major role in suggesting my paintings.'[39] Miró prepared the ground in watercolour or oil on a damp paper base that was then rubbed and sanded, producing uneven surfaces on which he painted semi-abstract forms in gouache (spirals, curves and triangles), figurative motifs (female figures, stars, suns and moons, insects, birds, animals) and brightly coloured blocks

of colour, especially where the black contours intersected (illus. 89). Miró maintained that the gouaches developed organically, the initial forms suggesting others, which in turn called for new forms, in an associative process. The artist developed the titles as he worked: at times they originated in a graphic element (*Femmes sur la plage*), elsewhere they were developed into a poetic line, as in *Personnages dans la nuit guidés par les traces phosphorescentes des escargots* (Figures in the Night Guided by the Phosphorescent Tracks of Snails) or a narrative fragment, for example *Le Bel Oiseau déchiffrant l'inconnu au couple d'amoureux* (The Beautiful Bird Deciphering the Unknown to Two Lovers). The series, initially titled simply *Tempera Paintings, 1940–1941*, was sent to New York at the end of the war for an exhibition of Miró's works at the Pierre Matisse Gallery.

In 1958 Pierre Matisse asked Breton to write a text to accompany a luxury edition with reproductions of 22 facsimile compositions in colour. Breton contributed two texts: an introduction, 'Joan Miró: Constellations', and 22 prose poems or *proses parallèles* (the term was coined by Breton).[40] In an appreciative letter to Breton, Miró wrote:

> At a time like this when everything is collapsing in the world, when space has been criss-crossed in all directions, your thought has become prophetic, that is why I am proud to see your text alongside these *Constellations* painted in 1940, when we were far from where we are now.[41]

A luxury edition of 350 copies – the first ten of which included an etching by Miró and a manuscript page by Breton – was published by Féquet and Baudier in Paris, the stencil reproductions were produced in Daniel Jacomet's studio, and the original lithographs printed by Mourlot Frères.[42]

Breton's introduction begins by situating the gouaches in their historical context, the tense atmosphere of France in 1940, just before the German invasion and France's defeat, a period evoked in Julien Gracq's novel *Un balcon en forêt* (A Balcony in the Forest, 1958), which Breton had just read and which is echoed in his text. He considers Miró's series as a means of resistance to the ambient chaos and destruction, a manifestation of the artist's freedom. In two paragraphs

from this introduction that were later omitted, he traces the evolution of Miró's work from the 'great clashing creatures' of his 'savage period' of the mid-1930s during the Spanish Civil War, to the harmony and equilibrium of the *Constellations*. The 'figurative grid' suggested in the titles is combined with the 'emblematic grid' composed of the circle, spiral, star, inverted triangle and blocks of colour. For Breton, the originality of the compositions resides in the interplay between concrete and abstract elements, and in the relation between form and colour. Beyond technical considerations, Breton confesses he is enthralled by 'the dissolution of space', setting in motion multiple poetic associations that extend beyond the paintings themselves (illus. 90).

Breton's prose poems were composed in Paris between October and December 1958. Short poetic fragments recalling Rimbaud's *Illuminations*, they are neither a description nor a gloss of Miró's gouaches. Rather than responding to the iconographical elements of the compositions, Breton has created a poetic text capturing their spirit, in an associative process parallel to that of the artist, yet following its own autonomous trajectory.[43] Miró's gouaches, 'these superb plates, designed to act as *floodgates* [*faire vannes*] from which love and freedom leap out in a single bound', liberate a flow of poetic associations.[44] The texts take as a point of departure Miró's open signs, his forms (spirals, curves, circles), movements (the topoi of gestation and birth, metamorphosis and eroticism) or motifs (women, animals, suns and stars). Sometimes the poem is developed from the title of a painting: *Femme à la blonde aisselle coiffant sa chevelure à la lueur des étoiles* (Woman with a Blonde Armpit Combing Her Hair by the Light of the Stars), for instance, acts as a generative matrix of the text, linking female figure and natural world. The woman's armpit generates a cavity of shallow water and a nest, while her hair suggests a rust-coloured torrent. The verbs of movement evoke an erotic space, at once intimate and cosmic, from the secret cavities of the woman's body to exploding stars, where the woman, evoked in terms of a 'gentle slope', awakens the man's pleasure ('the lover glides gently towards ecstasy').

The erotic theme is interwoven with a fairytale theme in *Personnage blessé* (Wounded Figure), a veiled narrative of desire and initiation, where one encounters the familiar elements of the fairytale

(the impenetrable wood, the female figure as both threatening old woman and desired object, a silver dagger, the Palace of Mirages). Childhood memories are interwoven with erotic images to create a sexual allegory: a space of sexual interdiction ('a small padlocked wood'), excitement ('obsessively caresses this silver ball') and fulfilment ('in gentle freefall'). Elsewhere, the artist's hybrid forms are echoed in the poet's images ('the plough with a lark's head'). Miró's playful graphic signs – Georges Raillard refers to them as '*ludèmes*'[45] – recall fairytale characters (Pierre-le-Hérissé, the fairy king Oberon, Guignol and Gnafron). In addition, Breton deciphers the *Constellations* in terms of Fourier's concept of 'universal harmony', which links human and cosmic forces through the principle of analogy.[46] Just as graphic forms are intermingled and superimposed in Miró's paintings, likewise the texts are composed of a palimpsest of intertextual references: not only to fairytale characters as mentioned above, but to legends (Huon of Bordeaux, the castle of Fougères associated with Mélusine), poets (Louise Labé, Baudelaire, Rimbaud, Forneret, Nerval), philosophers (Nietzsche, Fourier) and novelists (Julien Gracq). Breton creates poetic configurations parallel to the constellations of signs in Miró's compositions, developing the poet's – and the artist's – privileged themes: love, childhood, freedom, dreams.

Texts and images are juxtaposed on facing pages, and the eye travels back and forth between them without giving priority to one over the other. In such encounters, text and image are separate and autonomous, yet interlinked. As Éluard comments: 'In their collaborations, painters and poets declare themselves free. Dependency is degrading, preventing understanding and love. There can be no model for him who looks for what he has never yet seen. Finally, nothing is as beautiful as a chance resemblance.'[47] The 'chance resemblance' Éluard refers to is less the aleatory encounter privileged by Dada than the 'objective chance' so often stressed by Breton. This is chance in a productive or creative sense, as the encounter between inner desire and outer reality. Such encounters, one should add, were considered by the Surrealists themselves in terms of 'illumination' (Miró and Éluard) or 'revelations' (Ernst). Éluard also refers to the absence of closure of the book when he claims: 'Certain books are like doors,' giving onto imaginary worlds beyond the book. Breton used a similar

image when he confessed in *Nadja* that his sole interest lay in books 'left ajar, like doors; I will not go looking for keys'.[48]

The reader too, we should not forget, is an active agent, colluding with both artist and poet, free to move between text and image, encouraged to imagine, to dream. There is no doubt that the artist's book in general, and the Surrealist book in particular, have contributed to radical changes in our reading habits. First as an invitation to approach the book as a signifying object, where image and text engage with each other in a complex dialogue, sometimes enigmatic or contradictory as in *Nadja*. Then as an invitation to treat the book as a material object, to relate to the sculptural quality of the page or the work, engaged as both a visual and a tactile object, as illustrated in *Arcane 17*'s material collages. And above all, perhaps, finally, as an enticement to go beyond the page, as in Breton's poems for *Constellations* and, indeed, through the reader's active complicity, beyond the book itself. As the poet Benjamin Péret suggested when writing about Georges Hugnet's Surrealist object-books: 'Nothing can prevent the book from spreading out its tail feathers like a peacock and sweeping along in its wake the thousand gulls of desire approaching its chosen island.'[49]

seven
Wooden Masks and Sugar Skulls: Collecting

BRETON BOUGHT HIS FIRST OBJECT, an Easter Island fertility statue, in Lorient at the age of sixteen. Among his last acquisitions were pebbles from the river Lot. Over the course of a lifetime he collected an extraordinary range of very diverse objects: from oil paintings, drawings and photographs, to statues, stones and seashells; Cubist, Dada and Surrealist works; Oceanic, Mexican and Inuit masks and sculptures; works by nineteenth-century artists (Gustave Moreau, Victor Hugo); outsider art (Henri Rousseau, Aloïse Corbaz); anonymous works bought at the flea market; tarot cards, butterfly cases, an advert for Martini drinks, a wooden hand, bottles, driftwood and so on (illus. 91).

The Cubists Picasso, Braque, Derain and the Dadaist Tristan Tzara collected African masks and sculptures, while Guillaume Apollinaire owned African and Oceanian 'fetishes', works which attracted the attention of the young Breton on his visits to the poet's apartment at 202 Boulevard St Germain. He evokes its crowded space as a voyage of discovery: 'You edged your way in between bookshelves, rows of African and Oceanian fetishes, paintings of the most revolutionary kind for the times, like so many sails heading for the mind's most adventurous horizons: Picasso, Chirico, Larionov.'[1] Apollinaire was also a collector of kitsch objects (a bronze inkwell in the shape of the Sacré Coeur, for example), and his collection was a model for Breton's. Éluard's collection on the other hand merited only a disparaging comment in a letter from Breton to his first wife, Simone Kahn: 'paintings and other precious things lined up like kitchen utensils from cellar to attic . . . Not the slightest character, nothing which

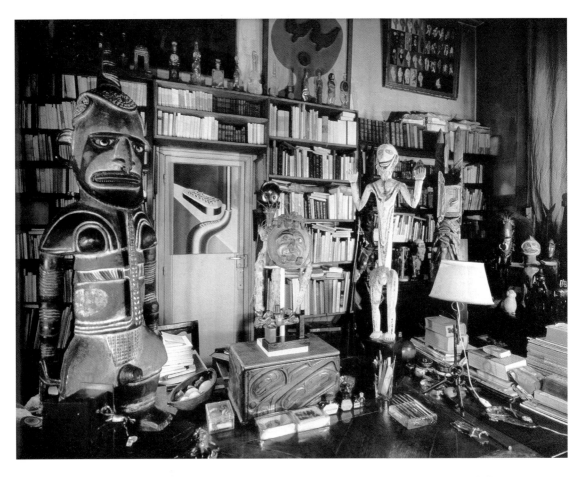

91 André Breton's studio, 1996.

shows a personal choice'.[2] An approach far removed from Breton's for whom, on the contrary, 'nothing that surrounds us is an object, everything is a subject.'[3]

Between 1921 and 1926 Breton was literary and artistic adviser to the fashion designer and collector Jacques Doucet, cataloguing his collection of books and advising him on purchases of artworks. Doucet's archive includes long letters from Breton, who informed the collector of recent trends in literature and art, promoting works by Picasso, De Chirico, Max Ernst and others, and recommended the purchase of paintings such as Henri Matisse's *Les Poissons rouges* (Goldfish) of 1912, André Derain's *Chevalier X* and Henri Rousseau's *La Charmeuse de serpents* (The Snake Charmer).[4] In 1923 Breton urged Doucet to buy Picasso's *Les Demoiselles d'Avignon*, describing the work in superlative terms: 'here, one looks directly into Picasso's laboratory

... the theatre of everything that has been happening for the past fifty years.'[5] Doucet did subsequently buy the painting in 1925. There were times when Breton was asked to negotiate a price with the artist, the most caricatural example being the purchase of *L'Intérieur de la vue* (1922), a painting by Max Ernst depicting five flower vases: Breton was sent to persuade the artist to paint a version with two vases, at a correspondingly lower price, 200 francs instead of 500. In response to Breton's recommendation that Doucet acquire a major work by André Masson, he bought instead 'the smallest canvas he could find' by the artist, a tiny landscape.[6]

Collecting

Above all, like Éluard, Tzara or Ernst, Breton was a passionate collector who purchased, traded and was gifted art objects throughout his life, building an ever-expanding and ever-changing collection (illus. 92).[7] He bought objects in the Paris flea markets and in auction houses, from art dealers and fellow Surrealists and during his travels. Among his early purchases were paintings by Picasso, Braque, Derain and Léger bought in 1921–2 at the sale of the sequestered collection of art dealers Daniel-Henry Kahnweiler and Wilhelm Uhde, some of which he later sold in New York through the Mexican artist and gallery owner Marius de Zayas. He also acquired works by Picabia at Duchamp's sale of the artist's paintings in 1926.

Although Breton was very attached to the objects of his collection and kept some of the works for many years, only reluctantly letting go of them, the collection reflects the evolution of his artistic interests. In the 1920s he acquired not only Cubist works but many paintings from fellow Surrealists Miró, Masson or Tanguy, as well as African masks and sculptures, many of which were auctioned in 1931, along with Éluard's collection, following the 1929 stock market crash. In the 1930s, with the Surrealists' creation and theorization of objects, he acquired several Surrealist objects, including Giacometti's *Boule suspendue* (Suspended Ball) of 1930–31 and Miró's *Objet du couchant* (Object of Sunset) of 1935–6. During his years in New York (1941–6) he bought Native American objects, from Alaska, Arizona and Mexico

THE EYE OF THE POET

92 Breton in his studio, 1962.

93 Kachina Hopi doll, Arizona, 1910–40, painted wood, string feathers.

in particular (illus. 93). In the post-war years, thanks to his collaboration with Dubuffet on the Art Brut project, his collection was enriched with paintings by Aloïse Corbaz, Fleury-Joseph Crépin and other outsider artists. In the 1950s, as director of the Galerie A l'Étoile scellée, he added works by lyrical abstract artists such as Duvillier and Loubchansky. In this way, the collection constantly evolved, revealing Breton's changing enthusiasms while responding at times to purely circumstantial or personal events. In 1926, for example, he sold a painting by Miró in order to help Nadja financially, writing in a letter to Simone Kahn on 8 November 1926: 'I would like to use the proceeds of the sale of a small painting to avoid a disaster . . . The empty space left on the wall will be a thousand times more precious than the painting itself.'[8] The motives could be negative, too: when he finally broke with Aragon in 1932, for instance, he sold all of his copies of Aragon's books; and in 1964, albeit reluctantly, he sold De Chirico's

150

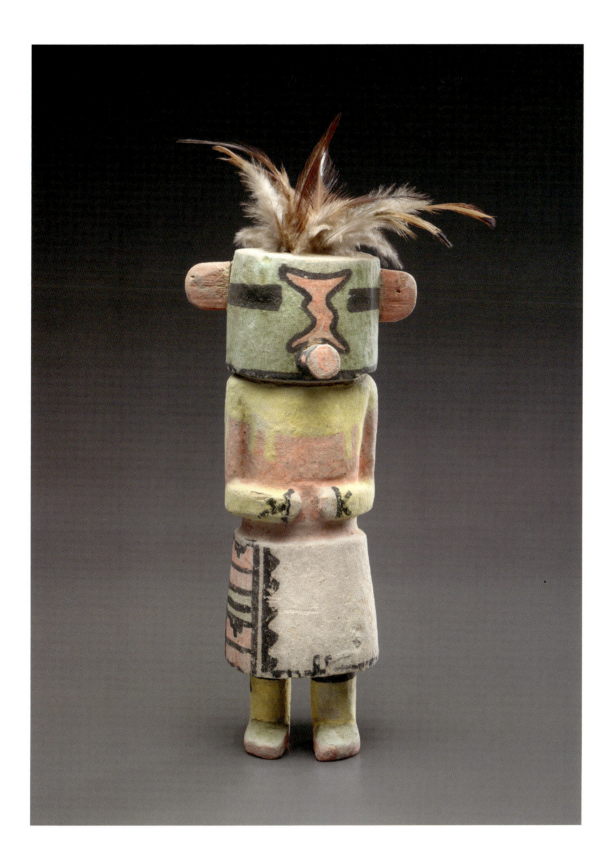

THE EYE OF THE POET

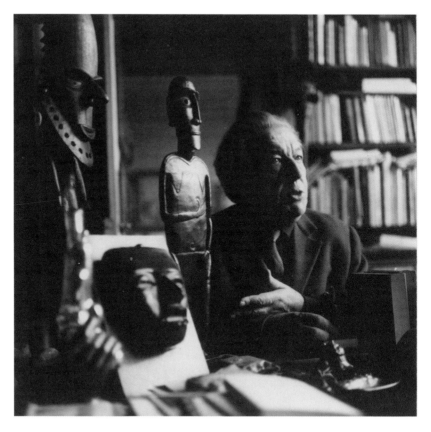

94 André Breton in his studio with Teotihuacan mask, 1962.

The Child's Brain, which he had owned since 1919, to the Moderna Museum in Stockholm, partly for financial reasons, but also out of anger with De Chirico, who had strongly criticized the Surrealists in *Le Figaro littéraire*.

 Critics have at times argued that the collection was actually governed by an overarching principle, whether psychic automatism, objective chance or, as Katharine Conley argues, a global aesthetic based on the model of the Baroque collection.[9] After visiting the studio in 1970 the American writer James Lord commented on the 'profusion of heteroclite objects [which] uncannily make a whole'.[10] For others, on the contrary, the space was in a state of chaos, lacking any underlying principle capable of turning the accumulation into a coherent unity. For most viewers the choice of objects does initially appear quite eclectic, and Breton himself rejected the idea of a hierarchy of the arts, making no aesthetic distinction between a Surrealist sculpture and a pebble found on the bed of the Lot, a

152

WOODEN MASKS AND SUGAR SKULLS: COLLECTING

collage by Ernst and the drawing of a naive artist, an Oceanic mask and Celtic coins. If a unifying principle exists, it would seem to lie in Breton's preference for the various forms of 'outsider art': examples of artistic expression allegedly freed from the restrictions of conventional artistic codes, whether the spontaneous works of self-taught artists; the art of the Pacific Northwest or Oceania (bypassing the strict social and aesthetic principles that governed their creation); or everyday objects not conventionally considered as art at all, waffle makers, wooden spoons and so on. The impetus came above all from objects that exerted a strong sensuous or emotional pull on the collector. The elective object, divested of its original context, acquires a subjective aura, a hallucinatory, fetishistic or disorientating character. Clearly, for Breton, objects have an active role, they possessed the power to speak to each other and to the poet, as he argues in 'Langue des

95 Teotihuacan mask, 3rd–7th century, stone.

pierres' (Language of Stones), for example, where he contends that 'stones . . . continue to speak to those willing to hear them.'[11] This was something he shared with Nadja, who was also alert to the words that she could hear emanating from the objects in Breton's studio. For example, an Easter Island sculpture appeared to say to her: 'I love you, I love you.'[12] The fascination exerted by the aesthetic object was thus grounded on a subjective relation, giving rise to an 'irresistible need to possess', a need sometimes expressed in terms of a tactile experience: 'I often need to come back to them, to watch them as I am waking up, to take them in my hands, talk to them, escort them back to their place of origin so as to reconcile myself to where I am.'[13] Such language reveals a highly personal, indeed quasi-erotic, relation to objects; we can perhaps glimpse it in a photograph where Breton is almost tenderly holding a Teotihuacan mask on his desk (illus. 94 and illus. 95). As Jean Baudrillard remarks about the relation between the collector and his collection: 'There is something of the harem about collecting, for the whole attraction may be summed up as that of an intimate series . . . combined with a serial intimacy.'[14]

A collage space

Between 1922 and 1966 Breton lived at 42 rue Fontaine in a two-room rented apartment (illus. 96), above the Cabaret du Ciel et de l'Enfer (Caberet of Heaven and Hell) and near the nightclubs and brothels of the Pigalle district in Montmartre. This was where many of the activities of the Surrealist group took place (the café was their other meeting-place), where they edited their journals, welcomed newcomers and ostracized others, argued over Surrealist principles and indulged in Surrealist games. In this space Breton wrote his poems and essays in the midst of his collection, an accumulation of books, paintings, sculptures and masks, on walls, shelves and table-tops, on the floor, in boxed compartments or glass cases containing miniature collections of beetles, butterflies and moths (illus. 97). It was an ever-evolving space and, like Apollinaire's apartment, it gave the impression of both proliferation and containment. There is then, perhaps, something absurd about the endeavour to categorize objects that

96 Sabine Weiss, *André Breton in His Studio, 42 rue Fontaine*, 1955, gelatin silver print.

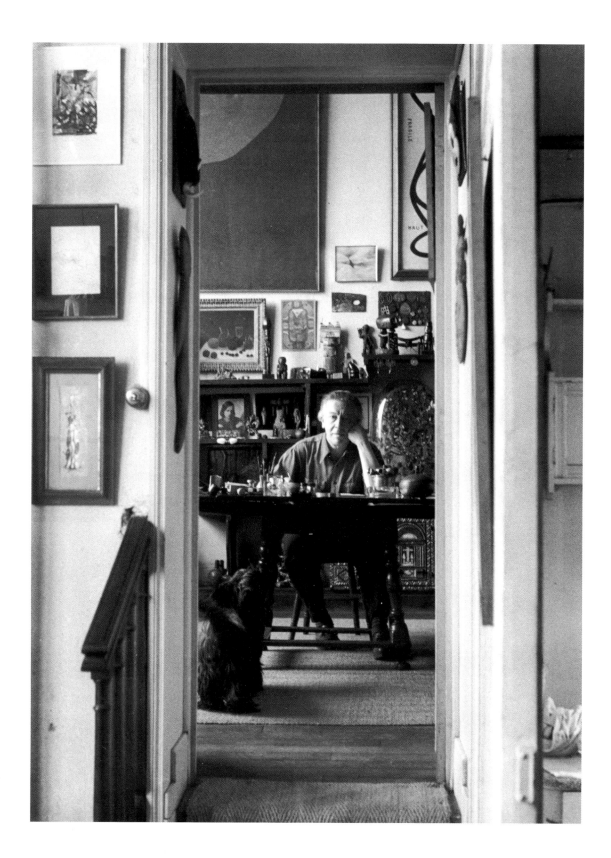

Breton himself randomized, thus subverting traditional classificatory systems with a cavalier disregard for historical and generic categories, bringing together stone and painting, Oceanic mask and Surrealist drawing. The collection – a 'Museum of the Marvellous'[15] – is reminiscent of the accumulated curios of the Baroque *Wunderkammer* or cabinet of curiosities (illus. 98), in Breton's own display of examples of *naturalia* (such as a box of mummified cicadas), *artificialia* (an engraved bone fish), *scientifica* (a case of insects), *exotica* (a glass globe of stuffed exotic birds) and *mirabilia* (transformation masks, half-human half-animal).

Among Breton's earliest acquisitions were two *objets d'aliénés* (objects created by the insane): like miniature cabinets of curiosity, they consist of rectangular wooden panels divided into glassed-in compartments displaying various objects and fragments (illus. 99). *Objet d'aliéné, la petite soupière* contains a miniature soup-tureen, textile fragments, two popular prints (a cock, a table) and three framed handwritten texts. The second box also contains various carefully arranged objects, including broken scissors, the fragment of a mirror, buttons, tool handles, hairpins, string, feathers, a watch cog and other items.[16] Like these apparently disparate objects boxed and displayed, Breton's collection both imitates and mocks traditional classificatory systems, the taxonomic principles of the museum. The beetles, butterflies and

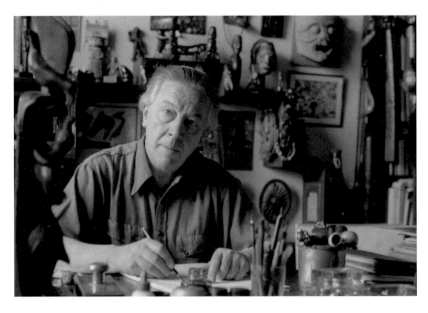

97 Sabine Weiss, *André Breton in His Studio, 42 rue Fontaine*, 1955, gelatin silver print.

98 Ferrante Imperato, *Ritratto del Museo di Ferrante Imperato (Wunderkammer)*, engraving from *Dell'historia naturale* (1599).

fish-hooks, carefully boxed and labelled, the Hopi Kachina dolls neatly aligned on the wall, might well suggest order and containment, as in the museum's systematic organization of data based on scientific principles. Here, however, such rational organization is subverted; the arrangement of objects subverts taxonomic and aesthetic norms, through a process of reclassification – driven by poetic principles – via juxtaposition with other objects. This is at work, for example, in the row of Kachina dolls on display just above paintings by Charles Filiger (illus. 100); a painting by Tanguy next to a mask from the Pacific Northwest (illus. 101); or an ancestor figure from Papua New Guinea alongside Picasso's canvas *Tête* (1939). Breton's *Wunderkammer* captures the eclecticism of the Baroque collection but, more wholeheartedly than the seventeenth-century collector, he favoured mystery over rationality, the Surrealist marvellous over Enlightenment science. We can apply to the dynamic, ever-changing and challenging space

of Breton's collection James Clifford's apt description of the journal *Documents* as 'a playful museum which simultaneously collects and reclassifies its specimens.'¹⁷

The studio – where primitive masks were placed next to Surrealist paintings, found objects and personal mementoes – was therefore less a depository of fixed, selected objects (inescapable in the term 'collection') than an active collage space of encounters. This shift is recorded for instance when looking at photographs taken at various dates: once reinserted into a chronology, they testify to the way Breton had moved objects around on the walls and surfaces of the studio, generating surprise encounters and unexpected transformations.¹⁸ Didier Ottinger catches the dynamics of the studio when he sees it as an ever-changing space where rational links ('therefore') were replaced by the principle of analogy ('like'), based on distance and disparity rather than similarity; a 'magnetic field' electrifying space

99 Anonymous, *Objet d'aliéné*, before 1910, wooden box, glass, various objects.

100 André Breton's studio, 1996.

THE EYE OF THE POET

101 Breton in his studio, 1951.

and producing irrational links.¹⁹ Thus an Inuit fish made from an engraved bone, placed below Giacometti's *Suspended Ball*, transforms its oblong shape into a fish. Another example is found in a letter to Roger Amadou in which Breton alludes to the shifting of objects when evoking the transformative power of encounters in relation to De Chirico's painting *Le Cerveau de l'enfant* (The Child's Brain, 1917; illus. 102):

> The painting having been placed between two British Columbian 'transformation masks' (reproduced in *Neuf*, no 1, June 1950), where the eyes can be opened and closed thanks to a system of strings, I find it difficult to tell whether the need to add eyes to that face (bloodless and soulless?) was overdetermined by the proximity of the masks or if, on the contrary it was an unconscious need that provoked me to hang them on both sides of the painting.[20]

In such juxtapositions, objects, freed from fixed meanings and liberating new energies, responding to the pull of other pieces, invade and transform each other. In this example, the male figure in De Chirico's painting, with its closed eyes, interacted with the opening and closing eyes of the British Columbian transformation mask, giving rise to Breton's collage *Réveil du 'Cerveau de l'enfant'* (Awakening of the 'Child's Brain') of 1950,[21] where open eyes are pasted on to a cheap print of De Chirico's painting (illus. 103).

How did visitors react to Breton's collection? For Surrealist and family friend Jean-Jacques Lebel: 'Rue Fontaine was an immense text which he had take 40 years to write: he lived inside his creation which has now been dismantled and it distresses me.'[22] For Jacques Derrida, too, the studio was a highly subjective space:

> This was more than just a writer's home. It was a space made up of creation and desire, the witness of a new form of thought being generated, experimentation which Breton himself called *art magique*. When you went into the flat, you discovered both the secret of a life and a movement of thought.[23]

For other critics, too, the collector's subjectivity takes pride of place when evoking the space, and is well summarized in Dagmar Motycka Weston's words: 'the tangible expression of a psychic landscape'.[24] Not all visitors responded enthusiastically to the ambience of Breton's studio, however. For Julien Gracq, for instance, it evoked a dark provincial museum or the disorderly storeroom of an ethnographic museum, exuding 'the atmosphere of an unchanging rainy day where the light

THE EYE OF THE POET

has been dulled by the ancient primitive objects crammed together'. The collection struck him as fixed, immobilized, with Breton 'scarcely alive himself, scarcely moving, as if hewn from knotted wood, with his large eyes, heavy and dull like those of an exhausted lion . . . an ancient almost ageless figure . . . [Everything] spoke of immobility, accumulation, the fine dust of habit.'[25] Stéphane Massonet shares that impression of fixedness: the photographs taken by Gilles Ehrmann in 1968, two years after Breton's death, seem to him sinister, almost necrophiliac in the absence of the poet, 'images from beyond the grave after the ghosts have left the place.'[26]

102 Giorgio de Chirico, *Le Cerveau de l'enfant*, 1914, oil on canvas.

On the contrary, during Breton's lifetime the studio space presented permanent movement and exchange: simple local classifications (boxed butterflies, rows of Hopi dolls) are simultaneously themselves and something other when they enter the orbit of neighbouring objects and thus are de-classified (a painting next to a trinket) and re-classified. The installation is without doubt Breton's greatest artistic work in its originality and dynamism, displaying the inadequacy of traditional systems and reconfiguring the world history of art. We are faced here with the tentative outline of a global aesthetic, fragmented, deliberately inchoate, an embodiment of Breton's concept of Surrealism as the 'future resolution of opposites'.

103 Breton, *Réveil du 'Cerveau de l'enfant'*, Almanach surréaliste du demi-siècle, La Nef, 63–4 (1950).

Selling

After Breton's death in 1966 his wife Elisa and daughter Aube, with the collaboration of the ACTUAL association, composed of former Surrealists presided by Jean Schuster, wanted to set up around his collection a 'Centre de documentation sur le surréalisme', or, in José Pierre's less constrained words, a 'Palais Idéal du Surréalisme'.[27] Hampered by a lack of funding and the indifference of French cultural institutions, the project had to be abandoned. And yet the state had initially expressed interest in preserving the collection. In 1989, Jack Lang, then Minister of Culture, visited the studio and, maintaining that 'this must all remain as part of our heritage', promised state support to conserve the collection. Shortly afterwards, however, President François Mitterrand also visited the studio and, on leaving, is said to have muttered: 'Quel bric-à-brac!' Presidential disdain soon translated into loss of interest in government circles. Meanwhile, several private investors expressed interest in buying the collection. Among them, the collector Daniel Filipacchi wanted to set up a foundation, but the idea was once again abandoned through lack of funds. The billionaire businessman François Pinault offered to buy the entire

collection for a museum he planned to build on Île Seguin on the Seine, the site of the former Renault factory. However, on the advice of gallery owner Marcel Fleiss, Aube rejected the offer, fearing the collection might actually be dispersed, a concern perhaps explained by the fact that Pinault is owner of the prestigious auction house Christies. The heirs were also approached by the Harry Ransom Center at the University of Austin, Texas, but were reluctant to see the collection leave Paris.

After the death in 2000 of Elisa, who had preserved the studio as it was at Breton's death, Aube and her daughter Oona decided on a public sale, organized by the auctioneers Calmels Cohen, under the supervision of former Surrealist Jean-Michel Goutier and supported by a team of experts that included gallery owner Marcel Fleiss (paintings and drawings), Daniel Fleiss (photographs) and Claude Oterelo (books). Faced with the disparate assortment of items in this rather unusual cabinet of curiosities, the valuer Henri-Claude Randier was, unsurprisingly, perplexed: 'Why not ask the price of the marvellous?' The entire collection – from paintings, photographs and manuscripts, to fossilized sea urchin, crystal ball and pebble – was sold between 7 and 17 April 2003 at the Hotel Drouot auction house (where Éluard and Breton had sold their collections of African and Oceanic art in 1931). It included 3,500 books, 800 manuscripts, 1,500 photographs, and 400 paintings and drawings. Calmels Cohen produced an impressive eight-volume catalogue, with an introduction by Goutier, as well as digital reproductions and detailed information of 28,000 documents, which then became the basis for the Breton database, www.atelierbreton.fr, an ever-expanding virtual museum and source of documentation curated by Constance Krebs.

Just before the sale an online petition of 3,400 people opposed to the dismantling of the collection called for the creation of a museum or foundation. Breton's apartment, it argued, was 'a work of art in itself, precious for its surprising juxtapositions, its studied disorder, its unique spirit'. It is, inevitably, somewhat ironic that they should call for a state-sponsored museum to harbour an individual who was well known to hate museums, which at best, he conceded, were to be visited at top speed: 'I confess that I have rushed through the slippery rooms of museums like a madman!'[28] Closer to the spirit

of Breton himself, the Chicago Surrealist Group signed a counter-petition opposed to the idea of a museum, ironically titled 'Who will embalm the embalmers?' Their argument was simple: 'CAN YOU IMAGINE any Surrealist, anywhere, asking the State to finance any sort of museum?'[29] A series of polemical articles and declarations in the French media also protested against the museification and commodification of the collection, deeming it an insult to the memory of Breton and an assault on Surrealism's collective memory. When the auction finally took place, people hostile to the dispersal of Breton's collection gathered outside the Hôtel Drouot in an attempt to prevent buyers and collectors from entering the auction house, and handed out fake ten-euro notes printed with Breton's head and the words: 'Your money stinks of the corpse of the poet you never dared to become.' In the sales room one individual tried to interrupt the proceedings by reciting Breton and Trotsky's *Manifesto*.[30] Such protests – which Breton, with his taste for polemics, would surely have relished – are evidence of the continuing vitality of the Surrealist movement among both its older members and younger artists and writers.

The sale of more than 4,000 lots brought in a total of 46 million euros. Various French national museums and libraries acquired objects by pre-emption, several of which were generously donated by the heirs. The Lille Métropole Musée d'art moderne acquired works which complemented its collection of art brut, including Pascal-Désir Maisonneuve's *La Reine Victoria* (c. 1924), an assemblage of shells, paint, plaster and nails on wood (illus. 104); *Le Tableau merveilleux no 11* (1946) by Fleury-Joseph Crépin (see illus. 128); two *objets d'aliénés*; a file on 'L'art brut', which includes a typescript of Breton's essay on 'Joseph Crépin' (1948); and letters from Dubuffet. In Paris the Bibliothèque littéraire Jacques Doucet acquired a large number of Breton's manuscripts, his books, correspondence, drawings and frottages; the drawing *La Fleur des amants* by Nadja; a New Ireland Uli statue (see illus.113), which Breton had placed on his desk, as well as the desk itself.[31] In 2003 Aube and Oona went to British Columbia to return a key mask to the Kwakwaka'wakws, used for their traditional dances during the potlatch ceremonies.[32]

Two-thirds of the items were sold to private collectors, mainly from outside of France; and while the sale clearly dispersed the

104 Pascal-Désir Maisonneuve, *La Reine Victoria*, before 1925, seashell, paint, plaster and nail on wood.

collection, it also ensured the continuing life of its individual objects. As Jean-Michel Goutier put it in his introduction to the sales catalogue: 'the pieces of the puzzle have been put in the hands of new players.'[33] A wall of Breton's studio, however, was donated in its entirety to a national museum . . .

The wall

In 2000 Aube Breton Elléouët bequeathed the wall behind Breton's desk to the Musée National d'Art Moderne in lieu of death duties (illus. 105). It was carefully dismantled, transported and reassembled behind a glass partition. It displays about 260 objects (minus the books), each one meticulously identified, ranging from Cubist and Surrealist paintings and sculptures to Pacific, Hopi and Inuit objects; from abstract paintings by Degottex and Kandinsky to works by Victor Hugo and Henri Rousseau; from Surrealist objects, including

105 Reconstruction of Breton's studio wall, 2003.

Le Petit Mimétique (1936) by Breton and Lamba, to popular art objects, stones, stuffed birds and so on.

The curator Didier Ottinger maintains that the wall presents a self-portrait of the Surrealist movement, with its three large central paintings as a summary of the history of Surrealism: Picabia's *Le Double Monde* (1919) on the left representing its Dadaist phase; Miró's *Head* (1927) its high point; and the post-1945 lyrical abstraction of Degottex's *Pollen Noir* (1955) to the right, as the renewal of Surrealist automatism.[34] Ottinger also sees the wall as 'a construction-manifesto': bypassing the traditional museum structure with its narratives of filiation, the works create among themselves a 'magnetic field'. While this was true in Breton's lifetime, as we saw above, when the objects were constantly moved around, creating new encounters and confrontations, in a museum they have, inevitably, been removed from a living dynamic space and suspended: frozen like the butterflies in their boxes, behind a glass screen; mute, like the masks with the dust of unknown rituals; amnesiac, with the lost memory of both provenance and potential; isolated and immaterial, no longer to be contemplated, held or caressed by Breton. Now haunted by the absence of the collector who assembled them, they have been dispossessed, no longer able to touch and be touched. The space, a museum turned mausoleum, has been transformed into a distant shrine, its once auratic objects now filling a reliquary whose stories have been interrupted.[35]

eight

From Easter Island to Alaska: Art and Ethnography

IN THE CATALOGUE TO THE EXHIBITION *Tableaux de Man Ray et objets des îles* (Paintings by Man Ray and Oceanic Objects), held at the Galerie Surréaliste in 1926, the caption below an illustration of a wooden Easter Island sculpture reads 'Easter Island, the Athens of Oceania', conveying a shift from Western to non-Western aesthetics. The shift is also materialized geographically in *Le Monde au temps des surréalistes* (The World at the Time of the Surrealists) of 1929 (illus. 106), an incongruous imaginary map in which the Pacific Ocean occupies the centre of the world; New Guinea, Easter Island, China, Alaska and Mexico have been magnified; Africa has shrunk; Western Europe is reduced to a tiny outpost of the vast Russian landmass, and the United States has simply disappeared.[1] This Surrealist *mappa mundi*, reshaped by a mix of history, myth and imagination, undoes established eurocentric views, subverts the notion of centre and periphery, and defies the supposed fixity and inviolability of frontiers, an explosive issue in an interwar Europe ferociously reshaping national and colonial borders. Beyond the attack, furthermore, it foregrounds privileged sites of the Surrealist imagination: countries of the revolution, whence the generous proportions given Russia or Mexico; and places that had developed an aesthetic that was alien to European norms (Alaska, South Pacific islands), whence the overthrow in the exhibition catalogue of a Greek statue as aesthetic model in favour of an Easter Island object. This imaginary map resonates with artists such as Paul Gauguin, who rejected European culture in favour of Polynesian sculpture and legends; with contemporary debates on the Spenglerian notion of the decadence of Europe; and with the idealization among the

106 Le Monde au temps des surréalistes, 1929, in Variétés – Le surréalisme en 1929.

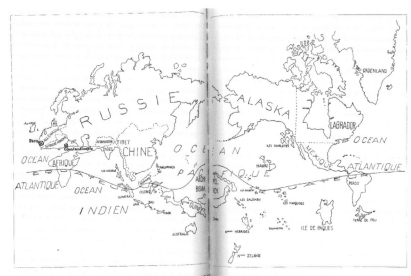

LE MONDE AU TEMPS DES SURREALISTES

avant-garde of extra-European countries, allegedly uncontaminated by Western culture.

The Surrealists actively participated in the 'Orient–Occident' debate that polarized French intellectual life in the 1920s and '30s. Rejecting supposedly French values like positivism, nationalism, the supremacy of reason and the belief in progress, they turned to non-European cultures. These embodied the forces of revolution and the irrational, in an eclectic notion of the Orient – openly acknowledged by Breton himself to be a 'pseudo-Orient' – encompassing cultures as diverse as India, Egypt, Russia and Germany. Aragon, for instance, loudly proclaimed his allegiance to the 'enemy', even calling on the peoples of the Orient to rise up against a moribund West, decried as 'condemned to death'.[2] Popular culture was gripped by a fashionable craze for *l'art nègre*, embodied in the dancer Josephine Baker (known as the 'Black Venus'), jazz music, colonial exhibitions and articles in publications such as *L'Illustration*. In 1922 Breton and Simone Kahn, with Picabia and Germaine Everling, visited the *Exposition Nationale Coloniale* in Marseille on their way to Barcelona (illus. 107). Objects brought back from colonial missions were displayed in the Trocadéro ethnographic museum (founded in 1878), introducing Parisians to the cultural artefacts of non-European cultures (illus. 108).

The Cubists Picasso, Braque and Derain were fascinated by African art, and collected masks and sculptures, integrating their formal qualities into their works. Tzara, Éluard and Breton had also assembled an important collection of African objects. By the late 1920s, African art as the site of fascination for the other had in fact become commodified (whence the diminutive Africa on the Surrealist map), and avant-garde artists turned to indigenous Pacific and American cultures as models of a new aesthetic. In 1928 the Trocadéro held the exhibition *Les Arts anciens de L'Amérique,* and in 1931 gallery owner Charles Ratton, a specialist in non-European art, curated an exhibition of Northwest Coast and Inuit art.

By 1930 Breton had already acquired a significant collection of objects from Africa, the Americas and Oceania. He bought from dealers in France and England (including pieces from W. O. Oldham in Clapham), flea markets and auction rooms. They were reproduced

107 *Exposition nationale coloniale*, 1922, exhibition poster, Marseille.

108 *Exposition ethnographique des colonies françaises*, 1931, exhibition poster, Paris.

THE EYE OF THE POET

in *La Révolution surréaliste* and put on display in exhibitions alongside Surrealist works. The sale of Breton and Éluard's collections in 1931, held at the auction house Hôtel Drouot, was one of the most important tribal art auctions held in Paris in the interwar years, following the Wall Street Crash and coinciding with the 1931 Paris Colonial Exposition; the timing allowed the vendors to profit from the fashion for the exotic. The sales catalogue of the collection, *Sculptures d'Afrique, d'Amérique d'Océanie*, gives an idea of the wide range of objects on offer: North American Native art, Pacific objects, African masks and statues (illus. 109). In the 1930s Éluard and Breton worked closely

109 *Sculptures d'Afrique, d'Amérique, d'Océanie*, 1931.

with Charles Ratton, promoting his gallery in their journals and lending their works for his exhibitions. While Éluard could be relied upon as a buyer and was sent to Belgium or the Netherlands to purchase ethnographic objects, Ratton was unwilling to employ Breton, telling art historian Elizabeth Cowling that 'Breton would have wanted to keep all the best things for himself.' On the other hand, when Ratton turned to Breton for the catalogue preface for an exhibition he was planning on African art, Breton was unable to complete it, claiming 'he had no feeling for African art at all'.[3]

According to anthropologist Claude Lévi-Strauss, in an interview with Mark Polizzotti, Breton was instinctively attracted to certain objects:

> Breton had an instinct about objects he loved, and he sometimes made me appreciate things I otherwise wouldn't have seen or appreciated. We once came upon an object that had obviously been made to be sold to whites; to my mind, it had no cultural function, and therefore was not interesting. But Breton stopped short in amazement, and after a while I, too, understood that it was nontheless very beautiful. He wasn't a purist, or trained; but because of this he saw things that I didn't.[4]

From the 1930s Breton collected few African pieces, preferring the art of the Americas and the Pacific. When he visited Mexico in 1938 he brought back numerous objects, including a Teotihuacan mask that he kept on his desk (see illus. 94). During the wartime years in New York he developed an interest in Northwest Pacific art, visiting the collections of the Museum of the American Indian and the American Museum of Natural History. It was thanks to Max Ernst that Breton and artists Roberto Matta and Enrico Donati, as well as Lévi-Strauss, discovered Julius Carlebach's antiques shop on Third Avenue Manhattan. This was a major encounter since Carlebach had access to the warehouse of the Museum of the American Indian, where its founder-director George Heye stored Alaskan and British Columbian masks and sculptures, treated at the time of minor ethnographic interest hence inexpensive. Lévi-Strauss sums up the discovery: 'There is

110 Kinugumiut or Napaskiak mask, Kuskokwim River, Alaska, wood, paint, feathers, fibres.

111 Haida transformation mask, British Columbia, 19th century, cedar wood, fibres, paint, metal pins.

112 Kovave Mask, Papua New Guinea, 20th century.

in New York a magical place, a meeting place for all one's childhood dreams.'[5] Breton bought several objects from Heye's store, including a mask from the Kuskokwim River in Alaska representing Akasta the sun (illus. 110) and a Haida mask from the former Queen Charlotte Islands, now called Haida Gwaii, in British Columbia (illus. 111). When he and Claro visited the Hopi and Navajo Indian reservations in Arizona in 1945, he acquired several Hopi dolls.[6] His interest in North American Native art was shared by a number of Surrealists, among them the Swiss-born artist Kurt Seligmann who was sent by the Musée de l'Homme to British Columbia and brought back a giant totem pole of the Tsimshian Indians. On his return he published an article in *Minotaure* (1939) on Indian totemic legends.[7]

Oceanic art fascinated Breton perhaps even more than indigenous American objects.[8] 'Oceania . . . this word has enjoyed a tremendous prestige in Surrealism. It will have been one of the great flood-gates of our hearts,' he wrote enthusiastically in a catalogue essay for the *Océanie* exhibition at the Galerie Andrée Olive in 1948.[9] To the formal qualities of African sculptures favoured by the Fauvists

and Cubists, Breton, like Gauguin and Apollinaire, preferred the 'poetic (Surrealist) vision of things' evoked by Oceanic art, in particular objects from Papua New Guinea (illus. 112). In 1964, thanks to the sale of De Chirico's *The Child's Brain*, Breton acquired what must have been one of the finest pieces of his collection, a New Ireland Uli statue (illus. 113). Unlike the surface qualities of African art, said to 'stop at the bark', Oceanic art was linked to a primordial 'return to the sap', expressing poetic depth. Breton gives as examples of works embodying this 'poetic *sublime*' New Ireland *malanggan* sculptures combining human and animal elements (illus. 114); a mask of the Hawaiian god of war with mother-of-pearl eyes and a body covered in feathers; a Torres Strait mask made of shells and bird of paradise feathers; a Baining mask with a butterfly proboscis; and above all a large New Britain Sulka mask he had seen at the Chicago Field Museum in 1945, 'a conical mask . . . crowned with a large parasol on top of which a six-foot-long praying mantis, made of pink elder pith like the rest of the mask, sits like a ghost'. Breton was openly attracted to the hybridity of many of the masks, half-human half-animal, and more generally to the disjunctive collage-like appearance of Oceanic objects – contrasting with the homogeneity of an African mask or sculpture – which replicated the structure of the Surrealist image.

Juxtapositions

In 1920 the art critic Félix Fénéon conducted a survey in which he asked ethnographers, artists and museum officials whether ethnographic objects should be exhibited in the Louvre. Salomon Reinach, curator of antiquities at the Louvre, responded angrily: 'The wooden sculpture of the Negroes is hideous; to take pleasure in it would seem to be an aberration, when it is not simply a joke.'[10] It was only in 2000 that sculptures from Africa, Asia, Oceania and the Americas were exhibited in the Louvre's Pavillon des Sessions. Yet the boundaries between Western and non-Western aesthetics were already collapsing in the 1920s, particularly in the publications and exhibition spaces of the avant-garde milieu, which repeatedly juxtaposed European and non-European artworks.

FROM EASTER ISLAND TO ALASKA: ART AND ETHNOGRAPHY

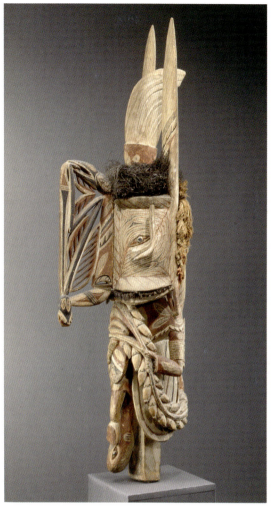

The practice of juxtaposition can be seen for example in *La Révolution surréaliste*, where, for instance, a New Ireland mask is reproduced alongside 'Surrealist texts', or the photograph of a ritual installation of New Britain masks is placed in the midst of a poem by Philippe Soupault.[11] Elsewhere, the photograph of a Kachina doll from New Mexico has been placed on a page opposite the drawing of an exquisite corpse (illus. 115).[12] Removed from its original cultural context and juxtaposed with a Surrealist work, the Kachina doll acquires the aura of a Surrealist object, underscored in the similarities between the disjunctive structure of the doll and the collaged elements of the exquisite corpse, and in the animal references in the

113 New Ireland Uli statue, 19th century.

114 New Ireland Malanggan ceremonial sculpture, 19th century, wood, coal, fibres.

115 *La Révolution surréaliste*, 9–10 (1927).

feathered headdress of the one and the octopus legs of the other. The two images are further suggestively united under the title of Péret's text 'Corps à corps', literally 'body to body' but here meaning 'hand-to-hand combat'. In this mise-en-scène the juxtaposition of a Surrealist drawing and a Hopi Kachina figure subverts aesthetic categories and hierarchies (Western/non-Western art), creating a micro-narrative that stages a new configuration.

Surrealist exhibitions also often displayed works by Surrealist artists side-by-side with ethnographic objects, many again loaned by Éluard and Breton. Indeed, for James Clifford, juxtaposition was central to the concept of 'ethnographic surrealism': 'Ethnography cut with surrealism emerges as the theory and practice of juxtaposition.'[13] For the inaugural exhibition of the Galerie Surréaliste in 1926, *Tableaux de*

Man Ray et objets des îles, paintings by Man Ray were shown alongside Oceanic objects, including masks from New Guinea and New Ireland lent by Breton (illus. 116). A year later *Yves Tanguy et objets d'Amérique* (Galerie Surréaliste, 1927) brought together Tanguy's Surrealist paintings with Mayan and Northwest Coast objects and Hopi Kachina dolls. In his catalogue essay for the event Breton linked Tanguy's paintings with the 'ancient cities of Mexico', underscoring the rapprochement between Surrealist and non-European art (see illus. 141).[14] A similar levelling process is at work in the *Exposition surréaliste d'objets* at the Galerie Charles Ratton in 1936 (illus. 117), where, for example, an Oceanic mask was displayed alongside Dalí's *Aphrodisiac Jacket* (1936), a Hopi doll next to a mathematical object. As artistic director of the short-lived Galerie Gradiva (1937–8), Breton continued this practice of display. And in the exhibition *Mexique*, which he curated in 1939, he mixed objects he had acquired in Mexico, from pre-Columbian sculptures and photographs by Manuel Alvarez Bravo,

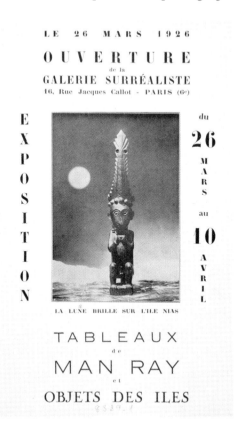

116 *Man Ray et objets des îles*, exhibition poster, 1926, Galerie 1900-2000.

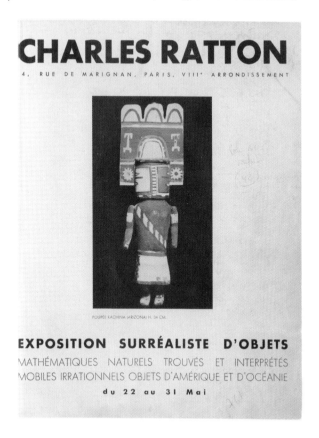

117 *Exposition surréaliste d'objets*, exhibition poster, 1936, Galerie Charles Ratton.

with sugar skulls, toys . . . and paintings by Frida Kahlo. Not everyone appreciated the gesture, however, and Kahlo herself was angry at Breton's cavalier display of her works alongside 'all this junk', and immediately broke with 'this bunch of coocoo lunatic sons of bitches of the Surrealists', referring to them bluntly as '*[s]hit* and only *shit*'.[15] Unmoved, unsurprisingly, Breton continued the practice of juxtaposition in the post-war period: for an exhibition he co-curated at the Musée Guimet, *Le Masque* (1959–60), objects from his collection were exhibited alongside contemporary masks created by Surrealists Jean-Claude Silberman, Mimi Parent and others.

Poetry or science?

In a letter to Claude Lévi-Strauss, written in 1941 on the ship taking them from Marseille to Martinique, Breton refers to two distinct impulses in his approach to the artwork: in the first he seeks sensuous or aesthetic pleasure, while in the second, sometimes mingled with the first, he interprets the work in relation to a need for objective knowledge.[16]

The debate among art historians and ethnographers opposing a scientific rather than an aesthetic approach to ethnographic objects was far from exclusive to Breton. The early twentieth century saw a shift in the reception of such objects in the West: originally considered simple 'curiosities', with the development of ethnography they acquired the status of documents for a scientific understanding of non-European cultures, and were later repositioned as models of a new aesthetic. The often strained relations between art-critical and anthropological positions were reflected in the pages of the journals *Documents*, *Minotaure* or *Cahiers d'art*. While the ethnographer Georges Henri Rivière promoted a dialogue between scientific and artistic approaches, the ethnographer and writer Michel Leiris (who took part in the official French ethnographic Dakar–Djibouti expedition in 1931–3) argued for the incompatibility between the poet's subjective engagement in the field in rites and rituals and the ethnographer's position, whose role is to analyse his object of study.[17] The question has continued to be relevant, for example in the debates surrounding

FROM EASTER ISLAND TO ALASKA: ART AND ETHNOGRAPHY

118 Yupi'k fish mask, Yukon/Kuskokwim, Alaska, early 20th century, wood.

the exhibition *Primitivism in 20th Century Art* at MOMA in New York in 1984, or, more recently, the lengthy controversy around the creation of the Musée du Quai Branly – Jacques Chirac in 2006.

Ernst and Tzara actively confronted the historical context of the ethnographic objects in their collections, whereas Breton appears at first to have shown little interest in the original function of the masks and statues he collected. In 'Phénix du masque', he openly rejects the ethnographer's 'scholarly explanations', said to imply a

cold detachment that acts as an obstacle to an immediate, sensuous approach.[18] In reality, the large number of ethnographic works in Breton's library, including studies by Stéphen Chauvet, Jean Guiart and Alfred Métraux, suggest he was also interested in the ethnographic dimension of the objects in his collection. Indeed, his notebooks and exhibition prefaces reveal on occasion precise knowledge of ethnographic texts. For example, in 'Notes sur les masques à transformation de la côte pacifique nord-ouest' (Notes on the Transformation Masks from the Northwest Pacific Coast), he quotes Georges Buraud's *Les Masques* (1948), as well as Leonhard Adam and Lévi-Strauss on the decoration of masks, and refers to the importance of the work of American ethnographer Franz Boas on the role of climactic, social and ritual contexts (such as the potlatch ceremony) for a full understanding of masks.[19] Similarly, in 'Main première' (First Hand), the preface to Karel Kupka's study of Australian aboriginal bark paintings *Un art à l'état brut* (or *Dawn of Art: Painting and Sculpture of Australian Aborigines*, 1962), he situates the works in their mythical, ritualistic and social context.[20]

In the same text, nevertheless, priority is given to the sensuous aspect of the paintings, their texture, colours and 'rhythmic unity'. Above all, he celebrates the gaze, uncluttered by ethnographic knowledge, open to the full emotional impact of the object. He thus exhorts the viewer to 'love, above all ... Only the gates of emotion provide access to the royal road; the roads of knowledge, otherwise, lead nowhere.' He celebrates the mystery of the works and is often opposed to their demystification, quoting Apollinaire's poem 'Zone': 'You will never really know / the / Mayas.'[21] Why wish to know them if their objects make us dream? As was the case with the *obscure* or *perverse* objects discovered in the flea market (*Nadja*), Breton was less interested in erudite ethnographic explanations (recovering their original function) than in their effect (recovering their spirit). The 'royal road' is therefore the path of emotion and poetry rather than knowledge, and he defined the *aura* of Oceanic sculpture ('*haloed* objects that captivate us'), as a hallucinatory power that 'hurls our reverie into the most vertiginous stream without banks'.[22] There is frequently an implicit analogy between ethnographic and Surrealist objects: for example, he underlines the hybrid character of Yupik masks, which combine animal

and human features (illus. 118), or of British Columbian Kwakiutl or Haida transformation masks, with articulated elements manipulated by a system of strings, revealing animal forms, 'from fish to bird, and bird to man', masks in which 'the blinking of the eyes effects the transition from the sun to the moon.'[23] More generally, he argues that 'the deepest affinities exist between so-called primitive thought and Surrealist thought.' But above all, he pursues the idea that the impact of the ethnographic object is identified with a return to a 'primitive mentality', invoked as the rejection of the supremacy of rational thought and the fusion between man and nature, 'that jungle of feeling where man . . . is still in search of himself in nature's entrails and is incompletely untangled from serpent and bird'.[24] The mask or statue thus returns the viewer to her origins, both individual (the memory of a mythical childhood) and collective (the memory of the tribe). In this way Breton links two aspects of the 'primitive': an exotic or exogenous primitive, that of Native Americans or South Pacific Islanders, and a subjective or endogenous primitive, equated with the unconscious. His argument echoes that of Freud who, in his introduction to *Totem and Taboo* (1913), invoked points of convergence between the psychology of primitive peoples and that of 'certain mental states of modern man'. For Breton and fellow Surrealists this included the child, madman, medium and poet. The Oceanic mask and the Kachina doll are thus both auratic objects, through voluntary *dépaysement* or decentring – to the depths of the unconscious, the horizon of the imagination – and absorbed into Surrealism.[25] Breton's position is firmly grounded in the ethnocentric concept of primitivism, referring not to non-European art itself but to the West's fascination with it, as argued for example by William Rubin.[26]

The Surrealists participated in the early twentieth-century primitivist vision of non-European cultures.[27] Breton was not totally free of contemporary cliches on so-called primitive man, whom he defined as late as 1962 as 'beings by definition governed by affects more elementary than our own'.[28] Such stereotypes were denounced by Claude Lévi-Strauss, who objected that the 'savage' had never been a being dominated by his instincts.[29]

Surrealist collecting and exhibition practices thus leave us facing a paradox. On the one hand, the juxtapositions of ethnographic

and Surrealist objects and images in their exhibitions and journals encouraged an apparent levelling of art-historical hierarchies, a democratization of difference. Yet, in spite of the Surrealists' overtly anti-colonial and anti-capitalist positions, their collecting practices, according to Louise Tythacott, 'mirrored the geography of French colonial possession. Their collections . . . were predicated upon the very capitalist and colonial distribution networks they despised.'[30] Furthermore, as art consultant to Jacques Doucet or director of the Galerie Gradiva, Breton was fully engaged in the art market. In the final analysis, co-opting the ethnographic object for Surrealism by conferring Surrealist qualities on it is evidence that the Surrealists had not totally freed themselves from the cultural imperialism of the day that, nevertheless, they did so much to undermine.[31]

Breton, Leiris, Lam

The Cuban artist Wifredo Lam (1902–1982) offers a revealing case study of the two 'temptations' outlined by Breton in his approach to art, poetic subjectivity versus scientific objectivity, thanks in large part to the confrontation between Breton and Leiris's writings, which forged conflicting constructs of 'Wifredo Lam' – essentially poetic for Breton, ethnographic for Leiris.

It was Picasso who offered Lam friendship and guidance when the young artist arrived in Paris in 1938 after ten years in Madrid, where he had studied painting and designed propaganda posters for the Republicans in the Spanish Civil War. Picasso introduced him to the Paris avant-garde milieu, including Michel Leiris, who at the time was in charge of the African collections at the Musée de l'Homme. Picasso is alleged to have said to him: 'Apprends à Lam l'art nègre!' (Teach Lam African art!) Lam would of course have seen African masks in Picasso's studio when he arrived in Paris: he was particularly attracted to an African Baule mask representing a horse's head (formerly in Breton's collection). Added to African art was the impact of modernism on his style, which combined Cubist structures and Surrealist automatism. His first solo exhibition took place at the Galerie Pierre in 1939, the year Picasso and Dora Maar introduced Lam to Breton,

119 Wifredo Lam, illustration in Breton, *Fata Morgana* (1940), pencil on paper.

who invited him to the Surrealists' café meetings. In 1940 Lam made his way to Marseille, where he joined the Surrealists waiting for a passage to America. There he illustrated the text that Breton was working on (*Fata Morgana*) with six drawings of totemic forms (illus. 119) and took part in the collective production of the Surrealist tarot game. In 1941 Lam, Breton and Levi-Strauss sailed to Martinique on the *Capitaine Paul-Merle*. From San Domingo Lam returned to Cuba, while Breton and his family continued to New York. During the war they kept in touch by letter, and Breton negotiated with New York gallery owner Pierre Matisse Lam's first solo exhibition in 1942 and wrote the preface to the exhibition catalogue.

120 Baga Nimba shoulder mask, Guinea, 19th century, wood, fibre and brass sculpture.

FROM EASTER ISLAND TO ALASKA: ART AND ETHNOGRAPHY

Breton's first text on the artist, 'Wifredo Lam. A la longue nostalgie des poètes . . .' (Wifredo Lam: The Long Nostalgia of Poets . . .), written as a preface to the exhibition, adopts a poetic, primitivizing approach to the artist.[32] The statue of 'the great Guinean goddess of fertility', a Nimba mask in the Musée de l'Homme (illus. 120), is seen as a catalyst for the modern artist, while the art of a mythical Africa ('the soul of what Baudelaire already called "superb Africa"') is construed by Breton as a response to the 'long nostalgia' of nineteenth-century poets. He extols their search for a 'primitive vision' belonging to 'the human being scarcely emerged from the idol, still half-buried in humanity's legendary treasure-house' and assimilated to images of half-sleep. Breton presents Lam's interest in African forms as intuitive, but in actual fact Lam's Africanizing forms were less instinctive (through his Afro-Cuban heritage) than acquired (through Cubism and the modernist avant-garde). The text closes on a characteristic rhetorical flourish, underscoring the paintings' lyrical qualities: 'Lam, the star of the liana on his forehead and everything he touches glowing with fireflies.' The claim to identify poetic qualities and spontaneity in Lam's paintings openly appropriates them for Surrealism.

The artist is co-opted once again by Breton in 'Wifredo Lam: La nuit en Haiti . . .' (Wifredo Lam: At Night in Haiti . . .), published as a preface to the catalogue accompanying Lam's 1946 exhibition in Port-au-Prince, where he had been invited by the French cultural attaché Pierre Mabille.[33] His visit coincided with Breton's stay in Haiti, invited to give a series of lectures (illus. 121). In this text the main focus is the marvellous in Lam's paintings and their supposed link to voodoo *loas* or spirits and rituals; but when Breton mentions Afro-Cuban rituals, it is essentially as poetic images, signalling the exotic rather than the ethnographic. Breton's poetic language succeeds in situating the artist's paintings in a mythical time and space: ancestral roots ('the point where the vital source

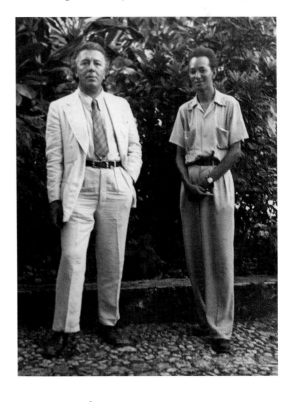

121 Breton and Wifredo Lam, Port-au-Prince, Haiti, 1946.

187

reflects the tree of mystery') and a new myth ('egrets taking wing from the surface of the pool where today's myth is being formed'). Indeed, Lam, described as 'a mind freed from all influences', appears in total isolation, both cultural and aesthetic, the lived equivalent of the blank page of automatism. His practice is, allegedly, a pictorial automatism, as if emerging from the unconscious, returning (regressing?) to an origin both racial and psychical.

This celebration of Lam's 'primitive vision' and automatic practice appropriates his works for Surrealism, locating the artist, supposedly freed from (perhaps even untouched by) the constraints of aesthetic conventions, alongside the art of children, the insane and the naive painters that Breton celebrates elsewhere. He thus blithely bypasses Lam's art-historical studies in Madrid and exposure to influential Paris art circles, choosing instead to respond to Lam's paintings not so much through description or interpretation but through a poetic elaboration, treating the paintings as a springboard for his own poetic development.

Breton's texts on Lam, essentializing the artist, erasing social context and privileging a lyrical response and a primitivist (meta)discourse, stand in marked contrast to the largely ethnographic approach to the artist adopted by Leiris. He examines the convergence in Lam of diverse elements characteristic of Caribbean culture, focusing on Lam's mixed cultural and ethnic background (Chinese-Spanish-African parents), and his godmother Mantonica Wilson, a priestess of the Santeria religion who introduced Lam to the cult of Shango, god of thunder.[34] More broadly, and more astutely, he situates the artist within the context of Cuba's syncretic colonial society as a fusion of European and African elements, in keeping with the metaphor of the crossroads (*carrefour*) central to his concept of ethnography.[35] Unlike Breton, he does not treat the object of ethnography as the study of myths, but as the analysis of interactions and transformations of groups and individuals within the colonial situation. Within this framework he locates Lam as a Caribbean, 'at the crossing of several civilisations',[36] opening onto the artist's exposure to Cubism and African masks that contributed to a syncretic style liberated from naturalism, so that on his return to Cuba in 1942 Lam's painting freely combined Afro-Cuban religious and cultural themes with a modernist European style.

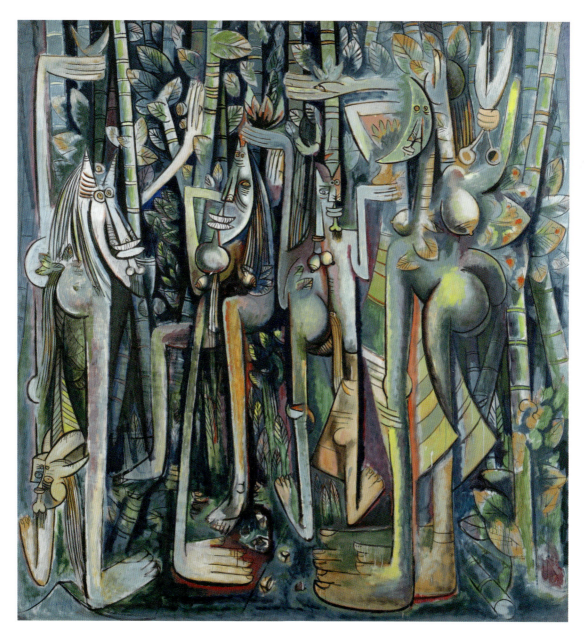

122 Wifredo Lam, *La Jungla*, 1943, gouache on paper mounted on canvas.

The notion of *carrefour* recurs in Leiris' interpretation of several Lam paintings, among them *La Jungle* (1943), arguably Lam's best-known painting, representing four figures in a tropical Cuban landscape (illus. 122). Everything in the painting is depicted in terms of hybridity and transformation: for example the figure on the right has a moon-shaped head, leaves and red flowers (the colour of Shango) growing out of her body, while the scissors in her hand are interpreted as a symbol of destruction and regeneration. The idea of crossroads is materialized in the painting in the references to Afro-Cuban religion (the Yoruba god Shango) and the Greek Fates and dancers (*coryphées*), embedding Lam's paintings within a material reality, treated as a confluence of influences and affinities, while rejecting any suggestion of eclecticism, 'harlequins made up of cultural bits and pieces'. On the contrary he considers them as spaces where several currents have converged, finally explicitly situating the painting in the chaotic political climate of the 1940s, and presenting Lam's role as an artist as socially and politically engaged.

These two interpretations – or constructions – of Lam, whether in the name of Surrealism or of ethnography and post-colonial culture, appear to be fundamentally opposed. To Breton's mythical *homme noir*, Leiris opposes a contemporary *homme métis*. In his texts on Lam, Breton was indeed defending an (already outdated) essentialist ethnographic position of *l'homme noir* as primitive and ahistorical (he refers for example to 'this race's resolute soul'), shaped by contemporary racial stereotypes. Breton was far from alone in this, of course, since the perspective was prevalent not only among a number of Surrealists,[37] but among some contemporary critics, who referred to Lam as 'un avatar de la jungle', a 'magician' or 'shaman', invested with a 'primitive wisdom'.[38] Leiris, for his part, distinguished between ethnographers attracted to 'cultures that appeared the most "intact", the least marked by European influence' (a category that would, clearly, include Breton), and his own interest in the hybridity of cultures. To Breton's sweeping concept of the 'primitive', seen as a figure of the unconscious (in terms of depth and spontaneity), Leiris opposes the idea of the *carrefour* as cultural intersection (in terms of horizontality and contemporary politics).

nine

Beyond Surrealism: Outsider Art

THE SURREALISTS' REJECTION of the aesthetic codes of classical Western art and their search for forms of artistic expression untrammelled by rationality or cultural mediation made them turn on the one hand to the art of extra-European cultures, and on the other, within Europe, to the art of the self-taught, children, mediums or the mentally disturbed, who produced works outside the conventional circuits of art schools, collectors and museums. Their fascination with work of this kind was fed by contemporary developments in psychoanalysis and ethnography, and the growing number of exhibitions of ethnographic art on the one hand, of psychotic and children's art on the other. James Clifford sums up this interest as based on the belief that 'below (psychologically) and beyond (geographically) any ordinary reality there existed another reality', in which both primitive man and the primitive in man could be revalorized, thus challenging both the colonial belittling of colonized cultures and the institutional relegation of the productions of the insane to documents of mere clinical interest.[1] The counter-myth of a spontaneous, authentic mode of artistic expression was designed to shatter that hierarchy and revitalize a moribund culture. As Breton contended: 'The European artist in the twentieth century can counter the dessication of his wellsprings of inspiration, which rationalism and utilitarianism have brought about, only by reviving so-called primitive vision, a synthesis of sensorial perception and mental representation.'[2] Breton himself identified essential affinities between 'primitive' thought and Surrealism, particularly through the practice of automatism, thanks to which both were allegedly able to bypass the conscious rational mind and liberate the irrational.

Outsider art

As medical students in wartime Paris at the St Dizier Neurological Centre and the Pitié Salpêtrière Hospital, Breton and Aragon became fascinated by the delirious speech and raw drawings of the shell-shocked patients they were treating. In a letter to Apollinaire on 15 August 1916, Breton wrote: 'Nothing strikes me so much as the interpretations of these madmen . . . My fate, instinctively, is to subject the artist to a similar test.'[3] When he took over the editorship of *La Révolution surréaliste* in July 1925 he illustrated the first page of his editorial with a drawing by a medium, Mme Fondrillon. An article written in 1933, 'Le Message automatique', reproduced works by mediums and mentally disturbed patients, including *Martian Landscape* (1896) by Hélène Smith (illus. 123) and an automatic drawing by 'Nadja D.'.[4] The term 'art brut', used to describe these works, was not coined until 1945 by the artist and collector Jean Dubuffet, who defined it, in contrast to 'art culturel', as artwork created by the unschooled artist, outside the institutional art circuit.[5] He was active in discovering and promoting such works, visiting for instance psychiatric hospitals in Switzerland with Gallimard editor Jean Paulhan, where they acquired works by patients Aloïse Corbaz, Heinrich Anton Müller, Adolf Wölfli and others. He subsequently extended his collection to include works by the self-taught, and in 1947 set up the 'Foyer de l'art brut' to house his collection in two basement rooms in the Galerie René Drouin. The following year, with Breton, art dealer Charles Ratton and art critic Michel Tapié among others, he formed the Compagnie de l'Art brut, for the purpose of collecting and exhibiting artworks based on spontaneity and freedom from the constraints of 'asphyxiating culture'.[6] The group's first major exhibition, *L'Art brut préféré aux arts culturels* (Raw Art preferred to the Cultural Arts), which took place in October 1949 at the Galerie Drouin, displayed more than two hundred works by about sixty artists. Dubuffet's catalogue preface is a manifesto of art brut in which he contrasts fossilized academic art (dubbed 'chameleon' or 'monkey' art) with the inventive art forms of the unschooled. Art brut was henceforth defined as the work of

artists unscathed by artistic culture . . . [who] draw everything (subject, choice of materials, means of transposition, rhythm, writing style) from their own depths and not from the clichés of classical or fashionable art. We are witnessing a pure, raw artistic operation, totally reinvented at each of its stages by the artist's own impulses.[7]

The collaboration did not last, however, and relations between Breton and Dubuffet soured after a dispute regarding the scope of art brut. Breton deemed Dubuffet too dictatorial and objected to his mixing art of the self-taught and the insane, while Dubuffet rejected Breton's tendency to incorporate art brut into Surrealism.[8] Their collaboration thus came to an end in 1951, and Dubuffet dissolved the Compagnie de l'art brut. His collection was stored first in the United States, then brought back to Paris in 1962. He later bequeathed it to Lausanne, where the Musée de l'Art Brut was opened in the Château de Beaulieu in 1976, bringing together 5,000 works by some two hundred artists.[9]

123 Hélène Smith (born Catherine-Élise Müller), *Paysage ultramartien*, 1896, watercolour on paper.

THE EYE OF THE POET

It was during this period that the art historian Roger Cardinal coined the term 'outsider art' as an English equivalent to art brut, grounding his concept on an analysis of Dubuffet's theoretical positions, while extending its range.[10] For Cardinal it designates modes of 'artistic marginality' largely outside the constrictions of academic training and commercial art circuits, yet not totally freed from some form of cultural legacy. While some art historians have been reluctant to use the term because it might suggest an inferior art form ostracized from mainstream art, it has now been largely adopted in art writings. Today 'outsider art' is no longer outside, having been fully integrated into the artistic canon and art market. The term now covers the art of the mentally ill, mediumistic art and the more general label of naive art.

124 Adolf Wölfli, *Untitled*, 1916, pencil and coloured pencil.

125 Aloïse Corbaz, *Reine Victoria dans le manteau impérial pontifical* (recto), pencil, watercolour and coloured pencil on paper.

The first art brut works to be collected by Breton were two anonymous *objets d'aliénés* from Dr Auguste Marie's collection, bought in 1929 at an exhibition of psychotic art at the Galerie Max Bine in Paris (see illus. 99).[11] Breton subsequently acquired several works by mentally ill patients from Dubuffet's collection, including two drawings by Adolf Wölfli, a Swiss psychotic patient (illus. 124). On a visit with Meret Oppenheim in the mid-1950s to the Waldau mental institution in Switzerland, where Wölfli had been interned since 1895, Breton bought one of his painted cupboards. Following his visit he asked Theodor Spoerri, a psychiatrist working at Waldau, for an essay on Wölfli for publication in *Le Surréalisme, même*.[12] Breton also collected

works by Aloïse Corbaz, including *L'Hymne à la terre* (Hymn to the Earth) and *Reine Victoria dans le manteau impérial-pontifical* (Queen Victoria in the Imperial Pontifical Mantle; illus. 125). Corbaz had been a governess at the court of Kaiser Wilhelm II and was interned in 1918 for schizophrenia. This produced erotic fantasies staging the Kaiser or Napoleon: in *Seduction de la Waleska*, for example, a gigantic woman is suffocating a tiny Napoleon. The importance for Breton of works like these, by Aloïse and other psychotic artists, is apparent in the fact that they were displayed on the walls of his studio and included in exhibitions alongside Surrealist works, in juxtapositions that exploded traditional classifications of artworks.

In 1948 Dubuffet had asked Breton to write an essay for *L'Almanach de l'art brut*, a project that never materialized.[13] However, in his essay 'L'art des fous la clé des champs' (The Art of the Insane, Freedom to Escape), illustrated with works by Wölfli and Aloïse, Breton listed studies on 'l'art des fous' (an expression used at the time) by psychiatrists who recognized the aesthetic value of works produced by mentally ill patients.[14] These included Marcel Réja's *L'Art chez les fous* (1905); Walter Morgenthaler's 1921 study of Wölfli, *Ein Geisteskranker als Künstler* (Madness and Art: The Life and Works of Adolf Wölfli); Hans Prinzhorn's *Bildnerei der Geisteskranken* (Artistry of the Mentally Ill) of 1922, which Max Ernst brought with him to Paris that same year; Jacques Lacan's 1932 doctoral thesis on the literary texts of his paranoiac patient Aimée; and Gaston Ferdière's *Les Dessins schizophréniques* (1947). Breton was clearly familiar with the work of these psychiatrists who, instead of filing the works of their patients as merely documents of their pathologies, acknowledged in them an aesthetic dimension. Prinzhorn for example freely compared the work of psychotic artists such as Wölfli and August Neter (or Natterer), to contemporary artists. In his essay 'The Art of the Insane, Freedom to Escape' Breton followed suit, lambasting the current prejudice against the works of the mentally ill among timorous art critics. He found support for his position in Joseph-Marie Lo Duca, author of an article titled 'L'art et les fous', from which he quotes: 'In my view the genuine madman expresses himself in admirable forms of expression in which he is never constrained or smothered by "reasonable" objectives.' Lo Duca even went so far as to maintain that it would be

difficult to distinguish between the works of schizophrenics or neurotics and those of Tanguy or Dalí.

While Dubuffet and Breton differed in their classification of the various types of art brut, both saw in the supposed spontaneity of the works an art form untouched by external influences, a position gaining ground at the time among art historians. Breton was a staunch defender of the notion of the 'pure' work of art as a totally acultural mode of expression, although this was a misguided position, it is now agreed, since it is well-nigh impossible to produce artworks in a vacuum, totally unmediated by cultural context or artistic tradition. Moreover, in his enthusiastic promotion of the works of the mentally ill as aesthetic objects, Breton turned a blind eye to the fact that they were often also the expression of deeply disturbed minds. This was a tactic apparent in the case of Nadja, for instance, as was argued earlier, since her drawings were read by Breton as products of a rich imagination that he was intent on interpreting in the light of Surrealism, thus eliding the mental suffering expressed in her works. Finally, where Dubuffet challenged not only the specific category of the art of the insane, declaring, 'There is no more art of the insane than art of dyspeptics or individuals with a knee ailment,' but more widely the notion of mental illness itself (for him the madman was essentially an asocial individual), Breton maintained a distinction between the art of the insane and mediumistic art.[15]

Mediumistic art

The world of the medium was first introduced into the Surrealist group in 1922 by the initiate René Crevel, via experiments in hypnotic trances. As recounted in Breton's 'Entrée des mediums' (Enter the Mediums) of 1922, their aim was the liberation of verbal and visual expression.[16] The link between the medium's utterances and automatic writing was explored by Morise in 1924 in 'Enchanted Eyes': echoing Breton's definition of psychic automatism as the 'real functioning of thought', Morise saw the verbal and visual works of mediums and the insane as recording 'the most imperceptible undulations of the flux of thought'.[17] A few years later, in 'The Automatic Message'

126 Breton, 'Le Message automatique', *Minotaure*, 3–4 (1933).

(illus. 126), while drawing a parallel between mediumistic art and automatism insofar as both bypass rational thought, Breton established a fundamental distinction between Surrealist and mediumistic automatism. Whereas the spiritist voice was experienced as external to the individual – Augustin Lesage, for instance, attributed his works to Leonardo da Vinci, and Hélène Smith to Martians – the Surrealist claimed to listen to the inner voice of the unconscious.[18] As a materialist, Breton vigorously rejected not only the idea of external sources of voices as a supernatural phenomenon, but more generally the spiritist belief in communication with the dead, claiming that mediumistic works were not without external influences. In 'The Automatic Message' he referred for example to the structure of the underground mining galleries in the paintings of the miner Lesage, as in his *Composition symbolique* (1928), titled *Peinture automatique de type architectural* (Automatic Painting of an Architectural Type; illus. 127). Interestingly, in spite of Breton's clear distinctions between the automatic products of Surrealists and spiritists, such works were reproduced together in their journals, as in the special *Surrealism* issue of *Variétés* (1929), where illustrations by Miró, Tanguy or Malkine appeared alongside Hélène Smith's drawings and Ferdinand Cheval's *Ideal Palace*.

Dubuffet was more fortunate on this second occasion when he asked Breton to write a text, this time for the *Almanach de l'art brut*, on the mediumistic artist Fleury-Joseph Crépin, whom Breton met in 1947 at the Galerie Drouin, where his paintings were shown at the opening exhibition of the Foyer de l'art brut.[19] In his essay, Breton presents an overview of the artist's biography. Born in the North of France in the Pas-de-Calais, Crépin trained as a plumber. He composed music and, in 1938, when copying music, his hand appeared

BEYOND SURREALISM: OUTSIDER ART

to be guided by an external force and he heard voices commanding him to paint 'marvellous' paintings which would have the effect of stopping wars and bringing about peace. His canvases include small symmetrical drawings executed with colour pencils on squared paper which were then transferred onto larger canvases. He drew temples with ornate columns and balustrades, vases, dots like musical notes, little human figures in acrobatic poses or reduced to a head and neck. Breton purchased two of these (both dated 1946), *Tableau merveilleux no. 396* and *Tableau merveilleux no. 11* (illus. 128), which depicted

127 Augustin Lesage, *Composition symbolique*, 1928, oil on canvas.

128 Fleury-Joseph Crépin, *Tableau merveilleux no. 11*, 1946, oil on canvas.

scattered symbols, numbers, words and letters, some legible, others more obscure, resembling cabbalistic or hieroglyphic signs. Breton went on to establish affinities with Asiatic and pre-Columbian art, as well as with other mediumistic artists like Victorien Sardou (whose automatic etching *Maison de Mozart dans Jupiter* (House of Mozart in Jupiter) illustrates Breton's article), Léon Petitjean (illustrated by a pen drawing, *Portrait d'esprits revêtus de leur costume fluidique* (Portrait of Spirits Dressed in Their Fluidic Costumes) and Augustin Lesage. Given their architectural structures and the fusion of outer and inner spaces, Crépin's temples are compared by Breton to the *Ideal Palace* by Ferdinand Cheval, 'the uncontested master of mediumistic architecture and sculpture'.[20] There is no evidence to suggest that Cheval actually had mediumistic revelations, however, and Breton's use of the word most likely equates with automatism.[21]

BEYOND SURREALISM: OUTSIDER ART

Art naïf

In fact, Crépin, Cheval and others can be considered under the broader category of *art naïf* or naive art, applied to artists with little or no formal art training. It took Ferdinand Cheval (1836–1924), a postman at Hauterives in rural France, more than thirty years to build his 'Palace of the Imagination', with materials – stones, fossils, pebbles – that he collected on his daily delivery rounds (illus. 129). With its elaborate niches and spiral staircases, his construction, inspired by his dreams and illustrations from France's colonial exhibitions, recalls Hindu, Japanese or Egyptian temples. This 'fairytale labyrinth', as Breton called it, fascinated the Surrealists.

In the summer of 1953 Breton visited a number of places across France linked to the precursors of Surrealism, including Cheval's Hauterives in the Drôme and Laval in Brittany, the birthplace of Henri Rousseau.[22] Better known as the Douanier Rousseau, owing to his job as a customs official working at the Paris toll-gate, it is Henri who perhaps best embodies the myth of *art naïf* for the Surrealists. He painted portraits, scenes of Paris and exotic landscapes in a childlike

129 Ferdinand Cheval's Palais Idéal, Hauterives, 1905.

201

130 Alexandre Cabanel, *Naissance de Vénus*, 1863, oil on canvas.

style, with flat colours, little perspective and careful detail. The French playwright Alfred Jarry introduced him to Picasso and Apollinaire, who promoted the artist's work and organized a banquet in his honour in 1908 at the Bateau-Lavoir – partly in jest, it has to be said. Breton took the artist rather more seriously, considering him to be the initiator of marvellous visions. One can argue that the artist's exotic landscapes meld with Breton's own imaginary Mexico or Martinique, and he clearly encouraged the myth when he claimed that Rousseau's paintings were 'like a spring from prehistoric times bursting into the modern world which, incredibly, *nothing* has polluted'.[23] In reality, far from being devoid of any cultural influence, Rousseau's paintings were actually mediated through contemporary images, and we know that he found his inspiration in postcards and illustrated journals such as *Le Petit Journal* and *Le Monde illustré*, in visits to the Jardin des Plantes in Paris and its brochures of exotic plants and animals, and the 1889 and 1900 World Fairs. Indeed, he exhibited regularly from 1886 at the Salon des Indépendants, and was familiar with the art of his contemporaries, admiring academic artists Alexandre Cabanel (1823–1889) and William-Adolphe Bouguereau (1825–1905). Cabanel's *Naissance de Venus* (Birth of Venus) of 1863 (illus. 130) may well have inspired Rousseau's *Le Rêve* (The Dream) of 1910 (illus. 131), for instance, while the title of his *Charmeuse de serpents* (The Snake Charmer) of 1907 echoes the well-known orientalist artist Jean-Léon Gérôme's *Charmeuse de serpents* (c. 1870). Somewhat confusingly, although Breton claimed

BEYOND SURREALISM: OUTSIDER ART

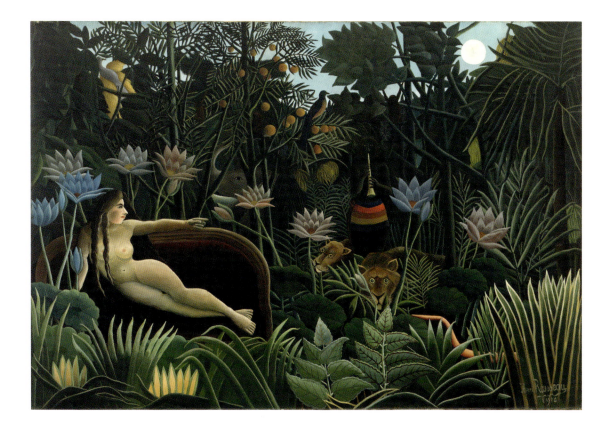

131 Henri Rousseau, *Le Rêve*, 1910, oil on canvas.

that Rousseau had 'neither master nor precursor' and that his paintings were unpolluted by artistic conventions, he was nevertheless keen to situate him within an artistic lineage.[24] Thus in 'Autodidactes dits "naïfs"' (1942) he traces the artist's 'primitive vision' to a host of precursors: Giotto, the Avignon masters, Uccello, Fouquet, Bosch and Grünewald, no less; and to popular images of religious banners and Breton gingerbread saints.[25] So much for the untutored. As was his habit, he also drew him into Surrealism, placing him as early as 1923 and as late as 1961 on Surrealism's genealogical tree: 'THESE WORKS, OF LITTLE INTEREST FROM A REALISTIC POINT OF VIEW, MUST DEFINITELY BE CONSIDERED PRECURSORS OF SURREALISM.'[26] Breton found poetic mystery in the paintings, claiming: 'It is with Rousseau that we could speak for the first time of "magic realism"'; and evoking *The Dream* in a characteristically hyperbolic tone: 'This great painting contains all the poetry and all the mysterious gestations of our time; in no other work of art does the eternally fresh spirit of discovery preserve the

feeling of the *sacred*.'[27] In the same exalted spirit, he even imagines the work borne in a religious procession through the streets of Rome, like Cimabue's *Virgin*.

Rousseau's carefully painted flowers and animals are characteristic of naive art, and their mix of real and fantasy recalls the bestiary of Aloys Zötl, considered by Breton as a precursor of Rousseau. Zötl (1803–1887), an Austrian master dyer and self-taught artist, produced 'the most sumptuous bestiary ever seen' between 1831 and 1887.[28] Breton bought eleven plates of his *Bestiarium* at auctions of the artist's works at the Hôtel Drouot in 1955 and 1956. Many of the animals look more imaginary than real, including *La tortue bleue* (Blue Turtle, 1881; illus. 132), *La Raie cendrée* (Grey Skate) and *L'Éléphant de mer* (Sea-elephant, 1887). When writing the preface to the sales catalogue of the artist's works in 1956, Breton underlined the visionary quality of the works, 'more admirable perhaps for their clairvoyance than for their perfection'. Zötl was fascinated by unusual or little-known species such as *Le Rhinocéros* (illus. 133) and Breton was a kindred spirit whose own bestiary ranges from the real duck-billed platypus or the anteater to the imaginary 'soluble fish'. Zötl's works combine close observation, based on his study of naturalists' works, and imagination.

132 Aloys Zötl, *La tortue bleue*, 1881, graphite and watercolour.

BEYOND SURREALISM: OUTSIDER ART

133 Aloys Zötl, *Rhinoceros sinus. (Burchell)*, 1861, pen, black ink and watercolour.

Breton linked the works to Charles Fourier's notion of 'universal harmony', actualized for example in the unity between the animal and its (often imaginary) habitat.

Breton's collection was to include several works by a number of other naive painters in the 1940s and '50s, such as Séraphine Louis, Morris Hirshfield, Miguel García Vivancos and André Demonchy, and he promoted their work in catalogue essays. Among them was the Haitian artist Hector Hyppolite.

Voodoo art

Breton celebrated Hyppolite's works for their 'total authenticity'.[29] In his essay on the artist, Breton, in tune with his turn to myth and the esoteric in the 1940s, links revolution to voodoo beliefs and practices which, he claims, had played a central role in freeing the Haitians from slavery when the 1791 slave revolt in the French colony of what was then Saint-Domingue had led to the creation of the first independent Black republic.

134 Breton, press cuttings on Haiti, *La Ruche* (17 December 1945).

In 1945 Breton was invited by fellow Surrealist Pierre Mabille, the French cultural attaché in Haiti, to give a series of lectures on art and literature in Port-au-Prince. Arriving on 4 December 1945, he was warmly welcomed by the young poets of *La Ruche* (the journal of the radical opposition, founded by the poet René Depestre) with their headline: 'Welcome to the great Surrealist André Breton' (7 December

1945; illus. 134). Haitian intellectuals and poets were already familiar with Surrealism at the time, through the journal *Tropiques*, co-founded by Martinican poet Aimé Césaire, and the writers Suzanne Césaire and René Ménil in 1941. Suitably expansive, the Haitian poet Paul Laraque recalled Breton as a prophet-like figure: 'With leonine head, a mane of sun, Breton stepped forward, a god begotten by lightning. To see him was to grasp the beauty of the angel of revolt. The shadows became sources of light.'[30]

The importance of Breton's visit is reflected in the fact that his first lecture, 'Le Surréalisme et Haiti', was attended by an audience of more than six hundred people, including students, politicians, local dignitaries and the Haitian president Élie Lescot himself. It was the first of seven lectures (out of the twelve originally scheduled) on subjects ranging from nineteenth-century poets and artists associated with the esoteric, magic and mystery, to the alignment of Surrealism's aims with those of the Haitian people and the condemnation of imperialism. Breton seized every opportunity, in both lectures and interviews, to underline the affinities between the esoteric in Surrealism and voodoo in Haitian culture. Interviews and lectures found a receptive audience among Haitian intellectuals, reflected in Depestre's enthusiastic report: 'They applauded fit to burst, they stamped their feet, they soared on Breton's contagious lyricism like birds discovering that the tree in which they have landed is a marvel of music and liberty.'[31] His opening lecture was published in a special edition of *La Ruche* (1 January 1946), but the journal, which also published a call for rebellion against the autocratic regime, was seized by the authorities and its editorial board arrested. The student protests, general strike and unrest that ensued culminated in a military coup that overthrew the dictator-president Lescot. While it is sometimes claimed that Surrealism, and Breton's lectures and interviews in particular, were among the catalysts for the coup and the appointment of the progessive Black president Dumarsais Estimé, back in France Breton was rather less fanciful, saying placatingly in an interview with Jean Duché 'Let's not exaggerate.'[32]

Among the many affinities that Breton did actually claim between Surrealists and Haitians were the links between voodoo rituals and Surrealist automatic practices as manifestations of primitive thought

and mental freedom. During his stay in Haiti Breton attended several voodoo ceremonies with Pierre Mabille, submitting to 'the flood of primal forces' while admitting he understood little of the rituals themselves.[33] However, as we saw with mediumistic art, Breton was aware that, in contrast to automatism's inner voice, voodoo possession is said to have an external source attributed to the *loa*.

In December 1945 Breton visited the Haitian Art Centre, a gallery and studio opened in 1944 in Port-au-Prince by the American artist DeWitt Peters and the Haitian poet Philippe Thoby-Marcelin. They held open studios, encouraging and exhibiting self-taught artists, including Hervé Télémaque and Wilson Bigaud. It was at an exhibition of Haitian artists organized by Peters in December 1945 that Breton discovered the paintings of Hector Hyppolite. A local drinks shack decorated by the artist in the interior of the island had attracted the attention of Peters and Thoby-Marcelin, who invited him to exhibit at the centre and bought his paintings. Since he did not have the means to buy painting materials, Hyppolite used Ripolin, a commercial paint that he applied with fingers or feathers on rough packing cases cobbled together. Breton and Hyppolite met later in Port-au-Prince, and while conversation was apparently somewhat hindered by the artist's shyness and his limited French, Breton's appreciation is reflected in his purchase of several paintings by Hyppolite, including *Ogoun Ferraille* (illus. 135) and *Marinéte pie che che* (Marinette of the Dry Feet, c. 1947).[34] In his essay 'Hector Hyppolite', written a few months after the artist's death in June 1948 and originally intended for Dubuffet's projected *Almanach de l'art brut*, Breton celebrates Hyppolite's works for both their freedom from formal artistic education and their poetic qualities: 'Hyppolite's paintings are guaranteed totally unalloyed, ringing like virgin metal.'[35] Hyppolite himself was actually a voodoo initiate, the descendant of a family of *houngans*, or voodoo priests, and his paintings depict aspects of voodoo rituals and *loas* such as Papa Legba, spirit of the crossroads or Ogoun Ferraille, god of war. His painting of the god, for example, shows the *loa* surrounded by objects related to magic, including a snake, playing cards, a gourd, candles and a sabre, suspended on the flat picture plane. In keeping with his analogical vision, Breton associated the image of Ogoun Ferraille with the magician in the tarot pack created by the Surrealists in Marseille.

BEYOND SURREALISM: OUTSIDER ART

135 Hector Hyppolite, *Ogoun Ferraille*, c. 1945, paint on cardboard.

Breton's enthusiasm is manifest, yet his reading appears once again to harbour a contradiction since his own text goes on to state that Hyppolite's paintings, far from being 'unalloyed', were informed by popular Christian chromolithographs. This is not altogether far-fetched, it is true, if one recalls the fact that the ethnographer Alfred Métraux, following fieldwork in Haiti in the 1940s, considered voodoo not as primitive or exotic but as a modern phenomenon, a syncretic religion linked to Christianity. Hence, for instance, the worship of Ogoun Ferraille is associated with St James Major, Papa Legba is identified with St Anthony of Padua, and the Virgin Mary is seen as an avatar of the goddess of love, *loa* Erzulie Freda, Hyppolite's 'mystical wife'.[36] As for Breton's own observations on voodoo, they were informed by his reading of Louis Maximilien's *Le Vodou haïtien* (Port-au-Prince, 1945), which he quotes in his essay.

This ever-expanding movement towards a global vision of art, present in the analogies drawn between Hyppolite's works and Christian or esoteric references, was accompanied by the now familiar appropriative tendency, in which Breton retrieves the Haitian artist for Surrealism, when he claims the paintings fuse outer perception and inner vision, a recurrent refrain in his texts: 'Hyppolite's vision

succeeds in reconciling superb realism with exuberant supernaturalism . . . the results of visual perception blend perfectly with the results of mental representation.' He gives the example of *Marinéte pie che che*, which represents a scene of a sacrificial ritual in which real and imagined figures are fused: 'the serpent-god Damballah is neither more nor less real and concrete than the sacrificer, the master of ceremonies and the two priestesses carrying flags.'[37]

Several of Hyppolite's paintings were sent to Paris by Peters for the exhibition *Le Surréalisme en 1947*, including *Papa Lauco*, which was reproduced in the exhibition catalogue. His works clearly fitted the initiatory, ritualistic structure of the exhibition, and attracted the interest of the Compagnie de l'art brut, which exhibited Hyppolite's works at the Foyer de l'art brut in 1949, alongside other self-taught artists such as Gaston Chaissac, Aloïse Corbaz and Fleury-Joseph Crépin.

Art magique

'The common denominator of the sorcerer, the poet and the madman cannot be anything else but magic,' wrote Benjamin Péret in 1943 in his introduction to a collection of Latin American myths and legends.[38] For Breton, too, the artist is a modern magician. During and immediately after the Second World War there was a shift of interest among the Surrealists, from dreams and the unconscious to magic and the esoteric.[39] In 1953 the Club français du livre commissioned Breton to write a book on *art magique*, planned as part of a new five-volume history of art, *Formes de l'art*, edited by Marcel Brion. It actually took Breton, with the collaboration of French Surrealist poet Gérard Legrand, four years to write this ambitious work, which developed into a history of art rethought through the broad concept of magic, published in 1957. In an interview with André Parinaud just before the book's publication Breton acknowledged that the project had not seemed problematic at first, since *art magique* was a field where he had some competence.[40] He admitted that he had soon encountered problems, however, because of the 'near-impossibility of defining the concept of *art magique*, which is constantly on the point of overspilling its boundaries – it is obvious that all authentic art is magical – or of

becoming inordinately restricted.' He was even led to call into question the very concept of *art magique* (illus. 136).

The result was a state of acute anxiety, expressed for example in a letter to Jean Paulhan on 12 August 1955: 'The words "magic art" ... have toyed with me as a cat toys with a mouse. And this for two years running, without being able to deal with anything else, while I stagnate more and more beneath its claws.' In another letter, to Roger Caillois, he attributed his writer's block to occult forces, in particular to the paralysing influence of a voodoo doll that he claimed stared at him from a shelf in his study.[41] Consequently, in December 1955 – having written the introduction and the results of a survey, and sketched out the main part of the work, which was to comprise the historical study – he asked Legrand to help him complete the project.

The published work is composed of an introduction, an extensive survey and a historical study; it includes 230 illustrations. The introduction considers various definitions of magic, quoting ethnographers, occultists, psychoanalysts, alchemists and poets, and concluding that, contrary to such stable notions as 'classical art' or 'baroque art' (the subject of other volumes in the series), *art magique* was a rather slippery notion, moving between the restricted definition of an art form linked to magic rituals and a wider poetic definition, as art claimed to have a 'magical' effect.

This is followed by the results of an extensive survey in the grand Surrealist tradition on the relations between art and magic (as opposed to religion or science), with the aim of warding off possible objections concerning the danger of applying subjective criteria when discussing *art magique*. It involved a series of questions on eleven very diverse works (from an Egyptian drawing or a Marquesas Islands shield, to a tarot card, Edvard Munch's *The Scream* and De Chirico's *The Ghost*), to be assessed according to the 'magical' effect

136 Engraving from Nicolas Simon aus Weida, *Ludus artificialis oblivionis* (1510), reproduced as frontispiece to Breton, *L'Art magique* (1957).

produced. The questionnaire was sent to eighty specialists, writers, artists, philosophers, historians and ethnographers. The results of the survey, along with Breton's comments, are printed on yellow paper in an insert in the volume. Among the respondents the anthropologist Lévi-Strauss (for whom the concept of *art magique* was anchored in precise cultural contexts) criticized Breton's use of the term as too vague and hence dissolving meaning, a response in keeping with his wider suspicion of the entire primitivist aesthetic of the avant-garde. For Bataille, too, magic was linked primarily to its 'material efficiency' in a specific cultural context, rather than to a supposedly poetic value.

The central section of the work, written in collaboration with Gérard Legrand, was based on discussions and an impressive documentation assembled by Breton, who had read a wide range of works by ethnographers and sociologists, such as Louis Chochod, Olivier Leroy and Jérôme-Antoine Rony. The text is weighed down, consequently, with long quotations from a wide range of sources, from poets (such as Achim von Arnim, Rimbaud, Lautréamont and Apollinaire) to ethnographers (Émile Durckheim, James George Frazer, Lévi-Strauss) and artists (Leonardo da Vinci, Henri Rousseau, Alfred Kubin). The neutral style makes it hard to distinguish individual inputs, but it is likely that the overtly didactic passages and a number of philosophical references could be attributed to Legrand, while the more lyrical passages suggest Breton's input.

The project was indeed ambitious, and the published text provides a unique insight into Breton's thoughts on the subject. The central section, 'L'Art, véhicule de la magie', explores an impressively wide range of prehistoric or archaic works linked to magical beliefs and practices worldwide, from the cave paintings of Lascaux and La Peña to British Columbian masks, the shamanic art of the steppes and Brueghel's *Temptation of St Anthony*. With this overview in place, 'Les Temps modernes: crise de la magie' explores the pertinence of early European artists like Paolo Uccello, Piero di Cosimo and Antoine Caron. Significantly, the Renaissance and post-Renaissance periods are omitted on the grounds that art was at those times subjected to increasingly rationalist constraints. Foregrounded instead are such major nineteenth-century 'visionary' artists as Goya, Blake, Füssli and Hugo, Moreau's symbolism, Gauguin's 'primitivism' and Rousseau's

'magic realism'. All this leads to 'La magie retrouvée: le surréalisme' ('Magic regained: Surrealism'), where the previous retrospective panorama reaches its climax, Breton and Legrand claiming that, far from being simply a renewal of the esoteric tradition, Surrealist art looks forward to the deployment of 'new myths'.

While a revealing insight into Breton's thinking, one would hesitate to call *L'Art magique* an art-historical study, in part because the focus was specifically the 'magical' dimension of the works, to the detriment of other readings; and in part because of the absence of any systematic contextualization – historical, ethnographic or stylistic – of the works discussed. Although, in the final analysis, an ambitious and original study that deviates markedly from conventional accounts based on the Graeco-Roman heritage of Western art, it remains ultimately a personal view.[42] An anecdote illustrates the chosen alternative. Reaching the French–Italian border on a trip, Breton apparently exclaimed, 'Italy and Greece will not function,' before turning tail and heading back to Paris.[43] The alternative aesthetic, turning its back on Mediterranean cultures, privileged African and Oceanic art and is encapsulated in the following lines from Apollinaire's poem 'Zone' (1913), often quoted by the Surrealists: 'A la fin tu es las de ce monde ancien . . . Tu en as assez de vivre dans l'antiquité grecque et romaine' (Finally you are tired of living in this ancient world . . . You have had enough of living in Greek and Roman antiquity).

It is hardly surprising that critical responses to this personal reading were mixed. At one extreme the art critic Henry Amer, in the 1 October 1957 issue of *La Nouvelle Revue française*, saw in the confusion at the heart of the co-authored essay signs of the intellectual and moral anarchy of the times; at the other, the astrologist Arnould de Grémilly praised Breton for seeking to rehabilitate the magical element in art. In the 6 January 1958 issue of *Combat-Art* the philosophers L.-P. Favre and C. Rivière – echoing Naville's 1925 'Beaux-Arts' article – were adamant: 'There is no *art magique*.' Arguing that magic can only be approached indirectly, they criticized Breton for promoting merely its outer trappings – totems, masks, charms – but failing to explain its 'inner power'.

Breton had the last word, however. Returning to the question a few years later in an interview for *Le Monde*, he acknowledged that

any attempt to fix the limits of the concept of magic (including his own) was doomed to fail. Magic, he declared, 'is not a special science. Everything is magical, and the power of a painting by Watteau is of the same nature as the fascination exerted by an alchemical drawing.'[44]

ten
Travels with Art: Off the Map

THROUGHOUT THE 1920S AND '30S Surrealism's frontiers were in constant flux. The streets of Paris, evoked in Aragon's *Paysan de Paris* (*Paris Peasant*) of 1926 or Breton's *Nadja* (1928) were the site of a dynamic decentring process, from the real to the surreal, the marvellous within the real. Extending beyond Paris, Breton embarked on the internationalization of Surrealism – in Prague, the Canary Islands, Mexico – in a 'voyage out', as charted in *The World at the Time of the Surrealists* (see illus. 106). While the mental process itself, from centre to periphery, was typical of the period, he diverged in recognizing in these places not a *terra nullius* to be occupied by Surrealism, but indigenous forms of the fantastic or the surreal with which he could negotiate in order to annex them to his model of Surrealism.

The Surrealists' polemical texts were underpinned by the conception of a psycho-geographical space based on the dominant binary model of Orient/Occident, but their's overturned the established hierarchy by opposing a devalued Occident to a valorized Orient – an opposition exacerbated in the 1930s by the economic, ideological and political upheavals affecting Europe. In Breton's search for a new impetus for Surrealism, his visit to Prague in March 1935, followed two months later by a visit to Tenerife, was driven by his desire to extend the geographical parameters of Surrealism, which was striving to divest itself of the nationalisms dividing Europe. As he put it in an interview during his stay in Tenerife: 'On arrival . . . I washed my hands with a common soap resembling lapis-lazuli. I washed my hands of Europe.'[1] But it was Mexico, visited in 1938, that was to take centre stage, as a foil to Western decadence and Stalinist totalitarianism, and as the model of the Surrealists' revolutionary aspirations. To this

Breton added the luxurious vegetation of the island of Martinique, as the embodiment of the myth of paradise.

Openly instrumentalized to advance a radical world-view, these elective landscapes (Tenerife, Mexico, Martinique), although topographically locatable, are primarily points of intersection, infiltrated by the operations of desire and imagination, so that seemingly identifiable borders between precise locations and imaginary landscapes, and more widely between reality and dream, are porous and fluid. Breton's perception of these spaces, filtered through memory, actually forms a rich intertextual network of literary and pictorial associations. For Mary Ann Caws, the immediacy of perception is combined with an inner vision fed by imagination and memory.[2] The process – in which geographical spaces, far from being apprehended as objective realities, are always already mapped discursively – will be illustrated in this chapter through three key examples: Breton's perception of Tenerife's volcanic landscapes, closely intertwined with the memory of Max Ernst's paintings of paradisiac landscapes; his construction of Mexico through illustrations in children's books and Surrealist paintings; and Martinique, perceived through Douanier Rousseau's paintings of jungles.

It is in 'Le Dialogue créole' that we find Breton's most concise explanation of the movement from outer to inner vision, from perception to imagination: 'We are not totally limited to the view from our window just because we are condemned to live in a particular place: there are the illustrations in children's books, from which so many visual memories spring up scarcely less real than others.'[3] The view from the window of his house in the medieval village of Saint-Cirq-Lapopie in southwest France provides a concrete example when it is compared to a well-known fifteenth-century illuminated book: 'Every day when I wake up, I seem to be opening the window on to the *Très Riches Heures* not only of Art, but of Nature and Life.'[4] Further afield, Haiti's landscapes are seen through the filter of contemporary works, Ernst's *The Eye of Silence* (1943–4) and Hyppolite's paintings, as well as the influential novel *Gouverneurs de la rosée* (1944) by the Haitian writer Jacques Roumain.[5] Elsewhere, an extended intertextual network is developed in Breton's travel journal on his visit with Elisa to the Hopi, Zuni and Apache Indian reservations of Arizona

and New Mexico in 1945: here his account of the Indian rituals they saw conjure up the paintings of Antoine Watteau and Francisco de Goya, while the dancers' masks could have been painted by Seurat.[6]

In what follows we set out to explore the multiple ways in which Breton's evocations of landscapes are shaped through memory, art and literature, where the banality of literal description gives way to the transformative filters of the poetic and the intertextual. 'Tenerife', 'Mexico' and 'Martinique' become psycho-geographical spaces, structured through intertextuality; in short they will be seen as a 'book-space' (*espace-livre*), a fruitful term used by Bertrand Westphal in his analysis of geocriticism, where the principle of intertextuality is applied to space.[7]

Tenerife

> *On me dit que là-bas les plages sont noires*
> *de la lave allée à la mer*
> *et se déroulent au pied d'un immense pic fumant de neige . . .*
>
> (They say that yonder the beaches are black / lava gone to the sea / spreading out at the foot of a high smoking snow-covered peak . . .)[8]

These lines are from a poem written in 1934, before Breton's visit to the island of Tenerife in 1935: it is as if the future were foretold in this automatic text, where the landscape of the volcanic island is imagined as an eroticized feminine space.[9] This fantasized 'Tenerife' was forged by descriptions of the island and postcards sent by fellow Surrealist Óscar Domínguez; by Yves Allégret and Eli Lotar's film *Tenerife*; and no doubt also by Breton's own exalted emotional state. Thanks to Domínguez, Breton, Jacqueline Lamba and Péret had been invited by the editor of *Gaceta de arte*, Eduardo Westerdahl, on the occasion of the *Exposicion Surrealista* held at the Ateneo in Santa Cruz in May 1935.[10] The exhibition displayed 76 works, including paintings by Ernst, Miró and Man Ray as well as by younger artists such as Dora Maar, Štyrsky and Domínguez himself. Breton's text 'Situation surréaliste de l'objet'

(Surrealist Situation of the Object), which had originally been given as a lecture in Prague a couple of months earlier, was published as the preface to the exhibition catalogue.[11]

Breton gave lectures in Santa Cruz and Puerto de la Cruz. Unfortunately, the planned projection of Buñuel and Dalí's violently anti-militarist and anti-clerical film *L'Age d'or* as part of the programme was banned by the governor of the island under pressure from Catholic associations. The polemic was no doubt welcome attention, but dismissed in an interview published in *La Tarde*, 'Saludo a Tenerife', where Breton focuses instead on the beauty of the island and pays tribute to the contribution of Spanish artists to Surrealism. October 1935 saw the publication of the second *Bulletin international du Surréalisme* (in French and Spanish), signed by Breton, Péret and the editors of *Gaceta de arte*. Texts included a collective introduction and extracts from Breton's recent lecture 'Position politique de l'art d'aujourd'hui' (Political Position of Today's Art), with illustrations by Domínguez and Picasso, and three photographs of the Surrealist group.

Shortly after his visit to Tenerife Breton wrote 'Le Château étoilé', an account of his ascent of the Teide volcano, recounting how the excursionists ascended by cable car from the black sand beaches and the town of Santa Cruz, to the botanical gardens of La Orotava, then through an area of mist towards the volcanic peak El Teide (which they failed to reach).[12] This Breton associated with the Château étoilé, a castle near Prague linked to the philosopher's stone of medieval alchemy, and he included in the account reflections on love, Freud, Engels, Buñuel and others. Even the topographical descriptions are constantly interwoven with erotic language – the ascent itself is recounted in terms of desire – and filtered through literary and pictorial associations, their very proliferation an index of Breton's heightened emotional state. Breton recalls the young girls he had crossed in the streets of the town, reimagined as multiple replicas of a painting by Picasso, *Girl in a Chemise* (c. 1905), which is reproduced in the text.[13] Rimbaud, Baudelaire, Lewis Carroll, Shakespeare, Max Ernst, Freud, Leonardo da Vinci and de Sade all make an appearance in his account. He was clearly, despite his claims, far from having washed his hands of Europe in this passionate – and erudite – encounter.

Elsewhere, in the same vein, his depiction of the Orotava gardens – dominated by a giant dragon tree – is filtered through the Genesis myth when he evokes an exotic Edenic space and time, a prelapsarian age ('the day as yet unsoiled by the apparition of man'), a space merging outer and inner realities, past and present ('the immense tree, plunging its roots in prehistory'). Even the serpent and the forbidden fruit make an appearance ('the Lilliputian tomato of *pitanga* with the exquisite taste of poison'), while Breton and Lamba are cast in the role of the primordial couple Adam and Eve.[14] Alongside the biblical subtext his account embarks on an analogy with Max Ernst's series of paintings *Jardins gobe-avions* (Garden Airplane Trap) of 1935–6 (illus. 137), which Breton had seen in March 1936 at the Château du Pouy in the Gers, during a visit to the English Surrealist Roland Penrose.[15] The paintings depict hybrid figures, at once insect, leaf and aeroplane, lying in spaces enclosed by wall-like partitions:

> It is the first time that I have felt, before the *never yet seen* [*le jamais vu*] such a complete impression of the *already seen* [*le déjà vu*]. This strange partition, this light of a heap of sand, these faded helixes lying around as after a great feast of praying mantises and, above all, this single flowering which one might be likely to take for the radiant seething of destruction, but of course: these are, such as he invented them two months before we left for the Canary Islands, these are the 'airplane-swallowing gardens' of Max Ernst. Then your life and mine were already turning around these gardens whose existence he could not have suspected and towards whose discovery he set off each morning, always more handsome under his kite-bird mask.[16]

Once again, like the volcanic beaches of Tenerife, the landscapes of the Orotava would seem to have been prefigured, this time in Ernst's paintings. As for the text, it marks an ambiguity, a slippage between perception and imagination: is Breton describing Tenerife or Ernst's painting, works that the artist himself actually described as being 'aux antipodes du paysage'?[17]

THE EYE OF THE POET

137 Max Ernst, *Jardin gobe-avions*, 1935–6, oil on canvas.

The text culminates in the fusion between narrator and volcano, and here Sade's erotic identification with Mount Etna in *La Nouvelle Justine* (1799) informs Breton's own fusion with a Teide both feminized and eroticized, a Teide inseparable from Jacqueline, whose love he is celebrating throughout the text: 'Wonderful Teide, take my life! . . . I want to make only one being with your flesh, the very flesh of the medusas, for one single being alone to be the medusa of the seas of desire.'[18]

Breton's experience of a pictorial image predicting, prefiguring and transforming an actual landscape echoes that of Ernst himself, who would later describe the real desert landscapes of Arizona in terms of the imaginary landscapes of his paintings. According to the

220

self-proclaimed 'paper Surrealist' (*surréaliste de pacotille*) D. Pérez Minik, when contemplating the lunar landscapes of the Teide Breton is said to have exclaimed: 'This is pure Surrealism!'[19] He would make a similar claim about Mexico, which he visited in 1938.

Mexico, 'the surrealist country par excellence'

When Breton sailed for Mexico on 18 April 1938 his horizon of expectations was already saturated. Mexico had been the object of his dreams and fantasies from an early age: 'Over there, the eyes of all the children of Europe, including the child I once was, preceded me with their thousand magical fires,' he wrote.[20] The visit had been organized by the propaganda services of the French Ministry of Foreign Affairs to give a series of lectures on French art and literature. 'Christopher Columbus should have set out to discover America with a boatload of madmen,' Breton had written in his 1924 *Manifesto*, calling on the colonial metaphor of the 'discovery' of the New World to evoke the artist's exploration of the unconscious.[21] Like Columbus, whose imagination was fed by Ptolemy's famous map, the empty sections of which were filled with hypotheses and imaginings – rather than Cortés, as some critics have implied – Breton had created a fantasized Mexico full of wild potential. The centrality thereof is demonstrated on the Surrealist map of the world (see illus. 106), which overturned the eurocentric world-view. It is clear that the 'Mexico' of Breton's imagination was a cornucopia of memories and reworkings: of his childhood reading, in particular Gabriel Ferry's popular story *Costal l'Indien* (1856) (illus. 138), which recounts the heroic adventures of nineteenth-century Mexican revolutionaries; Sergei Eisenstein's

138 Gabriel Ferry, *Costal l'Indien* [1856] (1925).

139 José Guadalupe Posada, *Calavera Maderista*, n.d., relief etching (zinc).

film *¡Que viva México!* (1931) and Jack Conway's *Viva Villa!* (1934); Rousseau's paintings of imaginary jungles; and Antonin Artaud's account of his visit in 1936. In an interview given shortly after he landed, Breton lauded Mexico as 'the surrealist country par excellence', surreal in its landscapes, its fauna and flora and the dynamism of its populations.[22] He even claimed, in a quasi-solipsistic process, that there was a seamless match between country and dreams: 'I dreamed of Mexico and I am in Mexico: moving from one to the other . . . happened smoothly.'[23]

In reality, Breton was to find Mexico rather more complex than his highly mediated vision of the country, the fragments of images and clichés he had brought in his luggage. Breton and Lamba stayed first with Diego Rivera and Frida Kahlo in their San Angel home. With Rivera, Kahlo and Trotsky the Breton couple travelled to Pátzcuaro, Cuernavaca, Toca and Xochicalco. Breton went fishing for axolotls with Trotsky, bought pre-Columbian objects in the villages with Rivera, and stole ex-votos from the walls of village churches (it seems that Breton had not quite cast off the colonial way of doing things). This diversity produced 'Memory of Mexico', a paradoxical Mexico, both a primitivist 'virgin land' and a 'land impregnated with blood', a reference to the Aztec practice of human sacrifice, colonization and the violence of the 1910 Mexican Revolution. He was particularly sensitive to examples of the co-existence of opposites in Mexican culture, and their correspondence to the Surrealist juxtaposition of disparate elements: the fusion between life and death central to Aztec culture; the merging of the Aztec past and post-revolutionary present in the Indigenist movement and the wall paintings of Rivera; or the black humour found in the satirical prints of José Guadalupe Posada (illus. 139).

It is clear that Mexico functioned primarily as a Rorschach image, revealing as much about Surrealism as it did about itself.[24] Indeed,

Breton's fabrication incorporated non-Mexican elements too, being openly mediated through Surrealist artists and poets. As early as 1927 Tanguy's paintings had been seen in terms of Mexican landscapes and monuments, 'those ancient cities of Mexico hidden forever from our eyes by the impenetrable jungle'.[25] In 'Memory of Mexico' it is now Mexico that is perceived through Tanguy's paintings, as we see for example in the monumental staircases, disintegrating walls and theatrical *trompe-l'oeil* effects characteristic of the colonial Baroque decor of the ruined palace of Guadalajara: 'we had to cross a bizarre courtyard and climb a genuinely fantastic set of stairs,' leading to landings lined with colonnades and streetlamps both real and painted, the painted panelled walls evoking still waters (illus. 140). From this theatrical decor emerged ghost-like apparitions, including an elegant man singing at the top of his voice, recalling a painting by El Greco, and a young girl – 'a magnificent creature ... smiling like the dawn of the world' – naked under her ragged evening dress.

Like the Passage de l'Opéra for Aragon in *Paris Peasant*, Breton's Mexico is thus a passage between, or opening onto, rather than an actual place. He reaches beyond Mexican reality and frontiers to explore a mental space liberated from historical and geographical reality, merging with the spaces of the unconscious: 'Part of my mental landscape – and by extension, I believe, of Surrealism's mental landscape – is manifestly mapped out by Mexico ... Mexican roads plunge into the very zones where automatic writing basks and lingers.'[26] In this perspective Mexico is re-envisaged as part of a vast world remapped, a geology of the mind, a submerged continent of the unconscious which surfaces at a few elective sites.

Breton had embarked for Mexico intent on finding in the New World a utopian response to the decadence of Europe. He may not have found utopia, but he created an imaginary space by displacing Mexican realities, re-interpreting them enthusiastically through Surrealist-tinted glasses. The process can be illustrated by Breton's evocation of Kahlo in the catalogue essay he wrote for her first solo exhibition at the Julien Levy Gallery in New York in 1938.[27] After an introduction presenting Mexico as both real and fantastic, he transforms Kahlo into a magical being, comparing her to an Aztec Colima statuette, or a magical being 'adorned ... like a fairy-tale princess,

overleaf

140 Yves Tanguy, *Large Painting Representing a Landscape*, 1927, oil on canvas.

141 Frida Kahlo, *Self-portrait Dedicated to Leon Trotsky*, 1937, oil on masonite.

143 Henri Rousseau, *La Charmeuse de serpents*, 1907, oil on canvas.

with magical spells at her fingertips, in the flash of light of the *quetzal* bird scattering opals among the rocks as it flies off'. He contemplates a self-portrait of the artist in Trotsky's study, her dress made of 'butterflies' golden wings' (illus. 141). Claiming that her works are situated at the point where the lines of politics and art intersect, and that they are exclusively feminine – defined, rather stereotypically, as seduction, purity and perniciousness – Breton refers to them as 'a ribbon around a bomb', declaring that her latest works are fully and naturally Surrealist, free of outside influences. He thereby cavalierly bypasses Kahlo's agency, her involvement in the indigenous Mexicanidad movement and the international avant-garde art milieu.

142 Frida Kahlo, *Lo que el agua me dio*, 1938, oil on canvas.

She is drawn, instead, into the orbit of so-called 'natural' Surrealists like Nadja. He even claims that Kahlo's painting *Lo que el agua me dio* (What the Water Gave Me) of 1938 (illus. 142), depicting Kahlo's legs immersed in a bath, illustrates a sentence once pronounced by Nadja: 'I am the thought on the bath in a room without mirrors.'[28] Yet the details of the painting, empty Tehuana dress, cacti, flowers, Mexican volcano and American skyscraper – which Breton chose to bypass – clearly demand the acknowledgement of distinct autobiographical and political factors. It is hardly surprising that this appropriation of the artist and Mexico for Surrealism angered Kahlo, who retorted: 'I never knew I was a Surrealist until André Breton came to Mexico and told me I was.'[29]

Martinique

The collaborative work of Breton and Masson, *Martinique charmeuse de serpents* (Martinique: Snake Charmer), reveals a similar intertextual network, the sophisticated interweaving of evocations of a landscape, literary and pictorial memories and reflections on aesthetics.[30] On 25 March 1941 Breton with his second wife, Jacqueline, and daughter Aube left Marseille, their passage to New York organized by the Emergency Rescue Committee. The three hundred passengers included writer Victor Serge, novelist Anna Seghers, artist Wifredo Lam and anthropologist Claude Lévi-Strauss. The latter recalls Breton pacing up and down the deck in his overcoat, 'like a blue bear'; during the crossing the two men discussed aesthetics and wrote long letters to each other.[31] They arrived in Fort-de-France in the French colony of Martinique, where they stayed for three weeks, waiting for a boat to continue their voyage to New York. The island's Vichy authorities considered these exiles with a suspicious eye, and Breton, labelled a 'dangerous agitator', was first interned with his family in the Lazaret camp, a former leprosy colony. Having finally convinced the island governor that far from being a threat to public order, he wrote books of 'merely' poetic or psychological interest, Breton obtained a permit to move to the capital, Fort-de-France. In 'Un grand poète noir. Aimé Césaire', Breton relates his subsequent meeting with the

leading Martinican poets René Ménil and Aimé Césaire, founders of the Negritude movement and the literary journal *Tropiques* (1941–5).[32] The Bretons spent time with Césaire and his wife Suzanne ('as beautiful as the flame on a bowl of punch') at their home and on excursions in the interior of the island. He also met up with André Masson, who had arrived on the island shortly after him, also on his way to New York, and together they wrote *Martinique charmeuse de serpents*, with texts by Breton and Masson and six drawings by Masson.[33] The title is drawn from a painting by Douanier Rousseau, *La Charmeuse de serpents* (The Snake Charmer, 1907), which portrays a female snake charmer in a jungle landscape (illus. 143); it also references a prose poem by Saint-Pol-Roux, 'Le Charmeur de serpents' (1890), set in a darker, altogether more satanic context. It is arguable that this double intertext echoed the real contradictions of the island as experienced by Breton and Masson in 1941: a heady tropical vegetation on the one hand, and the harsh colonial reality on the other. 'In Martinique, in spring 1941, our eye is divided,' wrote Breton in the introduction, acknowledging that they were both 'madly seduced' and 'wounded and indignant' by what they encountered. Consequently, their texts were similarly divided, between factual account and lyrical evocation. 'Eaux troubles' (Troubled Waters) is an example of the former, focusing on the political and economic realities of the island, denouncing both their treatment at the hands of the Vichy authorities on arrival, and the poverty, discrimination, exploitation and corruption. 'Le Dialogue créole' (Creole Dialogue) is an example of the latter, responding to the rich landscapes of the island and the colourful life of Fort-de-France, and celebrating Aimé Césaire. Leiris, when writing about the work, was particularly sensitive to the island's dual nature as experienced by Masson and Breton: 'However seductively Martinique is portrayed in Breton and Masson's short work, there is also a tragic note in the text and no-one, having read it, could still believe in the paradise myth.'[34] The governor's suspicions, clearly, were well founded.

'Le Dialogue créole' combines the voices of Masson and Breton, each one responding in turn to the questions or comments of the other.[35] Their observations on the landscape before them lead to reflections on the links between the real and the imaginary, nature and art; on the Douanier Rousseau and the question of whether he had in fact

spent his military service in the Caribbean as claimed by Apollinaire. Above all the two men return again and again to the evocation of the paradisiac landscape, already familiar to them, according to Masson ('The forest envelops us: we knew the forest and her spells before we arrived'), his automatic drawing *Délire végétal* (Vegetal Delirium) from the *Massacre* series (1925) anticipating their presence here. Breton concurs, noting that imagination, anticipating the real, could act as a confirmation of the surreal: 'Surrealist landscapes will be seen as the least arbitrary ones. It is inevitable that they should find a resolution in those lands where nature has not been tamed at all.' Although Breton claims that art as the imitation of nature would be more pertinent here than elsewhere, the artist and poet actually indulge in a myriad poetico-pictorial allusions that mediate their experience, ranging across children's book illustrations, Baudelaire's poetry, the paintings of Rousseau, De Chirico and Magritte, Captain Cook's travel journals, the film *White Shadows*, Sade's novel *Justine*, Gallé glass and even Oscar Wilde's reflections on nature imitating art. The otherness of the tropical landscape, it would seem, could only be apprehended in terms of another alterity, the *dépaysement* engendered by nineteenth-century texts or twentieth-century paintings. Finally, the text culminates in a Maldororian analogy that epitomizes the break with referentiality: 'the canna flower, as beautiful as the circulation of blood from the lowest to the highest life forms, its calices filled to the brim with this marvellous residue.' This is less the description of a tropical flower than a case of free association, the actual flower being no more than a point of departure for the poet's heady poetico-erotic trajectory, the 'entanglement' of the trees of the forest spun into the rich interweaving of poetic images. The frontiers between topography and imagination blur as the dialogue unfolds, poet and painter projecting their own memories and desires (the representation of inner landscapes) onto the natural world (the perception of outer reality). Poet and artist, in short, may well have been looking at the forest that surrounded them but, above all, they 'recognized' it. The magical moment of discovery of the new, the *jamais vu* (the unknown) is experienced paradoxically as a moment of recognition, the *déja vu* (the already-known). The experiential is simultaneously the interweaving of outer and inner reality, the latter expressed in the proliferation of associations triggered by

the memory of privileged texts and paintings. Among these Breton and Masson declared that in the Caribbean 'Rousseau is at home even more perhaps than over there.' Whether true or not, their own vision of the landscapes of Martinique was certainly filtered through the artist's landscapes and figures. But were they really unaware that Rousseau's landscapes were a construct, like their own, thus confirming the playful irrelevance of their musings on whether he had been to the Caribbean?[36] Rousseau's version of tropical jungles, collaged to produce a highly subjective vision, was in fact conditioned by popular sources such as brochures of the fauna and flora of the Paris Jardin des Plantes and illustrations for International Exhibitions.[37] Breton and Masson happily insert a cliché of exotic literature like Rousseau's female snake charmer among the people they supposedly encountered on the island: 'Since our arrival we pass her on our way every day. She has lost nothing of her mystery and enticement.' More generally, what passes for a description of the young women of Martinique is mediated through a poem from Baudelaire's *Les Fleurs du mal* (Flowers of Evil), 'Avec ses vêtements ondoyants et nacrés' (With her undulating lustrous clothes). In the same vein, Breton transforms a simple cane-cutter with his cutlass into a sabre-wielding warrior. While this has given rise to criticisims like that of Régis Antoine, who saw in the text 'a curious rehashing of clichés about the islands', there is more than simple repetition at work here.[38] Beyond the cliché, poet and artist call on the discourse of excess and desire in order to extend and revitalize exotic codes. Masson in particular evokes the island in terms of femininity, both in his drawings where female figures appear intertwined with luxuriant vegetation (illus. 144) and in his prose poem 'Antille', which merges exotic and erotic registers in his evocation of the island's vegetation: 'at the heart of the vaginal shadow reigns the carnal flower of the canna.'

 This associative process as a response to the natural world can be applied to urban spaces too, as we see in 'Des épingles tremblantes' (Trembling Pins), eight short prose poems recounting Breton's walks in Fort-de-France. The town's colourful everyday scenes give rise to pictorial associations, the otherness of Surrealist paintings, whether real or imagined. A painted shop sign, for instance, recalls 'an extremely nuanced Magritte . . . Imagine a sky-blue butterfly the

size of an eagle on which is written the word PIGEON in white letters.' While we learn that Pigeon is actually the name of a butterfly specialist, the effect of the playful disparity between words and image remains. Elsewhere, the fruit stalls in the town's market conjure up a painting by De Chirico, *The Transformed Dream* (1913), depicting the marble bust of Jupiter juxtaposed with bananas and pineapples.

144 André Masson, *Martinique charmeuse de serpents*, 1948, drawing.

145 André Breton at Saint-Cirq-Lapopie, *c.* 1953.

Conclusion:
Beyond the Wall

LIKE COLUMBUS, FOR BRETON and his 'boatload of madmen', to chart the spaces of Mexico, Tenerife or Martinique was to explore spaces constantly shaped by and shaping their fantasies, dreams and desires. Were they, then, explorers or conquerors? Critics have underlined the paradox in the Surrealists' position, their practice of a form of colonization alongside their claim to anti-colonialist relations with non-Western cultures. For Keith Jordan, for example, Breton appropriated Kahlo for Surrealism 'the way . . . colonial explorers claimed indigenous lands for their mother countries'.[1] Paradoxical too is the Surrealist analogical principle itself, at once an exploratory practice, probing the limits of rationality and the imagination; and a practice that serves to bring the unknown into the purview of the known, and that can thus be interpreted as reducing alterity in a gesture of appropriation within a eurocentric mindset.

It is this paradox that lies at the heart of Breton's writings on art, his collecting practice, or his work as curator. He left an eclectic corpus that reveals a dual tendency, centripetal and centrifugal. On the one hand artists and poets are generously, and at times somewhat cavalierly, appropriated for Surrealism, envisaged as precursor (Henri Rousseau), 'natural Surrealist' (Nadja), or simply 'Surrealist in absinthe' (Alfred Jarry). On the other hand, Breton's interests range widely beyond Surrealism and Europe, both geographically, from Native Australian to Pacific Northwest Coast art, and temporally, from ancient Gaul to contemporary Prague.

Breton's openness to diverse if not divergent artistic practices was in tune with the aesthetics of cultural relativism in art-critical discourse of the interwar years, an aesthetics in which artworks from

widely different domains were subsumed within the notion of a universal culture. The practice of juxtaposition of very diverse cultural artefacts was thus widespread, whether expressed materially in exhibition displays and artists' studios or discussed in avant-garde art journals. In *Cahiers d'art*, which played a crucial role in the circulation of photographic reproductions of artworks, the editor Christian Zervos juxtaposed for example illustrations of classical statues and contemporary paintings, the neolithic sculpture of a ram from Silesia alongside a collage bull by Picasso.[2] This aesthetic position was based on the principle of analogical associations among cultures across space and time, in which the contemporary artist was seen as 'a link in the chain started by prehistoric man and continued by supreme primitive man', a position that informed the myth of the modern artist's desire for a return to a primitive state freed of cultural accretions.[3] The idea of an all-embracing universal art was developed by 'Dr O.' in an alchemical metaphor expressing the transformation and fusion of cultural artefacts in a unifying vision:

> New cosmopolitan art sees the fusion into a vast community of French and Russian, German and Spanish artworks, the art of the islands of the South Pacific, of America, Africa . . . the face of the new culture created in the furnace of capital cities.[4]

A related vision was adopted by the Viennese artist Wolfgang Paalen (1905–1959), who travelled to Alaska and British Columbia in 1939, where he acquired a large number of objects, and settled in Mexico in 1940. In his preface to the Amerindian issue of *Dyn*, he called for a fusion of modern art with the art of the Americas, Asia, Africa and Oceania, via the notion of a 'universal osmosis', the integration of all art forms that would abolish temporal and spatial frontiers and create a 'world-consciousness' as 'the negation of all exoticism' – that is, the rejection of (colonialist) hierarchy in artistic systems.[5] In Paalen's Mexico City studio, objects from various cultures were displayed side by side, such as a Cycladic statue alongside the stone statue of an Aztec corn goddess. Paalen, aptly named by Breton 'a man at the intersection of major pathways',[6] believed in the

continuity between perception and memory, caught in the image of a 'level crossing' (*passage à niveau*): the levelling process of a horizontal rather than a hierarchical view of culture; and the crossing between what can be seen and what can be imagined.

In a similar vein, the French writer André Malraux's *Le musée imaginaire* (1947) developed the idea of an 'imaginary museum' that included works from Lascaux to China, early Renaissance Italian painting to Hindu statuary, an enterprise aided by the ready availability of photographic reproductions of artworks. Malraux's juggling with very diverse cultural artefacts was underpinned by the notion of the alleged unity of human culture (a notion defended by Paul Rivet, who founded the Musée de l'Homme in 1937), facilitated by isolating art objects from their original socio-cultural contexts.

When Breton exhibited paintings by Aloïse Corbaz and Friedrich Schröder-Sonnenstern alongside Surrealist artists at the 1959 *Exposition internationale du Surréalisme* (EROS) at the Daniel Cordier Gallery; when he juxtaposed Hopi Kachina dolls with a painting by Victor Brauner on the wall of his studio; when he compared the figures in Tanguy's paintings to Mayan temples; when he placed a Kachina doll opposite an exquisite corpse in *La Révolution surréaliste*, a stone next to a statue, he triggered horizontal associations or 'crossings' in an ever-expanding analogical spirit – 'the inexhaustible well of universal analogy', according to Baudelaire in *L'Art romantique* (1869). The sustained use of analogies is linked to Breton's interest in the philosophy of Charles Fourier, whose world-view was based on the analogical principle. But was his vision homogeneous or simply eclectic? The isolation of the objects from their original context enhanced their power of suggestion, reinforced the analogical processes, and facilitated their assimilation to an overarching concept such as 'magic'; or the esoteric (at work in *Le Surréalisme en 1947*); or as the projection of inner forces, 'a constant grasping of the invisible through the visible', in the words of the art historian René Huyghe (respondent in the survey for *L'Art magique* discussed in Chapter Nine). Such unifying categories are a critique of established aesthetic hierarchies, described by Roger Cardinal as 'a kind of esperanto of vision, inviting us to appreciate the delirium of analogy as concealing an implicit harmony, and thus perceive scattered fragments as the

components of a single discourse'.⁷ Breton's essentially centripetal unifying notion of art is opposed to Bataille's centrifugal and heterogeneous concept that, in the words of James Clifford, belongs to 'the order of an unfinished collage rather than that of a unified organism'.⁸ By promoting the poetic qualities of works and celebrating diversity, Breton appropriated them for the analogical principle and thus for Surrealism, endowing them with coherence and cohesion. At the same time he was embarking on a passionate and dangerous voyage out, a voyage of discovery:

> At the end of twenty years I find myself obliged, as I did in my youth, to take a public stand against every kind of conformity and in so doing also attack a Surrealist conformity that is all too obvious. Too many paintings, for example, appear on the scene today all decked out in what has cost the innumerable followers of Chirico, Picasso, Ernst, Masson, Miró, Tanguy (and tomorrow Matta) absolutely nothing; followers unaware of the fact that there can be no great expedition in art which is not undertaken *at the risk of one's life*, the route to follow has no safeguards, and each artist must take up alone the search for the *Golden Fleece*.⁹

References

one
Who Are You, André Breton?

1 Paul Éluard, dedication, *From Stendhal to René Char: Le Cabinet de livres de Renaud Gillet* (London, 1999), p. 154.
2 Marcel Duchamp, 'Duchamp raconte Breton', *Arts-Loisirs* (5 October 1966), p. 5.
3 Salvador Dalí, *The Unspeakable Confessions of Salvador Dalí*, trans. H. J. Salemson (London, 1976), p. 84.
4 Georges Bataille, 'Le lion châtré' (1930); translated as 'The Castrated Lion', in *The Absence of Myth: Writings on Surrealism*, ed. and trans. Michael Richardson (London and New York, 1994), p. 28.
5 Paul Laraque, 'André Breton in Haiti' [1971], in *Refusal of the Shadow: Surrealism and the Caribbean*, ed. and trans. Michael Richardson and Krzysztof Fijalkowski (London and New York, 1996), p. 218.
6 Duchamp, 'Duchamp raconte Breton'.
7 Calmels Cohen, *André Breton, rue Fontaine: Vente, Paris, Drouot-Richelieu*, 8 vols (Paris, 2003).
8 See, however, José Pierre, *André Breton et la peinture* (Lausanne, 1987); and *Lire le regard. André Breton et la peinture*, *Pleine Marge*, 13 (June 1991), ed. Jacqueline Chénieux-Gendron (Paris, 1993).
9 Two extensive biographies of Breton have been published: Henri Béhar, *André Breton. Le Grand Indésirable* (Paris, 2005); and Mark Polizzotti, *Revolution of the Mind: The Life of André Breton* (Boston, MA, 2009); see also Breton, *Entretiens* (Paris, 1952), translated as *Conversations: The Autobiography of Surrealism*, trans. and intro. Mark Polizzotti (New York, 1993).

10 Breton, 'Manifesto of Surrealism' [1924], in *Manifestoes of Surrealism*, trans. Richard Seaver and Helen R. Lane (Ann Arbor, MI, 1972), p. 40.
11 In 1931 Breton sent a copy of his prose text *Les Vases communicants* (Communicating Vessels) to Freud, who confessed he did not understand Surrealism.
12 Adrienne Monnier, *Rue de l'Odéon* (Paris, 1989), pp. 92–3.
13 Breton, 'Lâchez tout', *Littérature*, II/1 (April 1922), pp. 8–10.
14 Simone Kahn, letter of 31 July 1920, quoted in Breton, *Oeuvres complètes*, vol. I (Paris, 1998), p. xlii.
15 Breton, *Manifestoes*, p. 14.
16 Michel Leiris, *C'est-à-dire* (Paris, 1992), p. 16.
17 Breton, *Manifestoes*, p. 26 (translation modified).
18 Maurice Martin du Gard, 'Le Surréalisme? André Breton', *Nouvelles littéraires*, III/104 (October 1924).
19 Breton, *Manifestoes*, p. 123.
20 Brassaï, *Conversations avec Picasso* (Paris, 1964), p. 24.
21 Breton, 'Position politique de l'art d'aujourd'hui' (Political Position of Today's Art) and 'Situation surréaliste de l'objet, situation de l'objet surréaliste' (Surrealist Situation of the Object, Situation of the Surrealist Object), in *Position politique du surréalisme* (Paris, 1935); trans. *Manifestoes*, pp. 212–33 and 255–78.
22 Quoted in Polizzotti, *Revolution*, p. 512.
23 Letter to Matisse (5 February 1948), quoted in *André Breton. La beauté convulsive*, exh. cat., Musée national d'art moderne (Paris, 1991), p. 86.
24 Breton, 'C'est à vous de parler, jeune voyant des choses', *XXe Siècle*, 9 (1952), pp. 27–30 (p. 27); *Oeuvres complètes*, vol. IV (Paris, 2008), pp. 854–9.
25 Breton, 'Caractères de l'évolution moderne et ce qui en participe', *Les Pas Perdus* (1924); *Oeuvres*, vol. I, pp. 291–3.
26 Breton, *Manifestoes*, p. 27.
27 Surrealism's reception by Anglo-American critics has focused on Surrealism mainly in the context of the history of the visual arts, unlike its reception by French critics who, until recently, have considered it essentially as a literary movement.

two
'Whom do I haunt?': Encounters with Artists

1 Breton, *Nadja*, trans. Richard Howard (New York, 1960), p. 11.
2 Mark Polizzotti, *Revolution of the Mind: The Life of André Breton* (Boston, MA, 2009), p. 215.
3 Quoted in Marie-Laure Bernadec, 'André Breton et Pablo Picasso: "tout le sang possible vers le coeur"', in *André Breton. La beauté convulsive*, exh. cat., Musée national d'art moderne (Paris, 1991), p. 210.
4 Letter to Picasso (16 March 1936), quoted in *André Breton. La beauté convulsive*, p. 228.
5 Quoted in Etienne-Alain Hubert, 'Art as Event: The Surrealists' Reaction to the Work of Picasso', in *The Surrealist Picasso*, ed. Anne Baldassari, exh. cat., Fondation Beyeler (Basel, 2005), p. 210.
6 Polizzotti, *Revolution*, p. 172.
7 Breton, 'Hommage à Picasso', *Paris Journal* (20 June 1924).
8 Breton, *Lettres à Simone Kahn* (Paris, 2016), p. 99.
9 Breton and Éluard, *Dictionnaire abrégé du surréalisme* (Paris, 1938); Breton, *Oeuvres completes*, vol. II (Paris, 1992), p. 832.
10 'Le Surréalisme et la peinture', *La Révolution surréaliste*, 4 (1925), pp. 26–30, illustrated with Picasso's paintings *Arlequin* (1924), *Etudiant* (1913) and *Écolière* (1920). The same issue reproduced *Les Demoiselles d'Avignon* (1906–7) and *Jeunes Filles dansant devant une fenêtre* (1925).
11 Arthur Rimbaud, 'Alchimie du verbe', *Une Saison en enfer* (1873); 'Enfance', *Les Illuminations* (1886).
12 Breton, 'Le Surréalisme et la peinture', *La Révolution surréaliste*, 4 (1925), p. 29.
13 *La Révolution surréaliste*, 1 (1924), p. 19. Elizabeth Cowling, '"Proudly we claim him as one of us": Breton, Picasso, and the Surrealist Movement', *Art History*, VIII/1 (1985), p. 88.
14 Breton, 'Picasso dans son élément', *Minotaure*, 1 (1933), pp. 10–22; *Le Surréalisme et la peinture* (Paris, 1965), pp. 101–14.
15 Georges Bataille, 'Le Bas Matérialisme et la glose', *Documents*, II/2 (1930), pp. 1–8.
16 Brassaï, *Conversations avec Picasso* (Paris, 1964), p. 50.
17 Picasso also wrote poems, some of which were published in a special issue of *Cahiers d'art*, *Picasso 1930–1935*, 7–10 (1936). In his article

'Picasso poète' in the same issue, Breton treats the poems as a complement to his painting, 'His poetry can only be plastic, just as his painting is poetic.' Breton's *Anthologie de l'humour noir* (Paris, 1940) includes two poems and an etching by Picasso.

18 Breton, *Le Surréalisme et la peinture*, p. 56.
19 Letter to Penrose (6 July 1936), quoted in *André Breton. La beauté convulsive*, p. 230.
20 Breton, 'Comète surréaliste' (1947), first published in *Essais et témoignages*, ed. Max Eigeldinger (Neuchâtel, 1949); 'Surrealist Comet', *Free Rein*, trans. Michel Parmentier and Jacqueline d'Amboise (Lincoln, NE, 1995), p. 93 (translation modified).
21 Breton and Péret, 'La Vie imagée de Picasso', *Arts* (28 December 1951).
22 *Paris-Presse-L'Intransigeant* (22 March 1953); *Oeuvres complètes*, vol. III (Paris, 1999), pp. 1096–7. Breton is referring to a burlesque actor, nicknamed Dudule in French. Picasso's portrait of Stalin appeared on the first page of *Lettres françaises* (8 March 1953), three days after Stalin's death.
23 Breton, 'Pablo Picasso. 80 carats . . . mais une ombre', *Combat-Art* (6 November 1961); *Le Surréalisme et la peinture*, pp. 116–18.
24 Breton, *Conversations: Autobiography of Surrealism*, trans. Mark Polizzotti (St Paul, MN, 1993), p. 54.
25 Breton, 'Max Ernst' (1921) in *Oeuvres complètes*, vol. I (Paris, 1990), p. 246; Breton, *What Is Surrealism? Selected Writings*, ed. and trans. Franklin Rosemont (London, 1978), p. 16.
26 Breton, *Manifestoes of Surrealism*, trans. Richard Seaver and Helen R. Lane (Ann Arbor, MI, 1972), p. 37.
27 Max Ernst, *Au rendez-vous des amis 1931 or Loplop introduces members of the Surrealist Group*, *Le Surréalisme au service de la révolution*, 5 (1931), p. 37.
28 First published in VVV 2–3 (1943); *Oeuvres complètes*, vol. III (Paris, 1990), pp. 709–25.
29 Breton, 'Le Surréalisme et la peinture', *La Révolution surréaliste*, 9–10 (1927), pp. 38–41; *Le Surréalisme et la peinture*, pp. 23–32.
30 Breton, 'Avis au lecteur pour *La Femme 100 têtes* de Max Ernst', preface to Max Ernst, *La Femme 100 têtes* (Paris, 1929); *Oeuvres*, vol. II, pp. 302–6.
31 Max Ernst, Man Ray, Jean Arp et al., *L'Homme qui a perdu son squelette*, *Plastic/Plastique*, 4–5 (1939), pp. 2–6 and 5; pp. 2–9.

32 Breton, 'The Legendary Life of Max Ernst', *View*, II/1 (April 1942), pp. 5–7; translated as 'La Vie légendaire de Max Ernst', *Le Surréalisme et la peinture*, pp. 155–65.
33 Dorothea Tanning, quoted in Polizzotti, *Revolution*, p. 463.
34 Breton, *Le Surréalisme et la peinture*, pp. 166–8.
35 Ernst, *Écritures* (Paris, 1970), p. 344.
36 Breton and Gérard Legrand, *L'Art magique* (Paris, 1957); *Oeuvres complètes*, vol. IV (Paris, 2008), p. 286.
37 Breton, *Le Surréalisme et la peinture* (Paris, 1965), p. 70.
38 Ibid., p. 36.
39 Jacques Dupin, *Joan Miró* (Paris, 1961).
40 Joan Miró, *Ceci est la couleur de mes rêves. Entretiens avec Georges Raillard* (Paris, 1977), p. 77.
41 *Joan Miró: Selected Writings and Interviews*, ed. Margit Rowell (New York, 1992), p. 249.
42 Ibid., pp. 86–7.
43 Aragon and Breton, 'Protestation', *La Révolution surréaliste*, 7 (June 1926), p. 31.
44 Breton, *Le Surréalisme et la peinture*, p. 70.
45 Ibid., p. 36.
46 *Joan Miró: Selected Writings*, p. 116.
47 Salvador Dalí, 'Nous límits de la pintura', *L'Amic de les Arts*, III/23 (May 1928), p. 196; 'New Limits of Painting', in *Salvador Dalí: Collected Writings*, ed. and trans. Haim Finkelstein (Cambridge, 1998), p. 81.
48 Breton, *Manifestoes of Surrealism*, p. 125.
49 *Danseuse espagnole* was reproduced with *Portrait d'une danseuse* (1928) in a special Surrealism issue of *Variétés* (1929), edited by Aragon and Breton.
50 Margit Rowell, 'André Breton and Joan Miró', in *André Breton. La beauté convulsive*, p. 181.
51 Michel Leiris, 'Joan Miró', *Documents*, 1/5 (1929), p. 265.
52 Miró, *Ceci est la couleur de mes rêves*, p. 78.
53 Michel Leiris, *Journal, 1922–1989* (Paris, 1992), p. 154.
54 Maxime Alexandre, *Mémoires d'un surréaliste* (Paris, 1968), p. 181.
55 'Flouquet', *Monde* (30 November 1929); Tériade, *L'Intransigeant* (15 November 1929).
56 On the Breton–Bataille polemic see Jean-François Fourny, 'A propos de la querelle Breton-Bataille', *Revue d'histoire littéraire de la France*,

LXXXIV/3 (1984), pp. 432–8; Marie-Christine Lalla, 'Bataille et Breton: le malentendu considérable', in *Surréalisme et philosophie* (Paris, 1992), pp. 49–61. While Fourny claims that the theoretical divergence between Breton and Bataille hid deep psychological motivations of envy and rivalry, Lalla situates the debate on a philosophical level.

57 Breton, *Conversations*, p. 124.
58 Breton, 'Première exposition Dalí', *Oeuvres*, vol. II, p. 307.
59 Ibid., p. 308.
60 Bataille, 'Matérialisme', *Documents*, 1/3 (June 1929), p. 170.
61 Bataille, 'Le Langage des fleurs', *Documents*, 1/3 (1929), pp. 160–68.
62 Bataille, 'Le "Jeu lugubre"', *Documents*, 1/7 (December 1929), pp. 369–72.
63 Bataille, 'The Castrated Lion', in *The Absence of Myth: Writings on Surrealism*, ed. and trans. Michael Richardson (London and New York, 1994), p. 28.
64 Dalí, *The Unspeakable Confessions of Salvador Dalí*, trans. H. J. Salemson (London, 1976), p. 113.
65 Ibid.
66 Polizzotti, *Revolution*, p. 353.
67 The incident is related in detail by Georges Hugnet, *Pleins et déliés* (Paris, 1972), pp. 253–62.

three
Painting or Poetry? A Surrealist Aesthetics

1 André Masson, *Vagabond du surréalisme* (Paris, 1975), p. 56.
2 André Breton, 'Max Ernst', in *What Is Surrealism? Selected Writings*, ed. and trans. Franklin Rosemont (London, 1978), p. 16.
3 Breton, *Manifestoes of Surrealism*, trans. Richard Seaver and Helen R. Lane (Ann Arbor, MI, 1972), p. 37.
4 Ibid., p. 20.
5 Ibid., p. 21.
6 Ibid., p. 29.
7 Breton, 'Surrealist Situation of the Object', in *Manifestoes*, p. 260.
8 Vassily Kandinsky, *Complete Writings on Art*, vol. II (London, 1982), p. 833.

9 *Manifestoes*, p. 38.

10 Max Morise, 'Les Yeux enchantés', *La Révolution surréaliste*, 1 (1924), pp. 26–7.

11 Pierre Naville, 'Beaux-arts', *La Révolution surréaliste*, 3 (1925), p. 17. Masson shared Naville's position: 'Automatic drawings are the drawings of mediums: there is no break between the moment of creation and the object created. Whereas in painting a lot of preparation is needed, which creates a gap.' Masson, *Vagabond*, p. 79.

12 Breton, 'Max Ernst', p. 16.

13 Breton, 'La beauté sera convulsive', *Minotaure*, 5 (1934). The text was integrated into *L'Amour fou* (1937), translated as *Mad Love*, trans. Mary Ann Caws (Lincoln, NE, 1987), p. 19.

14 Benjamin Péret, 'La Nature dévore le progrès et le dépasse', *Minotaure*, 10 (1937), p. 20.

15 Breton, 'Prestige d'André Masson', *Minotaure*, 12–13 (1939), pp. 13–15; *Le Surréalisme et la peinture* (Paris, 1965), pp. 151–4.

16 Breton, 'Óscar Domínguez' [1936], in *Le Surréalisme et la peinture*, pp. 128–9; 'Wolfgang Paalen' [1938], preface to Paalen's solo exhibition at the Galerie Renou et Colle, *Le Surréalisme et la peinture*, pp. 136–8, trans. E.L.T. Mesens, *London Bulletin*, 10 (1939), pp. 16–17. See 'Des tendances les plus récentes de la peinture', *Minotaure*, 12–13 (1939), pp. 16–21; *Le Surréalisme et la peinture*, pp. 145–50.

17 Breton, *Le Surréalisme et la peinture*, p. 146.

18 The word *sauvage* has the connotation of wild or savage, but also of innocence, purity, primitivism. Breton's notion derives from the Romantics' belief in the poet's pre-rational vision. On the importance of the eye in Surrealism see Martin Jay's excellent analysis, *Downcast Eyes: The Denigration of Vision in Twentieth-century French Thought* (Berkeley, Los Angeles, CA, and London, 1994), pp. 236–62.

19 Breton, 'Déclaration', VVV, 1 (1942), p. 1; *Free Rein*, trans. Michel Parmentier and Jacqueline d'Amboise (Lincoln, NE, 1995), pp. 68–9.

20 Breton, 'Max Ernst', p. 16 (translation modified).

21 Breton, *Le Surréalisme et la peinture*, pp. 2–3.

22 Ibid., p. 221.

23 Pierre Bourdieu and Alain Darbel, *L'Amour de l'art. Les musées européens et leur public* (Paris, 1966), p. 108.

24 Ernst Gombrich, *Art and Illusion* (Princeton, NJ, 1960), p. 298.

25 Mary Ann Caws, *The Eye in the Text: Essays on Perception, Mannerist to Modern* (Princeton, NJ, 1981), pp. 3, 87–8.
26 Breton, *Le Surréalisme et la peinture*, p. 44.
27 Breton, *Conversations: The Autobiography of Surrealism*, trans. Mark Polizzotti (St Paul, MN, 1993), p. 176.
28 Breton, *Le Surréalisme et la peinture*, p. 308.
29 Breton, 'Avant-dire', in *Yves Tanguy* (New York, 1946), p. 9; *Oeuvres complètes*, vol. III (Paris, 1999), p. 146.
30 Susan Sontag, *Against Interpretation* (New York, 1966), p. 9.
31 Breton, *Mad Love*, p. 8.
32 'C'est à vous de parler, jeune voyant des choses . . .', *XXe siècle*, 3 (1952); *Oeuvres complètes*, vol. IV (Paris, 2008), p. 858.
33 Michael Riffaterre, 'Ekphrasis lyrique', in *Lire le regard. André Breton et la peinture*, ed. Jacqueline Chénieux-Gendron, *Pleine Marge*, 13 (1991), pp. 179–98.
34 Bernard Vouilloux, *La Peinture dans le texte (XVIIIe–XXe siècle)* (Paris, 1994), p. 28.
35 Breton, *Le Surréalisme et la peinture*, p. 30.
36 Ibid., p. 146.
37 Ibid., p. 154.
38 Ibid., p. 286. Breton's text was originally published in English under the title 'Some Appreciations of the Work of Wassily Kandinsky', translated by Samuel Beckett.
39 Quoted in Christian Derouet, *Kandinsky in Paris: 1934–1944* (New York, 1985), p. 52.
40 Breton, 'Avis au lecteur', *Oeuvres*, vol. II, p. 306.
41 Breton, *Le Surréalisme et la peinture*, p. 171.

four
Between Marx and Rimbaud: Art and Revolution

1 André Breton, *Manifestoes of Surrealism*, trans. Richard Seaver and Helen R. Lane (Ann Arbor, MI, 1972), p. 241.
2 Louis Aragon, 'Communisme et révolution', *La Révolution surréaliste*, 2 (1925), p. 32.
3 Robert Short, 'The Politics of Surrealism, 1920–36', *Journal of Contemporary History*, 1/2 (1966), pp. 3–25.

4 Helena Lewis, 'Surrealists, Stalinists and Trotskyists: Theories of Art and Revolution in France between the Wars', *Art Journal*, LII/1 (1993), pp. 61–8.
5 'La Révolution d'abord et toujours!', *La Révolution surréaliste*, 5 (1925), pp. 31–2; *Clarté*, 77 (1925).
6 Breton, 'Légitime défense', *La Révolution surréaliste*, 8 (1926), pp. 30–36.
7 Breton, *Manifestoes*, p. 151.
8 Breton, *Conversations: The Autobiography of Surrealism*, trans. Mark Polizzotti (St Paul, MN, 1993) p. 100.
9 Georges Charbonnier, *Entretiens avec André Masson* (Paris, 1985), p. 76.
10 Salvador Dalí, 'Rêverie', *Le Surréalisme au service de la révoution*, 4 (1931), pp. 31–6.
11 Breton, 'Position politique de l'art d'aujourd'hui', in *Position politique du surréalisme* (Paris, 1935); 'Political Position of Today's Art', *Manifestoes*, pp. 212–33.
12 Mark Polizzotti, *Revolution of the Mind: The Life of André Breton* (Boston, MA, 2009), p. 375.
13 Breton, 'Speech to the Congress of Writers' [1935], *Manifestoes*, p. 240.
14 Breton, 'Souvenir du Mexique', *Minotaure*, 12–13 (1939), pp. 29–50; 'Memory of Mexico', *Free Rein*, trans. Michel Parmentier and Jacqueline d'Amboise (Lincoln, NE, 1995), pp. 23–8.
15 Patrick Marnham, *Dreaming with His Eyes Open: A Life of Diego Rivera* (Berkeley and Los Angeles, CA, 2000), p. 284.
16 In 1925 Breton had written an admiring review of Trotsky's text on Lenin; 'Léon Trotsky: Lénine', *La Révolution surréaliste*, 5 (1925), p. 29.
17 Jacqueline Lamba, 'La rencontre Trotsky-Breton', in Arturo Schwarz, *Breton/Trotsky* (Paris, 1977), p. 209.
18 Breton, 'Visite à Léon Trotsky', *Quatrième Internationale*, 14–16 (1938); 'Visit with Leon Trotsky', *Free Rein*, p. 45. Originally given as a lecture in November 1938 on Breton's return from Mexico at a meeting of the Parti ouvrier internationaliste (POI).
19 Breton and Trotsky, 'Pour un art révolutionnaire indépendant', *Quatrième Internationale*, 14–15 (1938), pp. 239–41; 'Manifesto: Towards a Free Revolutionary Art', trans. Dwight Macdonald, *Partisan Review*, VI/1 (1938), pp. 49–53; *Free Rein*, pp. 29–34.
20 Louise Tythacott, *Surrealism and the Exotic* (London, 2002), p. 13.

21 Diego Rivera (1886–1957) took part in the muralist programme set up in 1921 by José Vasconcelos, the Mexican Minister of Education. His murals include those of the National Palace and the Ministry of Education in Mexico City, the National School of Agriculture in Chapingo, and, in the United States, examples in San Francisco, Detroit and New York.
22 See Emmanuel Rubio, 'André Breton et Diego Rivera, ou le rêve d'une terre indigène', *Mélusine*, 19: *Mexique, miroir magnétique* (1999), pp. 118–29.
23 Quoted in *Oeuvres complètes*, vol. III (1999), p. 1347.
24 Breton, 'Frida Kahlo di Rivera', *Le Surréalisme et la peinture*, p. 143.
25 Keith Jordan, 'Surrealist Visions of Pre-Columbian Mesoamerica and the Legacy of Colonialism: The Good, the (Revalued) Bad, and the Ugly', *Journal of Surrealism and the Americas*, II/1 (2008), p. 47.
26 Interview with E. F. Granell in Ciudad Trujillo (28 May 1941); *Oeuvres*, vol. III, p. 124.
27 Robin Adele Greeley, 'For an Independent Revolutionary Art: Breton, Trotsky and Cardenas's Mexico', in *Surrealism, Politics and Culture*, ed. Raymond Spiteri and D. LaCoss (Aldershot, 2003), p. 216.
28 Breton, 'Mexique', exh. cat. *Mexique*, Galerie Renou et Colle; *Oeuvres complètes*, vol. II (1992), p. 1237.
29 Breton, 'Rufino Tamayo', *Le Surréalisme et la peinture*, pp. 230–34.
30 Breton, 'Situation du surréalisme entre les deux guerres', VVV, 2–3 (1943), p. 50; *Oeuvres*, vol. III, pp. 718–9.
31 Charles Estienne, 'Surréalisme au Salvador (Dalí)', *L'Observateur*, 64 (17 January 1951).
32 Tzara left the Surrealist movement in 1935 and joined the PCF. An active member of the Resistance (with Aragon and Éluard) and the Comité National des Écrivains (a wartime underground association of writers), he published articles in clandestine publications during the war.
33 Ellen E. Adams, 'At the Boundary of Action and Dream: Surrealism and the Battle for Post-Liberation France', *French Cultural Studies*, XXXI/4 (2016), pp. 319–34.
34 Jean-Paul Sartre, *Qu'est-ce que la littérature* (Paris, 1948).
35 Breton, *Le Surréalisme et la peinture*, p. 202.
36 'Comète surréaliste' (1947), *Oeuvres*, vol. III, pp. 750–59; *Free Rein*, pp. 88–97.

37 'Pourquoi nous cache-t-on la peinture russe contemporaine?', *Arts* (11 January 1952); *Oeuvres*, vol. III, pp. 926–34. Three Russian paintings are reproduced on page 1: Alexandre Alexandrovic's *Fete des sports à Moscou* and Rianguine's *La violoniste* and *Construction du barrage*.

38 'Du "rèalisme socialiste" comme moyen d'extermination morale', *Arts* (1 May 1952); *Oeuvres*, vol. III, pp. 945–8.

39 Renée Mabin, 'La Galerie A l'Étoile scellée', *Mélusine*, 28 (2008), pp. 295–307.

40 *Arts* (5 December 1952); *Oeuvres*, vol. III, p. 1081.

41 Charles Estienne and José Pierre, 'Situation de la peinture en 1954', *Médium*, 4 (1955), pp. 43–55.

42 Breton, 'Comète surréaliste', *Free Rein*, p. 91.

five
Cutting and Pasting: Breton the Artist

1 See Elza Adamowicz, 'Hats or Jellyfish? André Breton's Collages', in *André Breton: The Power of Language*, ed. Ramona Fotiade (Exeter, 2000), pp. 83–96.

2 Louis Aragon, *Collages* (Paris, 1980), p. 49.

3 Many of Breton's collages and poem-objects are reproduced in André Breton, *Je vois j'imagine* (Paris, 1991).

4 *Le Comte de Foix allant assassiner son fils*, reproduced in André Breton, *Intervention surréaliste, Documents 1934* (1934); Breton, *Je vois j'imagine*, p. 64.

5 Gaston Tissandier, *Popular Scientific Recreations* (London, 1885), pp. 36 and 38.

6 *Charles VI jouant aux cartes pendant sa folie*, reproduced in Breton, *Intervention surréaliste, Documents 1934*; Breton, *Je vois j'imagine*, p. 65.

7 Anonymous, *La Nature*, 399 (22 January 1881), p. 121.

8 Breton's collage *Un temps de chien* [1932], staging a confrontation between a worker and a *gendarme* (police officer) in a desert setting, was published in the same issue.

9 Breton, 'Du poème-objet' [1942], *Le Surréalisme et la peinture* (Paris, 1965), p. 284.

10 Breton, *Le Surréalisme et la peinture*, p. 279.

11 See Breton's preface to the exhibition *Le Surréalisme et la peinture*, pp. 282–3.
12 René Magritte, 'Les Mots et les images', *La Révolution surréaliste*, 12 (1929), pp. 32–3.
13 Breton, 'Surrealist Situation of the Object', in *Manifestoes of Surrealism*, trans. Richard Seaver and Helen R. Lane (Ann Arbor, MI, 1972), p. 263.
14 Breton, *Conversations: The Autobiography of Surrealism*, trans. Mark Polizzotti (St Paul, MN, 1993), p. 127.
15 Breton, *Manifestoes*, p. 263.
16 Breton, 'Rêve-objet', *Cahiers d'art*, X/5–6 (1935), p. 125.
17 Octavio Paz, preface, in Breton, *Je vois j'imagine*, p. xi.
18 José Pierre, 'André Breton et le poème-objet', in *L'Objet au défi*, ed. Jacqueline Chénieux-Gendron and M-C. Dumas (Paris, 1987), p. 136.
19 Ibid.; Phil Powrie, 'The Surrealist *poème-objet*', in *Surrealism: Surrealist Visuality*, ed. Silvano Levy (Keele, 1996), pp. 57–77; Pascaline Mourier-Casile, 'Le poème-objet ou l'exaltation réciproque', *La Licorne*, 23 (2006), pp. 213–30.
20 Breton, *Le Suréalisme et la peinture*, pp. 284–5.
21 Breton also published interpretations of *Communication relative au hasard objectif* (1933), *Rêve-objet* (1935) and *Ces terrains vagues* (1941).
22 Breton, 'Le Corset Mystère', *Littérature*, 4 (June 1919), p. 7; *Oeuvres complètes*, vol I (1990), p. 16.
23 Jacqueline Chénieux-Gendron, 'Mentalité surréaliste et attitude ludique', in *Jeu surréaliste et humour noir*, ed. J. Chénieux-Gendron and M.-C. Dumas (Paris, 1992), pp. 311–29.
24 Jean Schuster, 'Enrichissez votre vocabulaire', *La Brèche*, 3 (1962), p. 52. Freud's *Jokes and their Relation to the Unconscious* (Vienna, 1905) was translated into French in 1930.
25 Breton and Éluard, *Dictionnaire abrégé du surréalisme* (Paris, 1938); *Oeuvres*, vol. II, p. 796.
26 Breton, 'Le Cadavre exquis, son exaltation', *Le Surréalisme et la peinture*, p. 290.
27 Paul Celan, *Varian Fry et les candidats à l'exil. Marseille 1940–1941*, exh. cat., Galerie d'art du Conseil général des Bouches du Rhône, Aix-en-Provence (1999).
28 Jean-Louis Bédouin, *20 Ans du surréalisme 1939–59* (Paris, 1961), p. 27.
29 Breton, 'Le jeu de Marseille', *VVV*, 2–3 (1943), pp. 88–90; 'The Marseilles

Deck', *Free Rein*, trans. Michel Parmentier and Jacqueline d'Amboise (Lincoln, NE, 1995), pp. 48–50. See also *Le Jeu de Marseille. Autour d'André Breton et des surréalistes a Marseille en 1940–41*, ed. Danièle Giraudy (Marseille, 2003).
30 Breton owned several works on the tarot, including Oswald Wirth's *Le Tarot des imagiers* (1927).
31 The set of cards is reproduced in *La Planète affolée* (Marseille, 1986), pp. 64–5. The cards were redesigned by Frédéric Delanglade and exhibited in 1941 at the Museum of Modern Art in New York; several were reproduced in VVV to illustrate Breton's article. A new edition was published in 1983 by André Dimanche. The original set of tarot cards was donated by Aube Breton Elléouët to the musée Cantini in Marseille in 2003.

six
Surrealism and Books: Doors 'left ajar'

1 André Breton, *Manifestoes of Surrealism*, trans. Richard Seaver and Helen R. Lane (Ann Arbor, MI, 1972), p. 277.
2 Breton, *Le Surréalisme et la peinture* (Paris, 1965), p. 284.
3 Breton, *Nadja*, trans. Richard Howard (New York, 1960). A facsimile of the original manuscript, with a text by Jacqueline Chénieux-Gendron and Olivier Wagner, was published in 2019.
4 Ibid., p. 11.
5 Ibid., p. 20.
6 There has been much speculation about the identity of Nadja. Consulting archives and interviews, the writer Hester Albach has written a biography of the young woman Léona Delcourt, who was the inspiration for Breton's *Nadja*. Hester Albach, *Léona, héroïne du surréalisme* (Paris, 2009).
7 George Melly and Michael Woods, *Paris and the Surrealists* (London, 1991), p. 51.
8 Breton, *Nadja*, pp. 112–13.
9 'When will all books worth anything stop being illustrated with drawings and appear with photographs only?' Breton, *Le Surréalisme et la peinture*, p. 32.
10 Breton, *Manifestoes*, p. 7.

11 Letter to Lise Meyer (2 September 1927), quoted in *Oeuvres completes*, vol. 1 (Paris, 1990), p. 1505.
12 Renée Riese Hubert, *Surrealism and the Book* (Berkeley, Los Angeles, CA, and London, 1988), p. 264.
13 Ian Walker, 'Her Eyes of Fern: The Photographic Portrait in *Nadja*', *History of Photography*, XXIX/2 (2005), p. 113.
14 Jean Arrouye, 'La Photographie dans Nadja', *Mélusine*, 4 (1982), p. 133.
15 Breton, *Nadja*, p. 60.
16 Ibid., p. 152.
17 Ibid., p. 152.
18 Breton, 'Nadja', *La Révolution surréaliste*, 11 (1928), p. 11.
19 Raymond Spiteri, 'Surrealism and the Political Physiognomy of the Marvellous', in *Surrealism: Politics and Culture*, ed. Raymond Spiteri and Donald LaCoss (Aldershot, 2003), p. 66.
20 Breton, *Nadja*, p. 19.
21 Ibid., p. 113.
22 Ibid., p. 52.
23 Ibid., p. 111.
24 Roger Cardinal, *Breton: 'Nadja'* (London, 1986), p. 28.
25 Breton, *Nadja*, p. 33.
26 Quoted in Béhar, *André Breton le Grand Indésirable* (Paris, 2005), p. 16.
27 Rosalind Krauss, 'The Photographic Conditions of Surrealism', in *The Originality of the Avant-garde and Other Modernist Myths* (Cambridge, MA, and London, 1986), p. 109.
28 Breton, *Nadja*, pp. 71, 101.
29 Breton's project for a new edition of his 'trilogy' *Nadja*, *Les Vases communicants* and *L'Amour fou* in a single volume united by photographs by Boiffard, Brassaï, Man Ray and others did not materialize.
30 Breton, *Conversations: The Autobiography of Surrealism*, trans. Mark Polizzotti (St Paul, MN, 1993), p. 158.
31 Victoria Clouston, *André Breton in Exile: The Poetics of Occultation, 1941–1947* (New York, 2018), p. 129.
32 Mark Polizzotti, *Revolution of the Mind: The Life of André Breton* (Boston, MA, 2009), p. 472.
33 The text was published in November 1944 by Brentano's in New York. It was republished in Paris in 1947 by the Editions du Sagittaire with

an added appendix. Preempted by the state at the 2003 sale of Breton's studio, the manuscript is now held in the Bibliothèque littéraire Jacques Doucet in Paris. A facsimile version was published by Adam Biro in 2008 with an introduction by Henri Béhar.

34 Breton is referring to Dante-Gabriel Rossetti's painting *Beata Beatrix* (Tate Gallery, London, *c*. 1860); it was reproduced in *Minotaure*, 8 (1936) to illustrate Dalí's article 'Le Surréalisme spectral de l'éternel féminin préraphaélite'.

35 See the detailed analysis of esoteric themes in *Arcane 17* by René Alleau, 'Le mystérieux Livre d'Heures du rêve d'Elisa', in *André Breton. La beauté convulsive*, exh. cat., Musée national d'art moderne (Paris, 1991), pp. 358–62.

36 Pascaline Mourier-Casile, *André Breton explorateur de la Mère-Moire* (Paris, 1986), p. 18.

37 Lucienne Thalheimer, 'Pourquoi des reliures surréalistes?', *Bulletin du bibliophile* (1979), pp. 49–50.

38 From 1926 the Surrealists had their own publishing house, Les Éditions Surréalistes, which published about sixty books; other publishers include Guy Lévis Mano (G.L.M.), Jeanne Bucher, Daniel-Henry Kahnweiler (Éditions de la Galerie Simon) and Georges Hugnet (Éditions de la Montagne).

39 Interview with James Johnson Sweeney, in *Joan Miró: Selected Writings and Interviews*, ed. Margit Rowell (Boston, MA, 1986), p. 209.

40 Joan Miró and André Breton, *Constellations* (Paris, 1959). A shorter version of the introduction was pre-published in *L'Oeil*, 48 (1958), pp. 50–55; 'Joan Miró. Constellations', *Le Surréalisme et la peinture*, pp. 257–64.

41 Miró, letter to Breton (21 January 1958), in Breton, *Oeuvres complètes*, vol. IV (Paris, 2008), p. 1239.

42 The work was exhibited in January 1959 at the Berggruen Gallery, Paris.

43 Georges Raillard, 'Breton en regard de Miró: *Constellations*', *Littérature*, 17 (1975), p. 4.

44 Breton, *Le Surréalisme et la peinture*, p. 264.

45 Raillard, 'Breton en regard de Miró', p. 3.

46 Pascaline Mourier-Casile, 'Miró/Breton, *Constellations*: cas de figure', *La Licorne*, 35 (1995), pp. 191–209.

47 Paul Éluard, 'Physique de la poésie', *Oeuvres complètes*, vol. 1 (Paris, 1968), p. 983.
48 Breton, *Nadja*, p. 19.
49 Benjamin Péret, 'Livres-objets par Georges Hugnet', *Minotaure*, 10 (1937), p. 40.

seven
Wooden Masks and Sugar Skulls: Collecting

1 Breton, *Conversations: The Autobiography of Surrealism*, trans. Mark Polizzotti (St Paul, MN, 1993), p. 29.
2 Letter to Simone Kahn (11 November 1923), *Lettres à Simone Kahn, 1920–1960* (Paris, 2016), p. 194.
3 Breton, *Le Surréalisme et la peinture* (Paris, 1965), p. 35.
4 François Chapon, *Mystères et splendeurs de Jacques Doucet* (Paris, 1984), p. 194.
5 Letter to Jacques Doucet (6 November 1923), *Lettres à Jacques Doucet* (Paris, 2016), p. 164.
6 Breton, *Conversations*, p. 77.
7 René Giraud, 'André Breton, collectionneur', *Jardin des arts*, 67 (May 1960), pp. 33–43; Isabelle Monod-Fontaine, 'Le tour des objets', in *André Breton. La beauté convulsive*, exh. cat., Musée national d'art moderne (Paris, 1991), pp. 64–8.
8 *Lettres à Simone Kahn*, p. 271.
9 Katharine Conley, 'Value and Hidden Cost in André Breton's Surrealist Collection', *South Central Review*, XXXII/1 (2015), pp. 8–22.
10 Mark Polizzotti, *Revolution of the Mind: The Life of André Breton* (Boston, MA, 2009), p. 554.
11 'Langue des pierres', *Le Surréalisme, même*, 3 (1957), p. 69; *Oeuvres complètes*, vol. IV (Paris, 2008), p. 965.
12 Breton, *Nadja*, trans. Richard Howard (New York, 1960), p. 129.
13 Breton, 'Océanie', *Océanie*, exh. cat., Galerie Andrée Olive, 1948; *Oeuvres complètes*, vol. III (Paris, 1999), p. 839; *Free Rein*, trans. Michel Parmentier and Jacqueline d'Amboise (Lincoln, NE, 1995), pp. 172 and 174.
14 Jean Baudrillard, *The System of Objects*, trans. James Benedict (London, 1996), p. 88.

15 Alain Jouffroy, 'La collection André Breton', *L'Oeil*, 10 (1955), p. 32.
16 Reproduced in *La Révolution surréaliste*, 12 (1929), pp. 42 and 43.
17 James Clifford, 'On Ethnographic Surrealism', in *The Predicament of Culture* (Cambridge, MA, 1988), p. 551.
18 Photographs of the studio were taken by Sabine Weiss (1955 and 1960). In 1968 Elisa Breton asked Gilles Ehrmann to photograph the studio as it was at the time of his death. A 1994 film by Fabrice Maze shows the collection before it was dispersed in 2003. See also Gracq and Ehrmann, *42 rue Fontaine. L'atelier d'André Breton* (Paris, 2003).
19 Didier Ottinger, 'Le mur de l'atelier', www.andrebreton.fr, accessed 31 March 2020.
20 Letter to Robert Amadou (1 December 1953), in *Oeuvres*, vol. IV, p. 877.
21 Reproduced in *Almanach surréaliste du demi-siècle, La Nef*, 63–4 (1950).
22 'La photo en finale de la vente Breton', *Le Monde* (18 April 2003).
23 Quoted in Paul Webster, 'Paris Shrine of Surrealism Dismantled', *The Observer* (30 March 2003), www.guardian.co.uk, accessed 18 April 2019.
24 Dagmar Motycka Weston, 'Communicating Vessels: André Breton and His Atelier, Home and Personal Museum in Paris', *Architectural Theory Review*, XI/2 (2006), p. 112.
25 Julien Gracq, *42 rue Fontaine. L'Atelier d'André Breton* (2003), n.p.; *En lisant, en écrivant* (Paris, 1981), pp. 249–50.
26 Stéphane Massonet, 'André Breton, collectionneur de primitivisme', *Mélusine*, 37 (2017), p. 211.
27 Jérôme Dupuis, 'Histoire secrète d'une vente surréaliste', *L'Express* (20 February 2003); Marcel Fleiss, 'Vente André Breton: dix ans déjà', https://laregledujeu.org, accessed 6 January 2020.
28 Breton, *Le Surréalisme et la peinture*, p. 3.
29 At www.surrealistmovement-usa.org, accessed 17 January 2019. See Wolfgang Asholt, 'La "Vente Breton" ou le fantome du surréalisme', in *Surréalisme et politique. Politique du surréalisme*, ed. W. Asholt and H. Siepe (Amsterdam and New York, 2007), pp. 249–64.
30 'Breton Sale at Drouot Auction Sets Records for Surrealist Images', www.iphotocentral.com, accessed 17 January 2019.
31 For details of the sale see Gérard Audinet et al., 'La collection André Breton. Oeuvres entrées dans les musées et bibliothèques de Oeuvres par dation, dons et achats', *Revue du Louvre*, 3 (June 2003), pp. 9–20.

32 Harry Bellet, 'Le masque d'André Breton rendu aux Kwakwaka'wakws', *Le Monde* (27 September 2003).
33 Jean-Michel Goutier, 'Etants donnés . . .', introduction, *André Breton, 42 rue Fontaine*, pp. 9–13.
34 Ottinger, 'Le mur de l'atelier'.
35 In the words of Marion Endt-Jones, the wall 'result[s] in a clinical, confined display that deprives the objects of their power to move and affect . . . the glass pane at Centre Pompidou adds a layer of containment and detachment, resulting in both physical and affective distance from the objects.' 'Between *Wunderkammer* and shop window: surrealist *naturalia* cabinets', in *Sculpture and the Vitrine*, ed. John Welchman (Farnham, 2013), pp. 105–6.

eight
From Easter Island to Alaska: Art and Ethnography

1 Anonymous, *Surréalisme, Variétés* (Brussels, 1929), pp. 26–7.
2 Louis Aragon, 'Fragments d'une conférence', *La Révolution surréaliste*, 4 (1925), p. 25.
3 Charles Ratton in conversation with Elizabeth Cowling; '"L'oeil sauvage": Oceanic Art and the Surrealists', in *Art of Northwest New Guinea*, ed. Suzanne Greub (New York, 1992), p. 189, n16.
4 Mark Polizzotti, *Revolution the Mind: The Life of André Breton* (Boston, MA, 2009), p. 455.
5 Claude Levi-Strauss, 'The Art of the North West Coast at the American Museum of American History', *Gazette des beaux-arts*, 24 (1943). See Elizabeth Cowling, 'The Eskimos, the American Indians and the Surrealists', *Art History*, 1/4 (1978), pp. 484–500.
6 Breton recorded his visit in his journal *Carnet de voyage chez les Indiens Hopi*; *Oeuvres complètes*, vol. III (Paris, 1999), pp. 183–209.
7 Kurt Seligmann, 'Entretien avec un Tsimshian', *Minotaure*, 12–13 (1939), pp. 66–9.
8 Cowling, '"L'oeil sauvage"', pp. 177–89.
9 Breton, 'Océanie', exh. cat., Galerie Andrée Olive, 1948; *Oeuvres*, vol. III, p. 837; *Free Rein*, trans. Michel Parmentier and Jacqueline d'Amboise (Lincoln, NE, 1995), pp. 170–74 (translation modified). Breton's preface is followed by a group of poems, 'Xénophiles',

whose titles ('Korwar', 'Tiki', 'Uli' and so on) are the names of Oceanic deities.
10 Quoted in Louise Tythacott, *Surrealism and the Exotic* (London, 2003), pp. 102–3.
11 Breton, *La Révolution surréaliste*, 6 (1926), pp. 4, 7 and 16.
12 Breton, *La Révolution surréaliste*, 9–10 (1927), pp. 34–5.
13 James Clifford, *The Predicament of Culture* (Cambridge, MA, 1988), p. 147.
14 Breton, *Le Surréalisme et la peinture* (Paris, 1965), p. 43.
15 Frida Kahlo, letter to Nickolas Muray (16 February 1939), quoted in *Frida Kahlo*, ed. Emma Dexter and Tanya Barson (London, 2005), p. 195.
16 Claude Lévi-Strauss, *Regarder écouter lire* (Paris, 1993), p. 143.
17 G. H. Rivière, 'Archéologismes', *Cahiers d'art*, 1/7 (1926), p. 177; Michel Leiris, 'L'œil de l'ethnographe', *Documents*, 117 (1930), pp. 405–14.
18 Breton, 'Phénix du masque', *xxe siècle*, XXII/15 (1960), pp. 57–63; *Oeuvres complètes*, vol. IV (Paris, 2008), pp. 990–94.
19 Breton, 'Notes sur les masques à transformation de la côte pacifique nord-ouest', *Neuf* (June 1950); *Oeuvres complètes*, vol. III (Paris, 1999), pp. 1029–33.
20 Breton, 'Main première', preface to Karel Kupka, *Un art à l'état brut* (Lausanne, 1962); *Oeuvres*, vol. IV, pp. 1024–27; trans. 'First Hand', *What Is Surrealism? Selected Writings*, ed. and trans. Franklin Rosemont (London, 1978), pp. 461–5.
21 Breton, *Free Rein*, p. 129.
22 Ibid., p. 172 (translation modified).
23 Breton, 'Notes sur les masques'.
24 Breton, 'Phenix du masque'. Breton's position echoes that of the Martinican writer Jules Monnerot, who saw affinities between Surrealism and Native American thought. *La Poésie moderne et le sacré* (Paris, 1945), p. 106; see *Conversations: The Autobiography of Surrealism*, trans. Mark Polizzotti (St Paul, MN, 1993), p. 193. As a student in Paris Monnerot and fellow Martinican Pierre Yoyotte signed the tract 'Murderous humanitarianism' (1932) against racism and colonialism (Nancy Cunard, *Negro Anthology* (London, 1934)). With a group of Caribbean students they published the anti-colonialist journal *Légitime défense* (1932, single issue).

25 On occasion Breton combined an ethnographic and poetic interpretation of ethnographic art in a form of 'ethnopoetics'. Poems such as 'Dukduk', 'Tiki' and 'Rano-Ruraku', published in the catalogue for the *Océanie* exhibition discussed above, combine precise ethnographic knowledge and poetic language, in a form of 'mimetic writing' of the sculptures evoked, as Jean-Claude Blachère has convincingly argued in *Les Totems d'André Breton. Surréalisme et primitivisme littéraire* (Paris, 1996), pp. 239–45.

26 William Rubin, 'Introduction', *Primitivism in 20th Century Art: Affinity of the Tribal and the Modern* (New York, 1984), pp. 1–79.

27 For a discussion of primitivism and Surrealism see Colin Rhodes, *Primitivism and Modern Art* (London, 1994), Chapter Two.

28 *What Is Surrealism?*, p. 462.

29 Claude Lévi-Strauss, *La Pensée sauvage* (Paris, 1962), p. 58.

30 Tythacott, *Surrealism and the Exotic*, p. 96.

31 See Katharine Conley, 'Value and Hidden Cost in André Breton's Surrealist Collection', *South Central Review*, XXXII/1 (2015), pp. 8–22.

32 Breton, *Le Surréalisme et la peinture*, pp. 169–71. The same text was used as a preface for the catalogue of Lam's first solo exhibition in Paris in 1953.

33 Breton, *Le Surréalisme et la peinture*, p. 172.

34 Michel Leiris, *Wifredo Lam* (Milan, 1970).

35 Leiris, 'Antilles et poésie du carrefour', *Conjonction*, 19 (1949), pp. 1–13.

36 Leiris, 'Wifredo Lam' [1969], in *Écrits sur l'art*, ed. Pierre Vilar (Paris, 2011), p. 431.

37 Blachère argues that the Surrealists refute the historicity of people of colour, preferring to construct a fantastical image of the 'savage'. *Les Totems d'André Breton. Surréalisme et primitivisme littéraire* (Paris, 1996), p. 274.

38 Lowery Stokes Sims, *Wifredo Lam and the International Avantgarde, 1923–1982* (Austin, TX, 2002), p. 105.

nine
Beyond Surrealism: Outsider Art

1 James Clifford, 'On Ethnographic Surrealism', *Comparative Studies in Society and History*, XXIII/4 (1981), p. 542.

2 André Breton, *Conversations: The Autobiography of Surrealism*, trans. Mark Polizzotti (St Paul, MN, 1993), p. 202.

3 Quoted in Marguerite Bonnet, *André Breton: Naissance de l'aventure surréaliste* (Paris, 1975), pp. 109–10.

4 Breton, 'Le Message automatique', *Minotaure*, 3–4 (1933), pp. 54–65; 'The Automatic Message', in *What Is Surrealism? Selected Writings*, ed. and trans. Franklin Rosemont (London, 1978), pp. 149–67.

5 Jean Dubuffet, 'L'Art brut préféré aux arts culturels', in *Prospectus et tous écrits suivants*, vol. I (Paris, 1967).

6 Dubuffet, *Asphyxiante Culture* (Paris, 1968).

7 Dubuffet, 'L'Art brut', pp. 201–2.

8 Letter from Breton to the Compagnie de l'art brut (20 September 1951), in *André Breton. La beauté convulsive*, exh. cat., Musée national d'art moderne (Paris, 1991), pp. 406–7.

9 European collections of *art brut* include the Musée de la Fabuloserie (Dicy); the Halle Saint-Pierre (Paris); abcd (Montreuil); LaM Lille (which acquired a number of art brut works from Breton's collection in 2003); and the Musgrave Kinley Outsider Art collection at the Irish Museum of Modern Art in Dublin.

10 Roger Cardinal, *Outsider Art* (London, 1972).

11 They were reproduced in *La Révolution surréaliste*, 12 (1929), pp. 42 and 43.

12 Theodor Spoerri, 'L'Armoire d'Adolf Wölfli', *Le Surréalisme, même*, 4 (1958).

13 See *Almanach de l'art brut* (facsimile), ed. Sarah Lombardi and Baptiste Brun (Milan, 2016).

14 Breton, *Le Surréalisme et la peinture* (Paris, 1965), pp. 313–17.

15 Dubuffet, 'L'Art brut', p. 202.

16 Breton, *Littérature*, 11/6 (1922), p. 1.

17 Max Morise, 'Les Yeux enchantés', *La Révolution surréaliste*, 1 (1924) p. 26.

18 Hélène Smith (1861–1929) was a medium from Geneva who invented a 'martian' language and painted visionary works. She was known thanks to Théodore Flournoy's *Des Indes à la Planète Mars* (From India to the Planet Mars, 1910).

19 'Un peintre médium, Joseph Crépin', *Combat-Art* (14 June 1954); *Le Surréalisme et la peinture*, pp. 298–307.

20 Breton, 'The Automatic Message'.
21 Cardinal, *Outsider Art*, p. 151.
22 Frances Morris and Christopher Green, *Henri Rousseau: Jungles in Paris*, exh. cat., Tate Modern (London, 2005).
23 Breton, unpublished lecture (Haiti, January 1946); *Oeuvres complètes*, vol. III (Paris, 1999), p. 246.
24 Breton, *Le Surréalisme et la peinture*, p. 367.
25 Ibid., pp. 291–4.
26 Ibid., p. 369.
27 Ibid., p. 294.
28 Breton, 'Aloys Zötl', *Le Surréalisme et la peinture*, pp. 354–5.
29 Breton, *Le Surréalisme et la peinture*, p. 309.
30 Paul Laraque, 'André Breton in Haiti' [1971], in *Refusal of the Shadow: Surrealism and the Caribbean*, ed. Michael Richardson, trans. Richardson and Krzysztof Fijalkowski (London and New York, 1996), p. 218.
31 René Depestre, 'André Breton in Port-au-Prince', *Opus International*, 123–4 (1991); *Refusal*, p. 232.
32 Breton, *Conversations*, p. 201.
33 Preface to Pierre Mabille, *Miroir du merveilleux* (Paris, 1962). Voodoo has been linked to the impact of mesmerism on the Haitians: Martinez de Pasqually founded a Masonic lodge in Port-au-Prince in 1772.
34 Breton also bought *Un re laucation pa pa dom balas* (c. 1945), *Une déês réprésonté mét gron bras* (1946), *Mari Travo* (c. 1945) and *Maître Adani* (date unknown).
35 Breton, *Le Surréalisme et la peinture*, pp. 202–6.
36 Terri Geis, 'Myth, History and Repetition: André Breton and Vodou in Haiti', *South Central Review*, XXXII/1 (2015), p. 61.
37 Breton, *Le Surréalisme et la peinture*, p. 205.
38 Benjamin Péret, 'Magic: The Flesh and Blood of Poetry', *View*, III/2 (June 1943), p. 46.
39 See Kurt Seligmann's articles in *View* and *VVV*, and his *The Mirror of Magic: A History of Magic in the Western World* (New York, 1948).
40 Radio interview with André Parinaud (24 April 1957), *Oeuvres complètes*, vol. IV (Paris, 2008), pp. 1148–51.
41 Mark Polizzotti, *Revolution the Mind: The Life of André Breton* (Boston, MA, 2009), p. 535.
42 In 'Le Triomphe de l'art gaulois' (1954) Breton condemned the Romans

as 'foreign invaders of the year 50' whose malicious influence continues to suppress the irrational in art; *Le Surréalisme et la peinture*, p. 332.
43 Polizzotti, *Revolution*, pp. 526–7.
44 Interview with Jacqueline Piatier, *Le Monde* (13 January 1962).

ten
Travels with Art: Off the Map

1 André Breton, 'Saludo a Tenerife', *La Tarde* (9 May 1935); *Oeuvres complètes*, vol. II (Paris, 1992), p. 581.
2 Mary Ann Caws, *The Eye in the Text: Essays on Perception, Mannerist to Modern* (Princeton, NJ, 1981), pp. 87–8.
3 Breton and Masson, 'Le Dialogue créole', *Lettres françaises* (January 1942); *Martinique charmeuse de serpents* (Paris, 1948); *Refusal of the Shadow: Surrealism and the Caribbean*, ed. Michael Richardson, trans. Richardson and Krzysztof Fijalkowski (London and New York, 1996), p. 186.
4 Joel Cornuault, *André Breton et Saint-Cirq-Lapopie* (Bassac, 2003), p. 10.
5 Breton, 'Pont-levis', preface to Pierre Mabille, *Miroir du merveilleux* (Paris, 1962); *Oeuvres complètes*, vol. IV (Paris, 2008), p. 1005. *Gouverneurs de la rosée* was translated in 1971 by Langston Hughes as *Masters of the Dew*.
6 Breton, *Carnet de voyage chez les Indiens Hopi*, unpublished text, *Oeuvres complètes*, vol. III (Paris, 1999), pp. 183–209.
7 Bertrand Westphal, 'Pour une approche géocritique des textes', in *La Géocritique mode d'emploi*, ed. B. Westphal (Limoges, 2001), p. 17.
8 Breton, *L'Air de l'eau* (Paris, 1934).
9 Henri Béhar, 'Une visite au jardin désespérides', *Ondes de choc* (Lausanne, 2010), p. 265.
10 Emmanuel Guigon, 'Le voyage d'André Breton à Tenerife', *Mélanges de la Casa de Velázquez*, 25 (1989), pp. 397–417.
11 The text was translated into English in the catalogue of the *International Surrealist Exhibition* in London (1936).
12 Breton, 'Le Château étoilé', *Minotaure*, 8 (1936), pp. 25–40; *L'Amour fou* (Paris, 1937); *Mad Love*, trans. Mary Ann Caws (Lincoln NE and London, 1987), pp. 67–97. Breton had originally planned to publish a translation of his text in Tenerife illustrated with drawings by Domínguez or

photographs of the island. Letter to Eduardo Westerdahl (15 July 1936), quoted in Béhar, 'Une visite', p. 273.

13 Breton, *Mad Love*, pp. 67 and 68.
14 Ibid., pp. 73–6.
15 Max Ernst, *Jardin gobe-avions* (Garden Airplane Trap, 1935), reproduced in *Minotaure*, 8 (1936), p. 10.
16 Breton, *Mad Love*, p. 90.
17 Ernst, *Écritures* (Paris, 1970), p. 58.
18 Breton, *Mad Love*, p. 96.
19 Béhar, 'Une visite', p. 268.
20 Breton, *Le Surréalisme et la peinture* (Paris, 1965), p. 141.
21 Breton, *Manifestoes of Surrealism*, trans. Richard Seaver and Helen R. Lane (Ann Arbor, MI, 1972), pp. 5–6.
22 Rafael Heliodor Valle, 'Diálogo con André Breton', *Universidad de México*, 29 (June 1938), *Oeuvres*, vol. IV, pp. 1181–6.
23 Ibid., p. 1182.
24 Melanie Nicholson, 'Surrealism's Found Object: The Enigmatic Mexico of Artaud and Breton', *Journal of European Studies*, XLIII/1 (2013), p. 28.
25 Breton, *Le Surréalisme et la peinture*, p. 43.
26 Breton, 'Memory of Mexico'.
27 Breton, 'Frida Kahlo de Rivera', *Le Surréalisme et la peinture*, pp. 141–4.
28 Breton, *Nadja*, p. 101. Kahlo's painting was reproduced in *Minotaure*, 12–13 (1939), p. 17.
29 Mark Polizzotti, *Revolution of the Mind: The Life of André Breton* (Boston, MA, 2009), pp. 40–49.
30 Breton and Masson, *Martinique charmeuse de serpents* (Paris, 1948); *Martinique: Snake Charmer*, trans. David Seaman (Austin, TX, 2008).
31 Claude Lévi-Strauss, *Tristes Tropiques* (Paris, 1955), pp. 14–15.
32 Breton, 'Un grand poète noir', *Martinique charmeuse de serpents*; 'A Great Black Poet: Aimé Césaire', *Refusal*, pp. 191–8. Césaire published *Cahier d'un retour au pays natal* (1939), a powerful poetic anti-colonialist text.
33 Breton appeared as the sole author, the cover indicating 'avec textes et illustrations d'André Masson'. Asked by Masson why his own name did not appear as co-author, Breton is said to have replied that 'painters make enough money as it is' (Polizzotti, *Revolution*, p. 501).
34 Leiris, 'Martinique charmeuse de serpents', *Temps modernes*, 41 (1949), pp. 363–4.

35 Breton, 'Le Dialogue créole', *Martinique charmeuse de serpents*; 'Creole Dialogue', *Refusal*, pp. 185–90.
36 Mireille Rosello, 'Martinique, charmeuse de serpents: "Changer la vue" sous les Tropiques', *André Breton, L'Esprit Créateur*, XXXVI/4 (1996), pp. 64–75.
37 Christopher Green, 'Souvenirs of the Jardin des Plantes: Making the Exotic Strange Again', in Frances Morris and Christopher Green, *Henri Rousseau: Jungles in Paris*, exh. cat., Tate Modern (London, 2005), pp. 29–47.
38 Régis Antoine quoted in Rosello, 'Martinique', p. 71.

Conclusion: Beyond the Wall

1 Keith Jordan, 'Surrealist Visions of Pre-Columbian Mesoamerica and the Legacy of Colonialism: The Good, the (Revalued) Bad, and the Ugly', *Journal of Surrealism and the Americas*, II/1 (2008), p. 46.
2 *Cahiers d'art*, V/1 (1930), pp. 68–9.
3 Christian Zervos, *Histoire de l'art contemporain* (Paris, 1938).
4 Dr O., 'Art primitif et psychanalyse d'après Eckart von Sydow', *Cahiers d'art*, IV/2–3 (1929), p. 66.
5 Wolfgang Paalen, Preface, *Dyn*, 4–5 (1943), n.p. Paalen co-curated the 1938 International Surrealist Exhibition in Paris and the 1940 International Surrealist Exhibition in Mexico with Breton and the Peruvian poet and painter César Moro. He was editor of *Dyn* (1942–4).
6 Breton, *Le Surréalisme et la peinture*, p. 138.
7 Roger Cardinal, 'Les arts marginaux et l'esthétique surréaliste', in *L'Autre et le sacré. Surréalisme, cinéma, ethnologie*, ed. C. W. Thompson (Paris, 1995), p. 68.
8 James Clifford, 'On Ethnographic Surrealism', in *The Predicament of Culture* (Cambridge, MA, 1988), p. 552.
9 'Prolégomènes à un troisième manifeste du surréalisme ou non'; VVV, 1 (1942), pp. 18–26; Breton, 'Prolegomena to a Third Surrealist Manifesto' (1942), *Manifestoes*, pp. 288–9 (translation modified).

Select Bibliography

Texts by André Breton

Oeuvres completes, ed. Marguerite Bonnet and Étienne-Alain Hubert, vol. I (Paris, 1990); vol. II (1992); vol. III (1999); vol. IV (2008)
L'Art magique (Paris, 1957), with Gérard Legrand
'La beauté sera convulsive', *Minotaure*, 5 (1934), pp. 9–16
Constellations (Paris, 1959), with Joan Miró
Je vois j'imagine (Paris, 1991), preface by Octavio Paz
'Picasso dans son élément', *Minotaure*, I (1933), pp. 10–22
Lettres à Jacques Doucet (Paris, 2016)
Lettres à Simone Kahn, 1920–1960 (Paris, 2016)
'Souvenir du Mexique', *Minotaure*, 12–13 (1939), pp. 29–50
Le Surréalisme et la peinture (Paris, 1965)
'Des tendances les plus récentes de la peinture surréaliste', *Minotaure*, 12–13 (1939), pp. 16–21

Translated Texts

Arcanum 17, trans. Zack Rogow (Toronto, 1994)
Conversations: The Autobiography of Surrealism, trans. Mark Polizzotti (St Paul, MN, 1993)
Free Rein, trans. Michel Parmentier and Jacqueline d'Amboise (Lincoln, NE, 1995)
Mad Love, trans. Mary Ann Caws (Lincoln, NE, 1987)
Manifestoes of Surrealism, trans. Richard Seaver and Helen R. Lane (Ann Arbor, MI, 1972)
Martinique: Snake Charmer, trans. David Seaman (Austin, TX, 2008)

Nadja, trans. Richard Howard (New York, 1960)

Ode to Charles Fourier, trans. Kenneth White (London, 1970)

Refusal of the Shadow: Surrealism and the Caribbean, ed. Michael Richardson, trans. Richardson and Krzysztof Fijalkowski (London and New York, 1996)

Surrealism and Painting, trans. Simon Watson Taylor (London, 2002)

What Is Surrealism? Selected Writings, ed. and trans. Franklin Rosemont (London, 1978)

Critical Texts on André Breton

Adamowicz, Elza, 'André Breton et Max Ernst: entre la mise sous whisky marin et les marchands de Venise', *Lisible visible*, *Mélusine*, 12 (1991), pp. 15–30

—, 'Hats or Jellyfish? André Breton's Collages', in *André Breton: The Power of Language*, ed. Ramona Fotiade (Exeter, 2000), pp. 83–96

Alleau, René, 'Le mystérieux Livre d'Heures du rêve d'Elisa', in *André Breton. La beauté convulsive*, exh. cat., Musée national d'art moderne (Paris, 1991), pp. 358–62

André Breton et l'art magique. Yüksel Arslan, exh. cat., LAM, Musée de Lille métropole (Villeneuve d'Ascq, 2017)

Arrouye, Jean, 'La photographie dans *Nadja*', *Mélusine*, 4 (1982), pp. 123–50

Asholt, Wolfgang, 'La "Vente Breton" ou le fantôme du surréalisme', in *Surréalisme et politique. Politique du surréalisme*, ed. W. Asholt and H. Siepe (Amsterdam and New York, 2007), pp. 249–64

Audinet, Gérard, et al., 'La collection André Breton. Oeuvres entrées dans les musées et bibliothèques de France par dation, dons et achats', *Revue du Louvre*, LIII/3 (June 2003), pp. 9–20

Beaujour, Michel, 'Qu'est-ce que Nadja', *Nouvelle Revue Française*, XV/172 (April 1967), pp. 200–219

Béhar, Henri, *André Breton le Grand Indésirable* (Paris, 2005)

—, 'Une visite au jardin désespérides', *Surrealismo siglo 21* (Tenerife, 2006), pp. 344–57

—, ed., *Dictionnaire André Breton* (Paris, 2012)

—, and Françoise Pye, eds, *L'Or du temps. André Breton 50 ans après*, *Mélusine*, 37 (Lausanne, 2017)

Bernadec, Marie-Laure, 'André Breton et Pablo Picasso: "tout le sang possible vers le coeur"', in *André Breton. La beauté convulsive*, exh. cat., Musée national d'art moderne (Paris, 1991), pp. 210–13

Berthet, Dominique, *André Breton et l'éloge de la rencontre. Antilles, Amérique, Océanie* (Paris, 2008)

Blachère, Jean-Claude, *Les Totems d'André Breton. Surréalisme et primitivisme littéraire* (Paris, 1996)

Calmels Cohen, *André Breton, rue Fontaine. Vente, Paris, Drouot-Richelieu*, 8 vols (Paris, 2003)

Cardinal, Roger, *André Breton: 'Nadja'* (London, 1986)

—, 'Du modèle intérieur au nid d'oiseau: Breton, Crépin et l'art des médiums', in *Art spirite, médiumnique et visionnaire: messages d'outre-monde* (Paris, 1999), pp. 67–77

Chénieux-Gendron, Jacqueline, ed., *Lire le regard. André Breton et la peinture*, Pleine Marge, 13 (1991)

Clouston, Victoria, *André Breton in Exile: The Poetics of Occultation, 1941–1947* (New York, 2018)

Conley, Katharine, 'Surrealism and Outsider Art: From the "Automatic Message" to Breton's Collection', *Yale French Studies*, 109 (2006), pp. 129–43

Cowling, Elizabeth, '"Proudly we claim him as one of us": Breton, Picasso, and the Surrealist Movement', *Art History*, VIII/1 (1985), pp. 82–104

—, 'L'Oeil sauvage: Oceanic Art and the Surrealists', in *Art of Northwest New Guinea* (New York, 1992), ed. Suzanne Greub, pp. 177–89

Fotiade, Ramona, *André Breton: The Power of Language* (Exeter, 2000)

Fourny, Jean-François, 'A propos de la querelle Breton-Bataille', *Revue d'histoire littéraire de la France*, LXXXIV/3 (1984), pp. 432–8

Geis, Terri, 'Myth, History and Repetition: André Breton and Vodou in Haiti', *South Central Review*, XXXII/1 (Spring 2015), pp. 56–75

Giraud, René, 'André Breton, collectionneur', *Jardin des arts*, 67 (May 1960), pp. 33–43

Giraudy, Danièle, *Le Jeu de Marseille. Autour d'André Breton et des surréalistes à Marseille en 1940–41*, exh. cat. (Marseille, 2003)

Gracq, Julien and Gilles Ehrman, *42 rue Fontaine, l'atelier d'André Breton* (Paris, 2003)

Greeley, Robin Adele, 'For an Independent Revolutionary Art: Breton, Trotsky and Cardenas's Mexico', in *Surrealism, Politics and Culture*,

ed. Raymond Spiteri and Donald Lacoss (Aldershot, 2003), pp. 204–25

Guigon, Emmanuel, 'Le voyage d'André Breton à Tenerife', *Mélanges de la Casa de Velázquez*, 25 (1989), pp. 397–417

Hubert, René Riese, 'Miró and Breton', *Yale French Studies*, 31 (1964), pp. 52–9

—, *Surrealism and the Book* (Berkeley, Los Angeles, CA, and London, 1988)

Jay, Martin, *Downcast Eyes: The Denigration of Vision in Twentieth-century French Thought* (Berkeley, Los Angeles, CA, and London, 1994)

Jouffroy, Alain, 'La collection André Breton', *L'Oeil*, 10 (October 1955), pp. 32–9

Klengel, Susanne, 'Ténériffe, Martinique – André Breton et l'expérience des îles: un rapprochement herméneutique?', in *History and Histories in the Caribbean*, ed. Thomas Brenner and Ulrich Fleischmann (Madrid and Frankfurt, 2003), pp. 199–215

Lalla, Marie-Christine, 'Bataille et Breton: le malentendu considérable', in *Surréalisme et philosophie* (Paris, 1992), pp. 49–61

Legrand, Gérard, *André Breton en son temps* (Paris, 1976)

Lequeux, Emmanuelle, 'André Breton et l'art des fous', *Beaux Arts Magazine*, 397 (July 2017), pp. 100–103

Lewis, Helena, 'Surrealists, Stalinists and Trotskyists: Theories of Art and Revolution in France between the Wars', *Art Journal*, LII/1 (1993), pp. 61–8

Mabin, Renée, 'La Galerie À l'étoile scellée', *Mélusine*, 28 (2008), pp. 295–307

Massonet, Stéphane, 'André Breton, collectionneur de primitivisme', *Melusine*, 37 (2017), pp. 207–20

Monod-Fontaine, Isabelle, 'Le tour des objets', in *André Breton. La beauté convulsive*, exh. cat., Musée national d'art moderne (Paris, 1991), pp. 64–8

Mourier-Casile, Pascaline, *André Breton explorateur de la Mère-Moire* (Paris, 1986)

—, 'Miró/Breton, *Constellations*: cas de figure', *La Licorne*, 35 (1995), pp. 191–209

—, 'Le poème-objet ou l'exaltation réciproque', *La Licorne*, 23 (2006), pp. 213–30

Nicholson, Melanie, 'Surrealism's Found Object: The Enigmatic Mexico of Artaud and Breton', *Journal of European Studies*, XLIII/1 (2013), pp. 27–43

Pierre, José, *André Breton et la peinture* (Lausanne, 1987)

—, 'André Breton et le poème-objet', in *L'Objet au défi*, ed. J. Chenieux-Gendron and M-C. Dumas (Paris, 1987), pp. 131–42

Polizzotti, Mark, *Revolution of the Mind: The Life of André Breton* (Boston, MA, 2009)

Powrie, Phil, 'The Surrealist *poème-objet*', in *Surrealism: Surrealist VIsuality*, ed. Silvano Levy (Keele, 1996), pp. 57–77

Raillard, Georges, 'Breton en regard de Miró: *Constellations*', *Littérature*, 17 (1975), pp. 3–13

Rosello, Mireille, '*Martinique, charmeuse de serpents*: "Changer la vue" sous les Tropiques', *André Breton*, *L'Esprit Créateur*, XXXVI/4 (Winter 1996), pp. 64–75

Rowell, Margit, 'André Breton and Joan Miró', in *André Breton: La beauté convulsive*, exh. cat., Musée national d'art moderne (Paris, 1991), pp. 179–82

Rubio, Emmanuel, 'André Breton et Diego Rivera, ou le rêve d'une terre indigène', *Mexique miroir magnétique*, *Mélusine*, 19 (1999), pp. 118–29

Schwarz, Arturo, *Breton/Trotsky* (Paris, 1977)

Tythacott, Louise, *Surrealism and the Exotic* (London, 2003)

Vouilloux, Bernard, 'Le "Trésor de l'oeil": André Breton dans l'image', *Poésie*, 84 (1998), pp. 118–26

Walker, Ian, 'Her Eyes of Fern: The Photographic Portrait in *Nadja*', *History of Photography*, XXIX/2 (2005), pp. 100–113

Weston, Dagmar Motycka, 'Communicating Vessels: André Breton and His Atelier, Home and Personal Museum in Paris', *Architectural Theory Review*, XI/2 (2009), pp. 101–28

List of Illustrations

Every effort has been made to contact copyright holders; should there be any we have been unable to reach or to whom inaccurate acknowledgements have been made please contact the publishers, and full adjustments will be made to any subsequent printings. Some locations of artworks are also given below, in the interest of brevity.

Reproductions of works by André Breton and Elisa Breton – courtesy of Aube Breton Elléouët.

AAB = Association Atelier André Breton

1. Man Ray, *André Breton*, c. 1930, gelatin silver print, solarized. © Man Ray 2015 Trust/DACS, London 2022.
2. *Un cadavre*, 15 January 1930, tract signed by Bataille, Leiris, Desnos et al.
3. Man Ray, *The Surrealist Constellation of Valentine Hugo*, c. 1935, gelatin silver print, 21 × 17.7 cm. © Man Ray 2015 Trust/DACS, London 2022. Photo: AAB.
4. Dadaists (André Breton, René Hilsum, Louis Aragon, Paul Éluard) with a copy of *Dada 3*, 1919.
5. André Breton at the Festival Dada, Paris, with placard by Francis Picabia, 27 March 1920. © ADAGP, Paris and DACS, London 2022.
6. Dadaists (Paul Éluard, Philippe Soupault, André Breton, Théodore Fraenkel) at a performance of Philippe Soupault's *Vous m'oublierez* (1920). Courtesy Bibliothèque Emmanuel Boussard, photo Bibliothèque nationale de France, Paris.

7 Man Ray, *Centrale Surréaliste*, 1924, photograph. © Man Ray 2015 Trust/DACS, London 2022.

8 Anna Riwkin, *Surrealists in Paris*, 1933, gelatin silver print. Courtesy Moderna Museet Stockholm.

9 Maria Cerminova Toyen, cover of *Spojité Nádoby* (*Les Vases communicants*), 1935. © ADAGP, Paris and DACS, London 2022. Photo: AAB.

10 *Bulletin international du surréalisme*, 2 (1935). © ADAGP, Paris and DACS, London 2022. Photo © Centre Pompidou, MNAM-CCI Bibliothèque Kandinsky, Dist. RMN-Grand Palais/Fonds Destribats.

11 *International Surrealism Bulletin*, 4 (1936). Photo: AAB.

12 Marcel Duchamp, cover design for André Breton, *Young Cherry Trees Secured Against Hares* (1946). © Association Marcel Duchamp/ADAGP, Paris and DACS, London 2022, photo AAB.

13 Roberto Matta, *Un poète de notre connaissance*, 1944–5, oil on canvas, 94.5 × 76.5 cm. © ADAGP, Paris and DACS, London 2022. Photo: © Centre Pompidou, MNAM-CCI, Dist. RMN-Grand Palais/Georges Meguerditchian.

14 Arshile Gorky, *One Year the Milkweed*, 1944, oil on canvas, 94.2 × 119.3 cm. National Gallery of Art, Washington, DC.

15 Elisa Breton, André Breton and Pierre Matisse, 1945, photograph. © Elisa Breton, photo AAB.

16 Jacques Cordonnier, Surrealist group at café de la place Blanche, 1953, photograph. Photo: AAB.

17 Elisa Breton, André Breton at Saint-Cirq-Lapopie, c. 1953, photograph. © Elisa Breton, photo AAB.

18 Elisa Breton, Surrealist group at Saint-Cirq-Lapopie, 1953, photograph. © Elisa Breton, photo AAB.

19 *La Peinture surréaliste*, exhibition catalogue, Galerie Pierre, 1925. Photo: Stefano Bianchetti/Bridgeman Images.

20 Invitation to opening of *Exposition internationale du surréalisme*, 17 January 1938, Galerie des Beaux-Arts, Paris.

21 Pablo Picasso, *André Breton*, frontispiece to *Clair de terre* (1923). © Succession Picasso/DACS, London 2022.

22 Germaine Berton with the Surrealist group, photomontage reproduced in *La Révolution surréaliste*, 1 (1924), p. 17. Photo: Bibliothèque nationale de France, Paris.

23 Pablo Picasso, *Guitare*, 1924, sculpture, painted metal, reproduced in *La Révolution surréaliste*, 1 (1924), p. 19. © Succession Picasso/DACS, London 2022, photo Bibliothèque nationale de France, Paris.

24 Breton, 'Picasso dans son élément', *Minotaure*, 1 (1931), p. 12, with photographs by Brassaï. Photo: Bibliothèque nationale de France, Paris.

25 Pablo Picasso, *Stalin*, reproduced in *Lettres francaises*, 8 March 1953. © Succession Picasso/DACS, London 2022, photo RMN-Grand Palais (Musée national Picasso-Paris)/Adrien Didierjean.

26 Dadaists (René Hilsum, Benjamin Péret, Charchoune, Philippe Soupault, Jacques Rigaut and André Breton) at the opening of Max Ernst's exhibition *La mise sous whisky marin*, Au Sans Pareil bookshop, 21 May 1921. Photo: AAB.

27 Max Ernst, *The Chinese Nightingale* (*die chinesische Nachtigall/le rossignol chinois*), 1920, collage of photographic prints and ink on paper, 12.5 × 9 cm. Musée de Grenoble, © ADAGP, Paris and DACS, London 2022.

28 Max Ernst, *Au Rendez-vous des amis*, 1922, oil on canvas, 130 × 195 cm. Museum Ludwig, Cologne. © ADAGP, Paris and DACS, London 2022, photo Bridgeman Images.

29 Max Ernst, *André Breton*, 1923, ink on cardboard, 40.5 × 31 cm. Private collection. © ADAGP, Paris and DACS, London 2022, photo © Archives Charmet/Bridgeman Images.

30 Max Ernst, *Loplop présente les membres du groupe surréaliste*, 1931, gelatin silver prints, printed paper, pencil and pencil frottage on paper, 50.1 × 33.6 cm. © ADAGP, Paris and DACS, London 2022, photo © Museum of Modern Art (MOMA), New York/Art Resource/Scala, Florence.

31 Max Ernst, 'Défais ton sac, mon brave', collage on laid Hollande paper from *La Femme 100 têtes* (1929). © ADAGP, Paris and DACS, London 2022.

32 Joan Miró, *Le Chasseur* (*Paysage catalan*), 1923–4, oil on canvas, 64.8 × 100.3 cm. Museum of Modern Art (MOMA), New York, © Successió Miró/ADAGP, Paris and DACS, London 2022.

33 Joan Miró, *Le Piège*, 1924, oil on canvas, 92.7 × 73.5 cm. Private collection. © Successió Miró/ADAGP, Paris and DACS, London 2022.

34 Joan Miró, *Homme et femme*, 1931, oil on wood, chain, metal, 34 × 18 × 5.5 cm. © Successió Miró/ADAGP, Paris and DACS, London 2022, photo © Centre Pompidou, MNAM-CCI, Dist. RMN-Grand Palais/Philippe Migeat.

35 Anna Riwkin, *André Breton, Salvador Dalí, René Crevel and Paul Éluard*, 1931, gelatin silver print. Courtesy Moderna Museet, Stockholm.

36 Salvador Dalí, *Le Jeu lugubre*, 1929, oil and collage on cardboard, 44.4 × 30.3 cm. Private collection. © Salvador Dalí, Fundació Gala-Salvador Dalí, DACS 2022, photo Fundació Gala-Salvador Dalí.

37 Diagram of Salvador Dalí's *Le Jeu lugubre*, *Documents*, 1/7 (1929). Photo: Bibliothèque nationale de France, Paris.

38 Invitation to *Exposition surréaliste*, Galerie Au Sacre du Printemps, 1928.

39 Automatic drawing by André Masson, 1925, *La Révolution surréaliste*, 3 (1925), p. 23. © ADAGP, Paris and DACS, London 2022, photo Bibliothèque nationale de France, Paris.

40 Man Ray, *Explosante fixe* (Prou del Pilar), 1934, gelatin silver print, 12.1 × 9.1 cm. © Man Ray 2015 Trust/DACS, London 2022, photo © Centre Pompidou, MNAM-CCI, Dist. RMN-Grand Palais/Guy Carrard.

41 Óscar Domínguez, *Untitled*, 1936, decalcomania (gouache transfer) on paper, 35.9 × 29.2 cm, illustration in André Breton, 'D'une décalcomanie sans objet préconçu', *Minotaure*, 8 (1936). Museum of Modern Art (MOMA), New York, © ADAGP, Paris and DACS, London 2022.

42 Wolfgang Paalen, *Orages magnétiques*, 1938, oil and fumage on canvas, 73.7 × 97.5 cm. © Succession Wolfgang Paalen and Eva Sulzer, photo courtesy Andreas Neufert.

43 André Masson, *André Breton*, 1941, india ink on paper, 47.5 × 62.5 cm. © ADAGP, Paris and DACS, London 2022, photo © Centre Pompidou, MNAM-CCI, Dist. RMN-Grand Palais/Philippe Migeat.

44 Max Ernst, *La Horde*, 1927, oil on canvas, 115 × 146 cm. Stedelijk Museum Amsterdam, © ADAGP, Paris and DACS, London 2022.

45 Vassily Kandinsky, *Dominant Curve*, 1936, oil on canvas, 129.3 × 194.3 cm. Solomon R. Guggenheim Museum, New York.

46 André Masson, *L'Armure*, 1925, oil on canvas, 80.6 × 54 cm. © ADAGP, Paris and DACS, London 2022, photo Peggy Guggenheim Collection, Venice.

47 Breton and Trotsky in Mexico, 1938, photograph. Photo: AAB.
48 Breton, Trotsky and Rivera in Mexico, 1938, photograph. Photo: AAB.
49 André Masson, *Le Thé avec Franco*, *Clé*, 2 (1938), p. 1, ink on paper, 45.5 × 58 cm. © ADAGP, Paris and DACS, London 2022, courtesy Jacques de la Béraudière, Brussels.
50 Diego Rivera, *The History of Mexico*, 1935, mural. Palacio Nacional, Mexico City. © Banco de México Diego Rivera Frida Kahlo Museums Trust, Mexico, D.F./DACS 2022, photo atosan/AdobeStock.
51 Manuel Álvarez Bravo, *Obrero en huelga asesinado*, 1934, gelatin silver print. © Archivo Manuel Álvarez Bravo SC/DACS, London 2022.
52 Rufino Tamayo, *Mystère de la nuit*, 1957, oil on canvas, 100 × 81 cm. Nasjonalmuseet, Oslo. © D.R. Rufino Tamayo/Herederos/México/Fundación Olga y Rufino Tamayo, A.C./ARS, NY and DACS, London 2022.
53 Jean-Baptiste Greuze, *La Cruche cassée*, 1771, oil on canvas, 109 × 87 cm. Musée du Louvre, Paris.
54 Ilya Mashkov, *Girl with Sunflowers* (*Zoya Andreeva*), 1930, oil on canvas, 102 × 77 cm. Collection of Inna Bazhenova.
55 Jean Degottex, *Désincarné*, 1955, oil on canvas, 195 × 130 cm. © ADAGP, Paris and DACS, London 2022.
56 Marcelle Loubchansky, *Bethsabée*, 1956, oil on canvas, 130 × 81 cm. Photo: AAB.
57 Endre Rozsda, *Amour sacré, amour profane*, 1944, oil on canvas, 104 × 79 cm. Musée des Beaux-Arts de Dijon. Courtesy José Mangani, Atelier Rozsda.
58 Breton, *Untitled*, n.d., ink and wax on paper, 12 × 7.7 cm. Photo: AAB.
59 Breton, collage poem, *c.* 1924, 21.2 × 17 cm. Photo: AAB.
60 Breton, *Lotus de Païni*, 1962, collage paper, aluminium, leaves, ink on paper, 29 × 25 cm. Photo: AAB.
61 Breton, *Le comte de Foix*, 1929, collage of printed papers, reproduced in *Intervention surréaliste*, *Documents 34* (1934).
62 'Experiment on inertia', illustration from Gaston Tissandier, *Les Récréations scientifiques, ou, L'enseignement par les jeux*, 4th edn (Paris, 1884), photo Getty Research Institute, Los Angeles.
63 Breton, *Charles VI jouant aux cartes pendant sa folie*, 1929, collage of printed papers, reproduced in *Intervention surréaliste*, *Documents 34* (1934).

64 Breton, *La Chouette noire*, 1955, poem-object, 18.6 × 14 cm. Private collection.

65 Breton, *La Nourrice des étoiles*, 1938, photocollage, 15.5 × 11.2 cm. The Israel Museum, Jerusalem, Vera and Arturo Schwarz Collection of Dada and Surrealist Art, photo AAB.

66 Breton, *Chapeaux de gaze garnis de blonde*, 1934, collage on printed paper, 17.5 × 21.5 cm. The Israel Museum Jerusalem, Vera and Arturo Schwarz Collection of Dada and Surrealist Art, photo © The Israel Museum, Jerusalem/Bridgeman Images.

67 Breton, *L'Oeuf de l'église (le serpent)*, 1932, collage on paper, reproduced in *Le Surréalisme au service de la révolution*, 6 (1933).

68 Breton, *Le Torrent automobile*, 1934, handwritten text on paper, penknife bound with twine mounted on card, 10.1 × 12.8 cm. Private collection.

69 Breton, *Untitled (Je vois j'imagine)*, 1935, poem-object, 16.3 × 20.7 cm. Scottish National Gallery of Modern Art, Edinburgh.

70 Breton, *Page-objet*, 1934, assemblage, 10 × 6.5 cm. Private collection, photo Luisa Ricciarini/Bridgeman Images.

71 Breton, *Untitled (Carte resplendissante de ma vie)*, 1937, assemblage, 39.4 × 30.4 × 3.7 cm. Art Institute of Chicago, Lindy and Edwin Bergman Collection, photo © Art Institute of Chicago/Art Resource/Scala, Florence.

72 *Cadavre exquis* (Salvador Dalí, Valentine Hugo, Gala Éluard and André Breton), c. 1934, pen, ink and pencil on paper, 26.7 × 19.5 cm. Private collection. © Salvador Dalí, Fundació Gala-Salvador Dalí, ADAGP, Paris and DACS, London 2022.

73 *Cadavre exquis* (Jacqueline Lamba, André Breton, Yves Tanguy), 1938, collage on paper, folded in half, 31 × 21.2 cm. Scottish National Gallery of Modern Art, Edinburgh. © ARS, NY, ADAGP, Paris and DACS, London 2022.

74 Victor Serge, Benjamin Péret, Remedios Varo and Breton at Villa Air-Bel Marseille, 1940–41, photograph.

75 Jacqueline Lamba, André Masson, Breton and Varian Fry, Marseille, 1941, photograph.

76 Collective drawings (Breton, Lamba and Lam), 1940, ink and coloured pencils, 23 × 29.8 cm. © ADAGP, Paris and DACS, London 2022. Courtesy Musée Cantini, Marseille.

77 Jacqueline Lamba, *Baudelaire, Jeu de Marseille*, 1940, gouache, india ink and collage on paper, 27.9 × 18 cm (each). © ADAGP, Paris and DACS, London 2022. Courtesy Musée Cantini, Marseille.

78 Breton, *Paracelsus, Jeu de Marseille*, 1940, black and coloured ink on paper mounted on cardboard, 23.7 × 13.8 cm. Courtesy Musée Cantini, Marseille.

79 Jacques-André Boiffard, Hotel des Grands Hommes, 1928, photograph. Photo: AAB.

80 Giorgio de Chirico, *The Enigma of a Day*, 1914, oil on canvas, 185.5 × 139.7 cm. Museum of Modern Art (MOMA), New York. © DACS, London 2022.

81 Nadja's eyes, photograph, in *Nadja* (Paris, 1963).

82 Léona Delcourt, *c.* 1926, anonymous photograph.

83 Léona Delcourt (Nadja), *Who Is She?*, 1926, drawing.

84 Léona Delcourt (Nadja), *La fleur des amants*, 1926, drawing.

85 Léona Delcourt, prints of Nadja's drawings, 1926. Bibliothèque littéraire Jacques Doucet, Paris. Photo: Heritage Image Partnership Ltd/Alamy Stock Photo.

86 Breton, *Arcane 17*, original manuscript page (1), 1944. Bibliothèque littéraire Jacques Doucet, Paris. Photo: AAB.

87 Breton, *Arcane 17*, original manuscript page (2), 1944. Bibliothèque littéraire Jacques Doucet, Paris. Photo: AAB.

88 Lucienne Thalheimer, binding, *Arcane 17*, 1956. Photo courtesy Bibliothèque littéraire Jacques Doucet, Paris.

89 Joan Miró, *Personnages dans la nuit guidés par les traces phosphorescentes des escargots*, 12 February 1940, ink, watercolour and chalk on paper, 37.9 × 45.7 cm, in *Constellations*. Private collection. © Successió Miró/ADAGP, Paris and DACS, London 2022.

90 Joan Miró, *Le Chant du rossignol à minuit et la pluie matinale*, 4 September 1940, gouache and oil wash on paper, 46 × 38 cm, in *Constellations*. Private collection. © Successió Miró/ADAGP, Paris and DACS, London 2022.

91 Gilles Ehrmann, André Breton's studio, 1996. © DACS, London 2022.

92 Paul Almasy, Breton in his studio, 1962, photograph. Photo: AAB.

93 Kachina Hopi doll, Arizona, 1910–40, painted wood, string feathers, 20.6 × 10.2 × 7 cm. Museum of Fine Arts, Houston (Gift of Miss

Ima Hogg), photo © Museum of Fine Arts, Houston/Bridgeman Images.

94 Paul Almasy, André Breton in his studio with Teotihuacan mask, 1962, photograph. Photo: AAB.

95 Teotihuacan mask, 3rd–7th century, stone. Musée du Louvre, Paris, on deposit from Musée du quai Branly. Photo: Marie-Lan Nguyen.

96 Sabine Weiss, *André Breton in His Studio, 42 rue Fontaine*, 1955, photograph. © Sabine Weiss, photo courtesy Sabine Weiss.

97 Sabine Weiss, *André Breton in His Studio, 42 rue Fontaine*, 1955, photograph. © Sabine Weiss, photo courtesy Sabine Weiss.

98 Ferrante Imperato, *Ritratto del Museo di Ferrante Imperato (Wunderkammer)*, engraving from *Dell'historia naturale* (Naples, 1599). Photo: Wellcome Collection (CC BY 4.0).

99 Anonymous, *Objet d'aliéné*, before 1910, wooden box, glass, various objects, 42.7 × 15.5 × 4 cm. Courtesy Musée LAM – Lille Métropole Musée d'art moderne, d'art contemporain et d'art brut, Villeneuve d'Ascq. Photo: Philip Bernard.

100 Gilles Ehrmann, André Breton's studio, 1996, photograph. © DACS, London 2022.

101 Jacques Cordonnier, Breton in his studio, 1951, photograph. Photo: AAB.

102 Giorgio de Chirico, *Le Cerveau de l'enfant*, 1914, oil on canvas, 80 × 65 cm. Courtesy Moderna Museet, Stockholm. © DACS, London, 2022.

103 Breton, *Réveil du 'Cerveau de l'enfant'*, Almanach surréaliste du demi-siècle, *La Nef*, 63–4 (1950), p. 145.

104 Pascal-Désir Maisonneuve, *La Reine Victoria*, before 1925, seashell, paint, plaster and nail on wood, 33 × 37 × 22 cm. Musée LAM – Lille Métropole Musée d'art moderne, d'art contemporain et d'art brut, Villeneuve d'Ascq. Photo: Jean-Pierre Dalbéra (CC BY 2.0).

105 Reconstruction of Breton's studio wall, 2003, photograph. Centre Pompidou – Musée national d'art moderne, Paris. © Successió Miró/Alberto Gironella/Association Marcel Duchamp/ADAGP, Paris and DACS, London 2022/Succession Picasso/DACS, London 2022. Photo © Centre Pompidou, MNAM-CCI, Dist. RMN-Grand Palais.

106 *Le Monde au temps des surréalistes*, 1929, in *Variétés – Le surréalisme en 1929*, pp. 26–7.
107 *Exposition nationale coloniale*, 1922, exhibition poster, Marseille.
108 *Exposition ethnographique des colonies françaises*, 1931, exhibition poster, Paris.
109 *Sculptures d'Afrique, d'Amérique, d'Océanie*, 1931, sales catalogue, Hôtel Drouot, Paris. Photo: Wellcome Collection (CC BY 4.0).
110 Kinugumiut or Napaskiak mask, Kuskokwim River, Alaska, wood, paint, feathers, fibres, 26.7 × 29.2 × 3.8 cm. Private collection. Courtesy Pace African & Oceanic Art, New York.
111 Haida transformation mask, British Columbia, 19th century, cedar wood, fibres, paint, metal pins, 51 × 25.3 × 15 cm. Photo © Musée du quai Branly – Jacques Chirac, Dist. RMN-Grand Palais/Patrick Gries/Valérie Torre.
112 Kovave Mask, Papua New Guinea, 20th century. Former Breton/Éluard Collection. Muséum d'Histoire Naturelle, La Rochelle.
113 New Ireland Uli statue, 19th century, 125 × 33 × 32 cm. Courtesy Bibliothèque littéraire Jacques Doucet, Paris.
114 New Ireland Malanggan ceremonial sculpture, 19th century. wood, coal, fibres, 122 × 40.5 × 23.5 cm. Photo © Musée du quai Branly – Jacques Chirac, Dist. RMN-Grand Palais/Hughes Dubois.
115 *La Révolution surréaliste*, 9–10 (1927), pp. 34 and 35. Photos: Bibliothèque nationale de France, Paris.
116 *Man Ray et objets des iles*, exhibition poster, 1926, Galerie 1900-2000. Photo © Archives Charmet/Bridgeman Images.
117 *Exposition surréaliste d'objets*, exhibition poster, 1936, Galerie Charles Ratton. Photo: Bibliothèque nationale de France, Paris.
118 Yupi'k fish mask, Yukon/Kuskokwim, Alaska, early 20th century, wood. Musée du Louvre, Paris, on deposit from Musée du Quai Branly, Paris. Photo: Marie-Lan Nguyen.
119 Wifredo Lam, illustration in Breton, *Fata Morgana* (1940), pencil on paper. © ADAGP, Paris and DACS, London 2022.
120 Baga Nimba shoulder mask, Guinea, 19th century, wood, fibres and brass sculpture. Musée du Louvre, Paris, on deposit from Muséum de Toulouse. Photo: Marie-Lan Nguyen.
121 Breton and Wifredo Lam, Port-au-Prince, Haiti, 1946, photograph. Photo: AAB.

122 Wifredo Lam, *La Jungla*, 1943, gouache on paper mounted on canvas, 239.4 × 229.9 cm. Museum of Modern Art (MOMA), New York. © ADAGP, Paris and DACS, London 2022.

123 Hélène Smith (born Catherine-Élise Müller), *Paysage ultramartien*, 1896, watercolour on paper, 23 × 30 cm. Private collection.

124 Adolf Wölfli, *Untitled*, 1916, pencil and coloured pencil, 64.7 × 48.8 cm. Kunstmuseum Basel.

125 Aloïse Corbaz, *Reine Victoria dans le manteau impérial pontifical* (recto), pencil, watercolour and coloured pencil on paper, 57.5 × 44 cm. Private collection. © Association Aloïse.

126 Breton, 'Le Message automatique', *Minotaure*, 3–4 (1933), p. 64. Photo: Bibliothèque nationale de France, Paris.

127 Augustin Lesage, *Composition symbolique*, 1928, oil on canvas, 141 × 109 cm. © ADAGP, Paris and DACS, London 2022. Courtesy Musée LAM – Lille Métropole Musée d'art moderne, d'art contemporain et d'art brut, Villeneuve d'Ascq. Photo: C. Thériez.

128 Fleury-Joseph Crépin, *Tableau merveilleux no. 11*, 1946, oil on canvas, 51.8 × 67 cm. Courtesy Musée LAM – Lille Métropole Musée d'art moderne, d'art contemporain et d'art brut, Villeneuve d'Ascq. Photo: Michel Bourguet.

129 Joseph Douzet, Ferdinand Cheval's Palais Idéal, Hauterives, 1905, photograph.

130 Alexandre Cabanel, *Naissance de Vénus*, 1863, oil on canvas, 130 × 225 cm. Musée d'Orsay, Paris.

131 Henri Rousseau, *Le Rêve*, 1910, oil on canvas, 204.5 × 298.5 cm. Museum of Modern Art (MOMA), New York.

132 Aloys Zötl, *La tortue bleue*, 1881, graphite and watercolour, 43.7 × 54.5 cm. Private collection.

133 Aloys Zötl, *Rhinoceros sinus. (Burchell)*, 1861, pen, black ink and watercolour, 37 × 47 cm. Private collection.

134 Breton, press cuttings on Haiti, *La Ruche* (17 December 1945), newsprint. Photo: AAB.

135 Hector Hyppolite, *Ogoun Ferraille*, c. 1945, paint on cardboard, 51 × 70 cm. Private collection.

136 Engraving from Nicolas Simon aus Weida, *Ludus artificialis oblivionis* (Leipzig, 1510), reproduced as frontispiece to Breton, *L'Art magique* (Paris, 1957). Photo: Zentralbibliothek Zürich.

137 Max Ernst, *Jardin gobe-avions*, 1935–6, oil on canvas, 54 × 64.7 cm. © ADAGP, Paris and DACS, London 2022, photo Peggy Guggenheim Collection, Venice.

138 Gabriel Ferry, *Costal l'Indien* [1856] (1925).

139 José Guadalupe Posada, *Calavera Maderista*, n.d., relief etching (zinc). National Gallery of Art, Washington, DC.

140 Yves Tanguy, *Large Painting Representing a Landscape*, 1927, oil on canvas, 116.5 × 90.8 cm. Private collection. © ARS, NY and DACS, London 2022, photo Bridgeman Images.

141 Frida Kahlo, *Self-portrait Dedicated to Leon Trotsky*, 1937, oil on masonite, 76.2 × 61 cm. © Banco de México Diego Rivera Frida Kahlo Museums Trust, Mexico, D.F./DACS 2022. Photo: National Museum of Women in the Arts, Washington, DC.

142 Frida Kahlo, *Lo que el agua me dio*, 1938, oil on canvas, 91 × 70.5 cm. Daniel Filipacchi collection, Paris. © Banco de México Diego Rivera Frida Kahlo Museums Trust, Mexico, D.F./DACS 2022, photo © Christie's Images/Bridgeman Images.

143 Henri Rousseau, *La Charmeuse de serpents*, 1907, oil on canvas, 169 × 189.5 cm. Musée d'Orsay, Paris.

144 André Masson, *Martinique charmeuse de serpents,* 1948, drawing, 46.9 × 32.1 cm. © ADAGP, Paris and DACS, London 2022, photo World History Archive/Alamy Stock Photo.

145 Elisa Breton, André Breton at Saint-Cirq-Lapopie, *c.* 1953, photograph. Photo: AAB.

Acknowledgements

I would like to thank Michael Leaman for commissioning this book and the team at Reaktion Books for their support and efficiency throughout the editorial and production process, in particular Alex Ciobanu for the illustrations, and Phoebe Colley, Amy Salter and Vivian Constantinopoulos for their editorial input. The André Breton Estate has been very supportive of the project, and my thanks go to Aube Elléouët Breton and Oona Elléouët for their kind waiving of copyright of Breton's own artworks. Thanks also to Constance Krebs, web curator of the Association Atelier André Breton, for her invaluable help in providing reproductions. I have also benefited from the kindness and patience of collectors and museum staff who have helped me obtain reproductions. The illustrations for the book were funded thanks to the support of the British Academy Small Grants fund, for which I am most grateful. Above all, I would like to thank Peter Dunwoodie for his unfailing encouragement and unsparing critical input throughout the project.

Index

Illustration numbers are indicated by *italics*

abstract art 91–3, 144, 166
 lyrical abstraction 30, 96–9, 150, 168
Africa 147, 149, 171, 173, 176, 188, *109, 120*
 Cubists and 171–3, 175–6
 Lam and 184, 187
 Nimba mask 187, *120*
 and Oceania 175–6, 236, *213*
L'Age d'or 218
alchemy 18, 91, 96, 124, 211, 214, 218, *136*
Alexandre, Maxime 52
Alvarez Bravo, Manuel 90–91, 179, *51*
analogy 73, 76, 91, 109, 118, 145, 159–60, 208, 209, 219, 230, 235–6, 237–8
Antoine, Régis 231
Apollinaire, Guillaume 13, 32, 63, 147, 176, 182, 192, 212, 213, 230
appropriation 31, 235, 238, *209, 227–8, 235, 187–8, 133, 34, 36, 88*
Aragon, Louis 13–14, 17, 18, 19, 39, 49, 63, 77, 92, 95, 150, 170, 192, *4*
Arcane 17 21, 127, 136–40, *86, 87*
 see also collage
art brut 192–7
 Almanach de l'art brut 196, 198, 208

 'L'Art des fous la clé des champs' 196–7
 Compagnie de l'Art Brut 24, 210
 Dubuffet and 24, 150, 165, 192–7, 198, 208
 Foyer de l'Art Brut 192, 198, 210
 Musée de l'Art Brut 193
L'Art magique 210–14
art naïf 191, 200–205
 'Autodidactes "dits naïfs"' 203
art nègre 170, 184
Artaud, Antonin 222
assemblage 36, 101–2, 117, 118, 165
 Breton 106, 110, *69, 70, 71*
 Miró 50, *34*
Association des Écrivains et Artistes Révolutionnaires 80
automatism 16, 61–8, 93, 99, 152, 191
 Lam and 184, 188
 and lyrical abstraction 96–7, 168
 and mediumistic art 197–8, 200
 'Le Message automatique' 192, 197–8
 Miró and 46–8
 and voodoo 207–8

Ballets Russes 49
Bataille, Georges 9, 19, 36–7, 50, 80, 81, 212, 238
 Un Cadavre 2
 Dalí 55–7, 58–9, *37*
Baudelaire, Charles 28, 92, 124, 145, 187, 218, 230, 231, 237

281

Bédouin, Jean-Louis 121
Bellmer, Hans 121
Bigaud, Wildon 208
Blake, William 95, 212
Boiffard, Jacques-André 28, 131, *79*
book 127–46
Brassaï 19–20, 36–7, *24*
Brauner, Victor 72, 121, 124, *237*
Breton Claro, Elisa 22, 103, 136–40, 163, 216
Breton Elléouët, Aube 12, 20, 103, 163–5, 166, 228
Bulletin International du Surréalisme 20, 218, *10, 11*

Cabanel, Alexandre 202, *130*
Un Cadavre 9, 19, 58, *10*
Cahiers d'art 62, 68, 180, 236
Caillois, Roger 211
Carlebach, Julius 173
Césaire, Aimé 21, 207, 228–9
 'Un grand poete noir' 228–9
Césaire, Suzanne 207, 229
Chaissac, Gaston 210
Cheval, Ferdinand 198, 200, 201, *129*
childhood 13, 19, 49, 71, 106, 145, 175
 children's art 49, 183, 188, 191
 children's books 43, 216, 221, 230
 Miró and 49
Chirico, Giorgio De 28, 29, 63, 64, 131–2, 148, 211, 230, 232, 233, 238, *80*
 Le Cerveau de l'enfant 150–52, 160–61, 176, *102*
 Réveil du 'Cerveau de l'enfant' 161, *103*
Clarté 18, 77–8
Clé 85
Clé des champs, La 52, 141
collage 32, 50, 62, 64, 101–10, 117, 121, 126, 238, *23, 31, 36, 73*
 Arcane 17 (ms) 136–40, *86, 87*
 Chapeaux de gaze garnis de blonde 108, *66*
 Charles VI jouant aux cartes pendant sa folie 105–6, *63*

Chouette noire, La 106, *64*
collage-poem 102, *59*
Le Comte de Foix allant assassiner son fils 105–6, *61*
'Le Corset Mystere' 116
and Ernst 15, 39–46, 75–6, *27, 30, 31*
rue Fontaine as 154–63, *96, 97, 100, 101*
Nourrice des étoiles, La 107, *65*
L'Oeuf de l'église (le serpent) 108–9, *67*
collection 147–63, 171–2, 173, *91, 92*
collecting 32, 49, 147–54, *33*
Musée national d'art moderne 165–8, *105*
petition 165
sale of 163–5
collective drawing 121, *76*
see also exquisite corpse
colonialism 77, 170, 191, 221, *107, 108*
anti-colonialism 80, 184, 235, 236
Cheval, Ferdinand 201
Cuba 188
Martinique 229
Mexico 222, 223
'Ne visitez pas l'Exposition coloniale' 235
communism 18, 19, 37–8, 45, 78–81, 83–4, 87, 92, 95
Constellations 127, 141–6
 Breton 143–5
 Miró 141–3, *89, 90*
Contre-Attaque 81
convulsive beauty 19, 65–6
Corbaz, Aloïse 30, 147, 150, 192, 195–6, 210, 237, *125*
Crépin, Fleury-Joseph 150, 165, 198–200, 201, 210, *127, 128*
Crevel, René 197, *35*
Cubism 32, 64, 78, 149, 166, 171
and Africa 171–3, 175–6
Lam and 184, 187, 188
Picasso and 34–5, 37–8, *23*

Dada 14–15, 32, 39–42, 77, *4*, *5*, *6*, *26*
Dalí, Salvador 9, 50, 52–60, 75, 80–81, 92, 112, 114, 179, 197, 218, *35*, *73*
　and Bataille 55–7, 58–9, *37*
　Le Jeu lugubre 52, 53–5, 56–7, 58–9, *36*, *37*
　'Première exposition Dalí' 53–5
De Zayas, Marius 149
decalcomania 67, 101, *41*

Degottex, Jean 96, 168, *55*
Delcourt, Léona (Nadja) 132–3, 136, 192, 197, *83*, *84*, *85*
Demonchy, André 205
Depestre, René 206, 207
Derain, André 140, 147, 148, 149, 171
Desnos, Robert 13, 17, 19, 28–9, 133, *2*
Documents 19, 36, 55, 159, 180, *37*
Dominguez, Oscar 67, 73–4, 121, 124, 217, 218, *41*
Donati, Enrico 21, 173
Doucet, Jacques 30, 32, 148–9, 184
Dubuffet, Jean
　and art brut 24, 150, 165, 192–7, 198, 208
Duchamp, Marcel 9–11, 28, 31, 32, 45, 77, 114, 119–21, 127, 149, *12*
　in New York 21, 45
Duvillier, Jean 96, 150

Ehrenburg, Ilya 81
Eisenstein, Sergei 221–2
Elléouët, Oona 164
Éluard, Gala 112, 136, *72*
Éluard, Paul 9, 13, 52, 81, 110–12, 128, 133, 145, 152, 172–3, 178, *35*, *72*
　collection 147–8, 149, 164, 171
　and communism 18, 45, 78, 80
　Dada *4*, *6*
　La Nourrice des étoiles 107, *65*
Emergency Rescue Committee 121, 228
Ernst, Max 39–46, 63, 73, 97–9, 121, 135, 149, 216, 217, 219, *44*, *72*, *137*
　1921 exhibition 15, 39–42
　'Avis au lecteur pour *La Femme 100 tetes* de Max Ernst' 43–5
　and collage 39–41, 43–5, *27*
　La Femme 100 têtes 75–6, 43–5, *31*
　'The Legendary Life of Max Ernst' 45
　'Max Ernst' 41
　portrait of Breton 42–3, *28*, *29*, *30*
erotic 73, 114, 144–5, 154, 196, 220, 230, 231
　and Tenerife 217–9
esoteric 21, 24, 91, 124, 139–40, 210, 213, 237
　and voodoo 205, 207
Estienne, Charles 92, 96, 97, 99
ethnography 169–90, 176, 180, 188, 191
　and art 180–81
　Lam and 184–90
　Leiris and 188–90
　'Main première' 182
　'Phénix du masque' 181–2
　see also Africa; Oceania
Europe 20, 82, 169–70, 188, 191, 212, 215, 218
　Mexico and 215, 221
exotic 58, 156, 183, 187, 202, 219, 231, 236
Exposition coloniale 80
Exposition nationale coloniale 170, *107*
exquisite corpse 45, 117–18, 177, *72*, *73*, *115*
　Le Cadavre exquis, son exaltation *118*

fairytale 144–5, 201
fascism 59, 80, 84
Fata Morgana 119, 121, 140–41, 185, *119*
Ferdière, Gaston 196
Ferry, Gabriel 221, *138*
Filipacchi, Daniel 163
Fleiss, Marcel 164
For an Independent Revolutionary Art 83–5

Forneret, Xavier 145
Fourier, Charles 91, 127, 136, 145, 205, 237
Francés, Esteban 67–8
free association 13, 16, 73–4, 230–31
Freud, Sigmund 13, 57, 83, 116, 124, 127, 183, 218
Fry, Varian 21, 121, 75
fumage 67, 42
Füssli, J. H. 212

galleries
 À l'Étoile Scellée 96, 150
 Au Sacre du Printemps 61, 38
 Charles Ratton 179, 117
 Daniel Cordier 237
 Gradiva 179, 184
 Guggenheim Jeune 74
 Pierre 184
 René Drouin 192
 Surréaliste 169, 179
games 116–26
 definitions 116
 exquisite corpse 117–18, 72, 73
 hypothesis 116
 portraits 121
 tarot 123, 77, 78
Gauguin, Paul 169, 176, 212
Giacometti 63, 112, 127, 149, 160
Gorky, Arshile 21, 14
Goutier, Jean-Michel 164, 166
Goya, Francisco de 212, 217
grattage 67–8, 73
Greece 213
Greuze, Jean-Baptiste 94–5, 53
Guggenheim, Peggy 45, 116

Haiti 22, 187, 205–10, 216, 121
 La Ruche 206–7, 134
Hérold, Jacques 93, 124
Hirshfield, Morris 205
Hopi 22, 114, 157, 163, 175, 178, 179, 216, 93
Hugnet, Georges 45, 146
Hugo, Valentine 11, 115, 3, 72
Hugo, Victor 140, 147, 166, 212

Hyppolite, Hector 72–3, 205, 208–10, 216, 135
 'Hector Hyppolite' 208–10

illustration 64, 78, 127, 198, 216, 230, 119
 Ernst 43
 Nadja 128–36
 Picasso 34–5
 Rousseau 231
image 40–42, 43, 59, 61–3, 68, 74, 114
intertextual 71, 73, 58, 145, 216, 217, 228
Italy 80, 213

Jarry, Alfred 63, 123, 140, 202, 235
juxtaposition 42, 61–2, 76, 91, 92, 101, 114, 145, 161, 176–80, 183–4, 196, 236

Kahlo, Frida 31, 180, 222, 223, 227–8, 235, 141, 142
Kahn, Simone 15, 17, 32, 42, 150, 170
Kahnweiler, Daniel-Henry 32, 149
Kandinsky, Vassily 62, 71, 74–5, 45

Lacan, Jacques 196
Lam, Wifredo 121, 124, 140–41, 184–90, 228, 76, 77, 121
 and Africa 184, 187
 and Cuba 188
 Fata Morgana 185, 119
 La Jungle 190, 122
 and Leiris 188–90
 'Wifredo Lam. À la longue nostalgie des poètes . . .' 187
 'Wifredo Lam. La nuit en Haiti' 187–8
Lamba, Jacqueline 19, 20, 45, 82, 114, 121, 124, 217, 228, 73, 75, 76, 77
landscape 55, 71
 Haiti 216
 Martinique 228–33
 Mexico 221–3
 Rivera 89

Rousseau 202
Tenerife 217–21
Lang, Jack 163
Laraque, Paul 9, 207
Lautréamont, Comte de 14, 35, 63, 83, 101, 124, 212
Légitime défense 78
Legrand, Gérard 24, 210–14
Leiris, Michel 16, 19, 36, 47, 48, 50, 52, 180, 184, 229, *2*
 and *carrefour* 190
 and colonialism 188
 homme métis 190
 and Lam 188–90
Leonardo da Vinci 73, 198, 212, 218
Lesage, Augustin 198, 200, *127*
Lévi-Strauss, Claude 173–5, 180, 183, 185, 212, 228
Lille Métropole Musée d'Art Moderne 165
Lo Duca, Joseph-Marie 196–7
London 20, 25, 74
Loubchansky, Marcelle 96, 150, *56*
Louis, Séraphine 205

Maar, Dora 184, 217
Mabille, Pierre 187, 206, 208
magic 46, 50, 62, 75, 92, 207, 208, 210–14, 237
 magic realism *see* realism
Magritte, René 72, 75, 114, 230, 231
Maisonneuve, Pascal-Désir 165, *104*
Malraux, André 237
Man Ray 45, 64, 66, 143, 120, 169, 179, 217, *1, 3, 7, 11, 40, 116*
 and *Nadja* 133, 135
Manifeste du Surréalisme 13, 15–16, 42, 51, 221
Marseille 20, 45, 118, 119–26, 170, 185, 228, *74, 75, 107*
Martinique 185, 202, 228–33
 'Le dialogue créole' 216–17, 229–31
 Martinique charmeuse de serpents 228–33
 Masson and 229–31, *144*
Marxism 77–81, 89, 94–5

Masson, André 64, 66, 70, 78–80, 85, 124, *39, 43, 46, 49*
 and *Martinique charmeuse de serpents* 229–31, *144*
Matisse, Henri 28, 31, 33, 95, 148
Matisse, Pierre 21, 143, 185, *15*
Matta, Roberto 21, 70, 173, 238, *13*
mediumistic art 197–200
 'Entrée des médiums' 197
Mélusine 136, 140, 145
Ménil, René 207, 228–9
Mexico 20, 85–91, 173, 215, 216, 221–8, *94*
 Indigenist movement 222
 Mexique 179–80
 'Souvenir du Mexique' 81–2, 85–6, 89, 222, 223
 Teotihuacan 173, *94, 95*
 see also Kahlo, Frida; Rivera, Diego; Posada, Guadalupe
Minotaure 19, 28, 36, 43, 66, 68, 90, 126, 175, 180, *24, 41*
Miró, Joan 46–52, 149, 168, 217, *32, 33*
 and automatism 47–8
 Le Chasseur 48–9, *32*
 and childhood 49
 Constellations 141–3, *89, 90*
Mitterrand, François 163
Le Monde au temps des surréalistes 169, 215, 221, *106*
Monnier, Adrienne 13
Mont de piété 140
Moreau, Gustave 28, 147, 212
Morgenthaler, Walter 196
Morise, Max 63–4, 197
Müller, Heinrich Anton 192
Musée de l'Homme 237
Muzard, Suzanne 129

Nadja *see* Delcourt, Léona
Nadja 65, 127–36, 135, 136, 140, 146, 150, 154, 165, 197, 215, 228, 235, *79, 81, 82*
 drawings (Léona Delcourt) 132–3, 136, 192, 197, *83, 84, 85*

La Nature 104–5, *62*
Naville, Pierre 63–4, 213
Nerval, Gérard de 63, 64, 137, 140, 145
Neter, August 196
New York 21, 45, 60, 91, 149, 173
 Museum of Natural History 173
 Museum of the American Indian 173
Nietzsche, Friedrich 127, 145
Northwest Pacific 171, 173
 Alaska 149, 173, *110*
 British Columbia 173, *111*
 'Notes sur les masques à transformation' 182
Novalis 124, 137, 140

object 110–14, 128, 132, 153–4, 173, 182
 'Crise de l'objet' 110–12
 'Situation surréaliste de l'objet' 20, 217–18
objective chance 19, 82, 112, 145, 152
objet d'aliéné 156, 165, 195, *99*
Oceania 29, 30, 69, 101, 147, 153, 164, 169, 171, 172, *113*
 and Africa 175–6, 236, *213*
 Easter Island 154, 169
 malanggan sculpture 176, *114*
 New Britain Sulka mask 176
 New Guinea 76, *112*
 New Ireland Uli 176, *113*
 'Océanie' 175–6
 Yupi'k mask 182–3, *118*
Oppenheim, Méret 114, 195
Orient 74, 170, 215
outsider art 192–7

Paalen, Wolfgang 67, 236, *42*
Paris 13, 22, 25, 128–32, 215
Paulhan, Jean 192, 211
Paz, Octavio 115
Penrose, Roland 37, 219
Péret, Benjamin 18, 31, 39, 45, 62, 78, 96, 121, 137, 146, 210, 217, 218, *26, 74*
Peters, DeWitt 208, 210

Petitjean, Léon 200
photography 32, 64, 70, 138, 162, 164, 236
 'photography of the mind' 64, 70, 75, 93
 see also Alvarez Bravo, Manuel; Brassaï; Man Ray
Picasso, Pablo 32–9, 63, 78, 141, 148–9, 184, 218
 and Cubism 34–5, 37–8, *23*
 portrait of Breton 32, *21*
 portrait of Stalin 39, *25*
Pinault, François 163–4
poem-objects 110–16, 127
 by Breton:
 Carte resplendissante de ma vie 110, *71*
 Je vois j'imagine 70, 110, *69*
 Page-objet 110, *70*
 'Le Poème-objet' 116
 Portrait de l'acteur A. B. . . . 116
 Rêve-objet 114–15
 Le Torrent automobile 115, *68*
 by Breton and Lamba:
 Le Petit Mimétique 114
politics 18–9, 27, 77, 92
 art and 20, 80, 83–4
 Contre-Attaque 81
 Kahlo 227
 Alvarez Bravo 90–91
 myth and 85–90
 realism and 93–5
portraits 39, 54, 65, 94, 70, 107, 140, 223, *88, 65*
 of Breton 9–12, 32, 42–3, 70, *1, 2, 3, 21, 43, 47*
 of Nadja 133, 135–6, *81, 82*
 self-portraits 136, *84, 85*
Posada, Guadalupe 222, *143*
Prague 20, 25, 62, 81, 215, 218
primitive 68–71, 85, 181, 183, 187–8, 190, 191, 203, 207, 209, 212, 222, 236
Prinzhorn, Hans 196

Quebec 136–8

Ratton, Charles, 171, 173, 192
realism 16, 92, 93–5, 97, 129, 210, 53
 'Comète surréaliste' 94
 magic realism 48, 64, 68, 203, 212–13
 'Position politique de l'art d'aujourd'hui' 81
 socialist realism 81, 88, 95, 97, 54
Réja, Marcel 196
Reverdy, Pierre 36, 61–2, 63
revolution 77–99, 123–4, 169–70, 205
 art and 37
 FIARI 84
 Mexican Revolution 81, 221, 222
 Russian Revolution 77, 81
La Révolution surréaliste 18, 19, 28, 32, 36, 37–8, 64, 78–9, 132, 172, 177, 192, *22, 23, 115*
Rimbaud, Arthur 63, 76, 77, 78, 144, 145, 212, 218
Rivera, Diego 82–4, 86–90, 91, 222, *48, 50*
Rivet, Paul 237
Rivière, Georges Henri 180
Rorschach test 71, 73, 222
Roumain, Jacques 216
Rousseau, Henri 148, 201–4, 212, 222, 229–30, 231, *131, 143*
Rozsda, Endre 96, *57*
rue Fontaine 154–63, 96, 97, 100, 101

Sade, Marquis de 27, 58, 80, 83, 124, 127, 220, 230
Saint-Cirq-Lapopie 24–5, 216, *17, 18, 145*
Saint-Pol-Roux 229
Sardou, Victorien 200
Sartre, Jean-Paul 92
Sculptures d'Afrique, d'Amérique, d'Océanie 172, *109*
Second Manifeste du Surréalisme 13, 18–19, 43, 50, 58, 78
Seligmann, Kurt 175
Serge, Victor 121, 228, *74*
Seurat, Georges 217

Smith, Hélène 124, 136, 192, 198, *123*
Soirées de Paris 3
Spanish Civil War 144, 184, *84–5*
 Le Thé avec Franco 84–5, *49*
Stalinism 19, 39, 83–5, 92, 215
 Picasso and 39, *25*
 'Position politique de l'art d'aujourd'hui' 81
Štyrsky, Jindřich 20, 103, 217
Le Surréalisme au service de la révolution 19, 28, 80, 108–9, 112
Le Surréalisme et la peinture 61
'Le Surréalisme et la peinture' 34, 43, 55, 64, 68
Le Surréalisme, même 195
Surrealist exhibitions 12, 20, 24, 28–9, 39, 46, 47, 61, 93, *19, 20*
 L'Art brut préféré aux arts culturels (1949) 192
 Cadavres exquis (1948) 29
 Exposicion surrealista (1935) 217
 Exposition internationale du surréalisme (1938) 29
 Exposition internationale du surréalisme (EROS) (1959) 237
 Exposition nationale coloniale (1922) 170, *107*
 Exposition surréaliste (1928) 61, *38*
 Exposition surréaliste d'objets (1936) 29, 112–14, 179, *20*
 First Papers of Surrealism (1942) 45
 Le Masque (1959–60) 180
 Mexique (1939) 79–80
 Le Surréalisme en 1947 24, 92, 96, 127, 137, 210, 237
 Tableaux de Man Ray et objets des îles (1926) 169, 179
 Yves Tanguy et objets d'Amérique (27) 179
Surrealist group 17, 19, 22–4, 25, 154
 photographs *7, 8, 16, 18, 22, 28, 30, 145*

Tamayo, Rufino 91, *52*
Tanguy, Yves 30, 45, 55, 63, 69, 80, 96, 149, 157, 179, 223, *73, 101, 140*

Tapié, Michel 192
tarot 101, 119, 121–6, 136, 139, 185, 208, 211, *77*, *78*
Télémaque, Hervé 208
Tenerife 20, 215–21
text-image 114, 127, 129–30, 137–40, 144–6
Thalheimer, Lucienne 140, *88*
Thoby-Marcellin, Philippe 208
Tristan, Flora 136
Trocadéro, musée du 170, 171, *108*
Tropiques 21, 207, 229
Trotsky, Leon 12, 82–5, 20, 68, 86, 165, 222, *47*, *48*
Trotskyism 19–20, 81, 85
Tzara, Tristan 14–15, 22–3, 39, 92, 147, 171, 181

Uhde, Wilhelm 149

Variétés 198
Varo, Remedios 121, *74*
vision 68–71, 183, 187–8, 191, 209–10, 216, 219, 230, 236–7
Vivancos, Miguel García 205
voodoo 187, 207–9, 211
vvv 21, 43, 70, 137

war 77, 93, 210
 First World War 13, 14, 40, 192
 Second World War 21, 45, 60, 85, 110, 136
Watteau, Antoine 214, 217
Westerdahl, Edouardo 217
Wölfli, Adolf 192, 195, 196, *124*
Wunderkammer 156–7, *98*

Zervos, Christian 62, 236
Zötl, Aloys 204–5, *132*, *133*